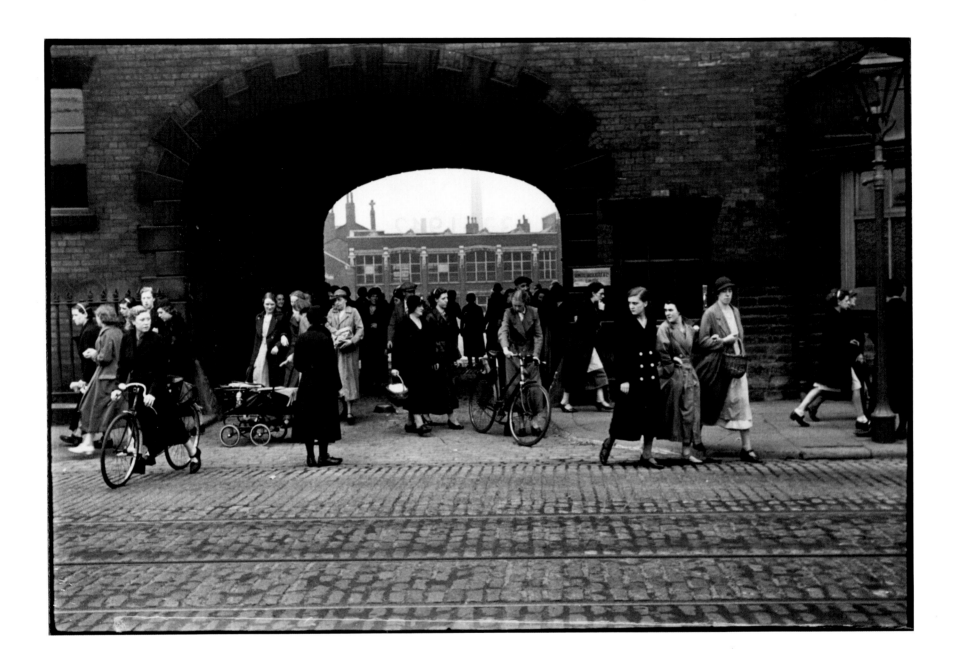

# HUMPHREY SPENDER'S HUMANIST LANDSCAPES: PHOTO-DOCUMENTS, 1932–1942

Deborah Frizzell

Yale Center for British Art
Paul Mellon Centre for Studies in British Art

Published on the occasion of an exhibition
Yale Center for British Art, New Haven, Connecticut
September 10 – November 9, 1997

© 1997 Yale Center for British Art
ISBN 0-300-07334-8
Library of Congress Catalog Card Number 97-061161

Designed and set by Julie Lavorgna
Printed by Herlin Press Inc.
Distributed by Yale University Press

Front cover: cat. 25
Back cover: cat. 64
Frontispiece: cat. 35

# TABLE OF CONTENTS

# ACKNOWLEDGMENTS

This catalogue and the accompanying exhibition originated in a serendipitous visit to a Connecticut bookstore, where I first encountered the photographs of Humphrey Spender in *'Lensman': Photographs, 1932–1952*. Spender's *'Lensman'* combined a selection of his documentary photographs with personal recollections from his years as a photojournalist during the Depression era through World War II. I found the images and text of *'Lensman'* intellectually compelling and emotionally involving; the photographs seemed to me to embody a myriad of subtle human interactions, and to demand a further exploration by the viewer of the specifics of place, time, and conditions. Who were these people? What was the nature of their lives? Under what conditions and for what reasons was the photographer documenting these people and particular situations? Having purchased the bookstore's last two copies of an out-of-print *'Lensman,'* I mailed one copy to my former teacher, the late poet laureate, Joseph Brodsky. As an ardent admirer of the poems of W. H. Auden and Stephen Spender, Humphrey Spender's brother, Brodsky would, I felt sure, appreciate the correlations between Auden's and Spender's Depression-era poems and Humphrey Spender's photographs. Brodsky, equally moved by *'Lensman,'* became a catalyst in fostering the concept of an exhibition of Spender's photographs in this country. And it was through the generosity of Brodsky's friends, Sir Stephen and Natasha Spender, that I was able to meet Humphrey Spender and begin the process of studying his photographs.

I have many people to thank for their support and encouragement. Scott Wilcox, Associate Curator for Prints and Drawings at the Yale Center for British Art, gave very special and continuous help in the realization of this undertaking. His keen commitment from the inception of the idea for an exhibition to the final installation was an invaluable contribution, as were his dialogues with me concerning the formulation of issues, and his precise and penetrating critiques of the drafts for this catalogue text. I am also indebted to the former Director of the Center, Duncan Robinson, and the current Director, Patrick McCaughey, for their dedication to the Spender project. In addition, I would like to extend my thanks to the entire staff of the Center for their professional support and guidance. Finally, special thanks are due to the Paul Mellon Centre for Studies in British Art, London, which has made possible the publication of this catalogue.

I am especially obliged to the Graduate Center of the City University of New York for making it possible for me to travel to England to complete my research through a CUNY Travel Stipend. And I owe special gratitude to several of the faculty at the Graduate Center's Art History Department for their close readings and critical assessments of the drafts for the catalogue text at various stages of development. Rose-Carol Washton Long provided important bibliographical and contextual materials concerning Weimar culture in Germany, so intrinsic to Spender's photographic aesthetic. I have profited considerably from the advice and careful criticism of Carol Armstrong in the rewriting of later drafts. Anna Chave's bibliographical suggestions of contemporary critical discourse on documentary photography were indispensable. And I am grateful to Sally Webster for reading through my formal proposals of the project later presented to the Yale Center for British Art.

Christopher Phillips's analysis of the initial draft for the text and his significant bibliographical suggestions concerning illustrated magazines of the 1930s were crucial to the early stages of research, as were the comments of Marek Bartelik and Ellen D'Oench.

Many people in England contributed to this endeavor. The art historical scholarship of Dr. David Mellor of the University of Sussex, to whom I am especially indebted, provided seminal analyses of the evolution of Spender's connections to German avant-garde culture; and my conversations with him regarding British documentary and culture offered stimulating and challenging feedback for the development of issues with which I was grappling. Dorothy Sheridan, Archivist and Director of the Mass-Observation Archive at the University of Sussex, and Joy Eldridge, Archive Assistant, contributed their expertise during all phases of my research into Spender's work for M-O. Larry Naughton, son of Mass-Observer and writer, Bill Naughton, shared his personal experiences and remembrances of Bolton and M-O. My friends, Derek and Margaret Warrilow, offered their kind hospitality by making their home my "second home" during my stays in England.

The staff of the Yale Center and I are grateful to Hulton Getty and Toby Hopkins for their assistance and permission to exhibit and publish Spender's photographs taken for *Picture Post* and the original pages of issues of the magazine reproduced here. We wish to thank also the Imperial War Museum for the permission to reproduce one of Spender's World War II photographs. The Bolton Museum and Art Gallery, the Victoria and Albert Museum, the Manchester City Art Gallery, and the National Gallery of Canada generously lent works to the

exhibition and granted permission to reproduce these works in the catalogue. We are grateful to the Sterling Memorial Library of Yale University for the loan of crucial texts and periodicals from the 1930s.

The most important and special thanks go to Humphrey Spender, whose remarkable accomplishments as a photographer are the focus of this exhibition and catalogue. Spender opened up his studio to me and was endlessly generous in sharing both his time and his knowledge. In particular, I came to admire his unflinching honesty in describing his past experiences and in articulating his thoughts and concerns as a documentary photographer. He and his wife Pauline were marvelous hosts, and their acute recollections of the Depression and War years brought those days into vivid relief. Many of the photobooks, Mass-Observation publications, and period journals critical to apprehending British culture in the 1930s, have been borrowed from Spender's own archives. Most of the photographs in the exhibition are lent by the artist himself, and most have been printed either by Spender or his printer, Danny Chau. Much of the organization of Spender's photographs was undertaken by Rachel Hewitt, Spender's assistant. I cannot thank Spender and his assistants enough for helping to coordinate the assemblage of photographs and materials from the Studio in Ulting.

Finally, I would like to thank my husband David for critically reading the many drafts of this text and for his continuous encouragement of this project over the past three years. Without his support, I would not have been able to sustain my efforts.

# PREFACE

Humphrey Spender's photo-documents from the Depression era in Britain occupy a quiet but distinguished place in the history of modern social documentary and candid street-life surveys. Underappreciated until quite recently, Spender's exceptional contributions to this genre occurred in the decade from 1932 to 1942, when he created a remarkable series of photographs that embody with lucidity, detail, and breadth an entire complex of social relations. His merging of individual drama with an evolving social consciousness is at the heart of the British documentary movement and is paralleled in the prose and poetry of the Auden Generation, especially in the concerns of Humphrey's older brother, the late Sir Stephen Spender, who wrote in 1938: "In what is essentially a revolutionary period, the task [of the artist]…is tremendous: it is to realise by every means at his disposal the nature of what is happening, and clarify this realisation for his audience."[1] This was the task that Humphrey Spender set for himself.

While attending the University of Freiburg im Breisgau and the Architectural Association School of Architecture in London from 1927 until 1934, Spender traveled in Germany, Austria and other parts of Europe, absorbing the aesthetic experiments of the German and Russian avant-garde. In his first years as a professional photojournalist, he provided images of a pastoral England for the *Daily Mirror*, while concentrating his creative and intellectual energies on the more challenging subject matter of Britain's large industrial cities. His photographs of unemployment and poverty in Newcastle-upon-Tyne, Jarrow, and Stepney, published in such journals as the *Listener* (1934) and the *Left Review* (1936), were critical social documents at the inception of the British documentary movement. Spender's growing commitment to the sociological study of the British people led to his involvement with Mass-Observation, the project to survey British culture and society initiated by the anthropologist Tom Harrisson, the poet and journalist Charles Madge, and the surrealist painter and filmmaker Humphrey Jennings. Spender was the photo-documentarian for the project, capturing "significant moments" in the midst of the flow of life in pubs, parks, markets, factories, offices, locker rooms, and on the street.

In 1938, as one result of the Mass-Observation project, Spender became a photojournalist for the new illustrated weekly magazine *Picture Post*, edited by Stefan Lorant, the noted pioneer of photojournalism. Spender's photographs contributed to the success of *Picture Post*, which played a key role in the forging of modern British journalism and in shaping the new social consciousness and radicalism of the war years. In photo-stories both on conditions in Britain's industrial cities and on servicemen and civilians coping with the war, Spender continued to deepen and refine his work as a photographer and his understanding as an observer of human relations.

In 1939, after Spender's first year at *Picture Post*, the diagnosis of his first wife's terminal illness imposed significant limitations on his time spent as a photojournalist. Spender's photographic work temporarily ceased in February 1941, when he was drafted into the Royal Army Service Corps. But by early 1942, the British government acknowledged the armed forces' need for photographers, and Spender was commissioned as an army photographer (War Office Official). He was transferred to Photo-Interpretation in 1944 to work with the Theatre Intelligence Service, using RAF aerial photography to make maps for the D-day invasion of France. Following World War II, Spender devoted himself primarily to painting and textile design, returning only intermittently to photojournalism.

Much of Spender's work as a documentary photographer went unnoticed or unpublished until the 1970s, when interest in Mass-Observation and revisionist historical analysis began. The publication in 1975 of many of his photo-documents by the Royal College of Art in *Britain in the Thirties: Photographs by Humphrey Spender with an introduction and commentary by Tom Harrisson*, was the beginning of a reappraisal of British documentary. In the same year, London's Hayward Gallery mounted a seminal group exhibition entitled *The Real Thing: An Anthology of British Photography, 1840–1950*, focusing on and defining British realism in its many forms, while in 1978 the journal *Camerawork* published a special issue, number 11, examining Mass-Observation, including articles placing Spender's photographs within the documentary movement. Humphrey Spender's solo photographic exhibition in 1977 at the Gardner Arts Centre at the University of Sussex, home of the Mass-Observation Archive, was the first full-scale scholarly analysis of his Mass-Observation work, with an important catalogue essay by David Mellor.[2] During the 1980s, scholarly, critical, and popular interest continued to be focused on 1930s documentary style, with solo and group exhibitions of Spender's photographs organized at the National Museum of Photography, Film and Television at Bradford (1987), the Museum of London (1981), the Museum of

Modern Art at Oxford (1982), Arnolfini Gallery, Bristol (1982), and Geffrye Museum in London (1982), among other public and private venues. A major publication of Spender's Mass-Observation photographs, *Worktown People: Photographs from Northern England, 1937–1938*, was published in 1982 (and republished in 1995 by Jeremy Mulford's Falling Wall Press), while his works appeared for the first time in Mass-Observation publications: *Britain Revisited* (1961, Gollancz) and *The Pub and the People* (1971, Seven Dials Press; and 1987, Cresset Library). A selection of photographs from his entire photojournalistic career appeared in 1987 with *'Lensman': Photographs 1932–1952*, coinciding with an exhibition on Mass-Observation at Watermans Art Centre, Brentford.[3] In 1993 and 1994, exhibitions at the Bolton Museum and Art Gallery and at Smithills Hall Museum in Bolton contributed to the reassessment and chronology of Spender's M-O documentary work.[4]

The present catalogue analyzes the aesthetic, critical, and art-historical importance of Spender's work within the genesis of British photojournalism, its place within the broader dialogue of the British documentary movement, and its functions within the context of the Mass-Observation cultural anthropology project and the popular illustrated magazine *Picture Post*. Spender's work for *Picture Post* and his involvement with the Mass-Observation project to survey British culture and society open a unique window onto the social and aesthetic concerns of the 1930s, while at the same time raising broader issues about the nature of documentary and journalistic photography.

# INTRODUCTION

*The camera is only the go-between, the exact and remorseless medium, between the see-er and seen …The photograph…is a halfway house between the purely mental creation of the abstract design, and the Academician's adumbration of the obvious. In this, it seems to me, lies its unique value. Between what is in the painter's [or photographer's] mind and the world which he confronts there is an infinity of proportions of the two.[5]*

In 1931, when G. H. Saxon Mills wrote his introductory essay to one of the newly popular photobooks, *Modern Photography*, Humphrey Spender (b. 1910, London) was a twenty-one-year-old student at the Architectural Association School of Architecture in London. While a student, Spender avidly experimented with the possibilities offered by the technically advanced cameras and lenses manufactured in Germany, where he traveled during the summer months. Within the pages of *Modern Photography*, Spender studied closely the spectrum of the "infinity of proportions" embodied in the photographs, from the distilled, abstracted designs of Laszlo Moholy-Nagy to the external, chaotic world candidly captured by Erich Salomon in his intimate shots of conferring diplomats.[6] Between the artist's inner visions and the outer surfaces of the phenomenal world, the camera, according to Saxon Mills, was a perfected, nearly transparent medium, equally adept at constructing detached, "beautiful relations of light and form"[7] and capturing a "fine isolated verisimilitude" from within the flow of life itself.[8] In pouring over the annual issues of *Modern Photography*, Humphrey Spender responded to the irresistible possibilities offered by the medium of the camera. Advances in the technology of the camera and the urgency of the political and

social crises of the Depression era, together with the difficulties of finding work as a trained architect, enticed Spender away from architecture and into the burgeoning documentary movement in Britain.

During the 1920s and through the 1930s, the camera-eye came to represent the means by which one might grasp "objective truth," seemingly without the intervention of subjectivity and interpretation. In his *Modern Photography* essay, Saxon Mills advanced the camera's claim of objectivity:

> *And in that it* [the camera] *cannot lie, you have…the first point of superiority of the camera-eye over the human eye…It singles out with no sacred aura the house on the cliff where you were born. But, dispassionately and coldly and truthfully, it gives you the whole scene in its beautiful relations of light and form.[9]*

In recording the surfaces of the world, the photograph was equated with a supreme form of authentication or evidence of the "truth" of events. It seemed to reify our very existence for coming generations. As August Sander wrote of his ethnographic photo-survey of German life, "The tragedy of our photographic language would be understood by all past and future human beings without further commentary." The photograph would "fix and hold fast history" and "express the whole brutal, inhuman spirit of the time in universally comprehensible form."[10] This "brutal" reality was transcribed by artists with a "New Objectivity" or "Neue Sachlichkeit," as the movement was called in Germany, where the frontiers of modern photography were rapidly expanding. The aesthetic of "New Objectivity" and its impact on a reportorial, candid-camera

approach to documentary photography had infiltrated the visual consciousness of British artists by the mid-1930s when Spender was beginning his photographic career.[11]

Objectivity was implied by the camera's ability to capture surface texture and detail with immaculate precision, lifting off reflected light waves that fit like air on the object's epidermis. It was generally presumed that any human being could "read" photographs from anywhere and anytime, simply because human beings share more inherent similarities than differences. But the grammar and syntax of the camera-eye are coded, "devoted to the singular and contingent rather than the universal and stable."[12] The camera needs physical presences for the split second it takes to imprint light waves chemically on film. The instantaneous and ephemeral as well as the local and specific are a part of the camera's vocabulary. And the camera, by its very structure, which abstracts a slice of monocular vision and permits the three-dimensional illusion to be printed on paper, reinforces a specific optical tradition of perceiving the world. In addition, the person behind the camera imprints his or her subjective aesthetic in selection, cropping, tonalities, light source, and all the technical manipulations that photographic technology affords.[13]

The contradictions of an assumed objectivity and an ever-present subjectivity embedded within our uses and readings of photographs, from the advent of photography in 1839 until the present day, have been well documented over the last two decades by a number of scholars.[14] The indexical nature of the photograph left it open to innumerable interpretations, due to its contingency within the phenomenal world and its birth within the taxonometrically-minded

industrial nineteenth century. This "birthright" technically situated the photograph as a chemical process grounded within the realm of science and technology, while at the same time it was identified aesthetically with the expressive imagination and the pictorial. Thus, photographs were employed almost immediately as legal evidence, as instrumental educational objects, and as stand-ins for "objective truth." Simultaneously, photographs were defined as pictorial creations expressive of the imagination, as a universal language magically revealing hidden eternal truths. This dichotomy is manifest in Saxon Mills's essay from *Modern Photography* excerpted above. He describes the camera as concurrently mediating the subjectivity of the photographer's mind with the outside "real" world, while characterizing the camera as a superior-to-the-human-eye objective instrument, translating the momentary into "beautiful" aesthetic form. Paradoxically, Saxon Mills writes of both the objectifying and aestheticizing power of the photograph in a statement that combines references to science with references to magic:

*It does more than depersonalize—it de-categorizes. It stops half-way between the chair and the table—half-way between the house and the tree—and gives due value to the shapes between…For us, facing the world with prejudiced senses, the camera captures a deeper truth than we see. Not only does it snatch the event in space from its imprisonment in the conventional context—it snatches the event in time.*[15]

From the outset, the many approaches to photography sought to synthesize Enlightenment and Humanist values with scientific objectivity.[16] Therefore, within documentary photography, the photograph's meanings have been continually challenged and contested. The same photograph may sometimes be read as legal proof, as metonymy, as universal metaphor, or as consumable, aestheticized composition. The problematic "realism" inherent in documentary is compounded by the intentions, unconscious responses, and decisions of the photographer, by the technical aspects of the subtly malleable machine that is the camera, and by the interpretations of editors, archivists, viewers, and scholars who read photographs for different purposes. The modes of production of the archive project and the illustrated magazine of the 1930s, which sometimes elided the intentions of the photographer, have to be considered. Added to this list of complexities is the use to which the photographs were put politically and socially, and the conditions under which they were commissioned or taken. Ute Eskildsen has recently written of these dilemmas:

*In looking at photographs of this period [1920s, Neue Sachlichkeit, and into the 1930s] we have to remember that the image is at two removes from the spectator. There is the historical distance, with its implication of authenticity, and the formal aspect, determined by contemporary technical considerations. Beyond these considerations we have to take account of the new communicative values of a photography in the 1920s, which obliged the photographer to integrate this aspect into his work—the application affected the image production.*[17]

Exactly how did these contradictions and paradoxes shape Humphrey Spender's work as a socially reform-minded documentarian? How did Spender define for himself the nature and practice of documentary and journalistic photography? How did his photo-documents[18] operate within the Mass-Observation social surveys and the production of the illustrated magazine *Picture Post*, as well as within the broader spectrum of British documentary culture? In what ways did the emergence of the documentary movement reflect or impact the larger issues percolating within British society and culture of which Spender was a part?

# HUMPHREY SPENDER'S EARLY YEARS, 1927–1933

*For the person who wants to capture everything that passes before his eyes…the only coherent way to act is to snap at least one picture a minute, from the instant he opens his eyes in the morning to when he goes to sleep. This is the only way that the rolls of exposed film will represent a faithful diary of our days, with nothing left out.*[19]

Like Italo Calvino's compulsive fictional protagonist, who believes that the truth of events will be located in the cumulative array of captured individual moments on film, the new "objective" documentary movement of the thirties would rely on the camera as a comprehensive recorder of everyday life. The camera would unfold a journalistic story, from behind the scenes and close-up, brought to the masses in the form of illustrated magazines, newsreels, and cinema. A participatory documentary aesthetic would pry artists out of their secluded studios and away from their esoteric experiments with "significant form"[20] and into the coal mines, steel and cotton mills, and slums of Northern industrial towns hardest hit by the departure of much heavy industry from Great Britain. Even the arch formalist W. H. Auden would write in his poem "Letter Written to William Coldstream," of his and Coldstream's stint with the GPO Film Unit in 1935 and 1936, "We'd scrapped Significant Form / and voted for Subject."[21] From these beginnings coupled with an immersion into the international crises of the thirties, the British documentary movement forged a new social consciousness, culminating in a responsive parliamentary democracy intent on building a more egalitarian and cohesive society within the populist radicalism of the war years and the reforms of the immediate post-war era.[22]

As a young photographer drawn to the new cultural ideals and swept into the political events of the thirties, Humphrey Spender realized early in his career that his subject matter was people, particularly the relationships between people in the course of everyday life:

*the kind of photograph that interests me most is a revelation of human behavior… the photographers I continue to appreciate and admire most are those concerned with humanity—those who, in disclosing humanity and human behavior, also disclose part of their own attitude towards humanity and human behavior.*[23]

Human activity, apprehended through the camera lens, was thus caught in the midst of action but stilled and distanced: "Composition, frames of reference, verticality, horizontality, balance and rhythm… you do eventually train yourself into an awareness of this mysterious thing called composition."[24] The distancing effect of composition, captured instantaneously through the camera lens, aesthetisized a slice of the "real" world passing before one's eyes. While quietly observing human relations unfold and selecting a moment to transcribe in form, Spender not only documented a fragment of an environment and an event drawn from life, he also uncovered aspects of his own attitudes and point of view. Thus, the arresting of a moment in time allowed for the retrospective study of gesture and expression, providing revelations not only of those individuals in front of the camera, but of humanity generally and of himself.

Spender's first awareness of the mysteries of the fluidity of composition as seen through a camera lens occurred when he was nine-years old, when an uncle sent him a box camera from Switzerland. His older brother Michael, who was working for the Leitz Company in Germany, makers of the Leitz Leica camera, was a knowledgeable photographer himself and taught his younger brother the detailed mechanics of the camera and how to develop his own photographs.[25] As Spender was growing up with his three siblings in Frognal, London (c. 1920–1923), and at Gresham School in Norfolk (1923–1927), the technical as well as conceptual revolution in modern photography was taking place in Germany at the famed Bauhaus in Weimar (1919–1924) and later in Dessau (1925–1933), and in cities such as Munich and Berlin. In these urban centers, the new "candid" photojournalism was unfolding alongside experimental "photograms" and forays into the depiction of "pure" geometric abstract forms by the manipulation of objects and light before the camera lens.

At the suggestion of his maternal grandmother, Spender studied art history and German at the University of Freiburg im Breisgau (1927–1928).[26] But it was his own close study of German avant-garde and *Neue Sachlichkeit* photography from 1927 through 1933, while spending extended periods of time in Vienna, Berlin, and other German and Austrian cities, that was the decisive visual education that Spender needed to formulate his own aesthetic choices.[27] Although his rigorous training at the Architectural Association School of Architecture in London (1929–1933) honed his skills as a draftsman in the Beaux-Arts manner and expanded his technical knowledge of media, he developed a sense of what the camera was capable of achieving technically through his study of the new photo-books such as *Modern Photography* and *Photographie*,[28] and avant-

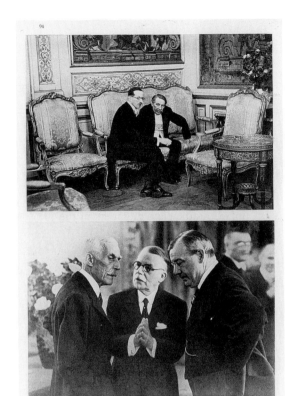

94

FIG. I    ERICH SALOMON, "DEBT CONFERENCE IN PARIS," FROM
MODERN PHOTOGRAPHY, LONDON, THE STUDIO, 1931

banal into the unfamiliar by manipulation of compositional elements. The aesthetic of "New Vision" tended to emphasize the formal qualities of line, tone, texture, pattern, and shape over and above the content of the photograph. In fact, formal qualities became the primary subject matter of this aesthetic seduction.

Spender soon employed the high-angled view of a street in his 1933 photograph, *Lützowplatz, Berlin, 1933–35* (cat. 2, ill.), reproduced on the cover of Christopher Isherwood's 1939 novel *Goodbye to Berlin* (cat. 3). During the same vacation trip, he photographed his friend Isherwood in raking light and dark shadow, looking down on the same street (and assuming the photographer's camera-eye position) from his curtained apartment window (cat. 1, ill.).[31] Spender had studied the cinema-like close-ups of Helmar Lerski's photo-portraits in *Close-Up* magazine and Lucia Moholy's photo-portraits in *Photographie* and as a result had experimented with camera angles and lighting in photographing both Isherwood and his brother Stephen Spender (cat. 4, ill.) during their trips to the continent.[32]

Magazines on the arts and letters such as *transition*, German photo-books like Germaine Krüll's *100 X Paris* and the French *Photographie*, catalogues for the exhibitions *Film und Foto* (1929) and *Das Lichtbild* (1930), and film journals such as *Close-Up*, formed a matrix of aesthetic styles and approaches from which Spender developed a visual vocabulary and eventually came to discover his own sensibility through experimentation.[33] In addition, he studied the "candid camera" photographs of Erich Salomon in the *Graphic*, Andre Kertesz's work in *Die Kölnische Illustrierte*, and the films of the Russians, Eisenstein and Pudovkin, as well as Mikhail Kauffmann's *Spring* and Ruttman's 1929 film, *Berlin: The Symphony of a Great City*, shown regularly at London's

Film Society in 1932.[34] The unpredictable, real-life edge of Ruttman's and Salomon's work would be the foundation of his aesthetic as the "unobserved observer," snapping the contingent image in the midst of a continuous flow of life. Ruttman's revelatory uses of a hidden camera and non-actors as real-life participants would profoundly affect the practices and content of the work of photographers and filmmakers in the thirties and beyond.[35] Salomon's intensely dynamic and direct photographs of the elite in conversational action, hardly aware of his austere presence, occupied a psychological space of immanent penetration by observation which Spender and his colleagues would emulate in this decade of constant crisis (fig. 1). Salomon's use of natural light, and his keen intuition concerning precisely the right unobtrusive distance to place between himself and the human interaction, were analyzed by photographers not only in the *Graphic* but also in the German press and in the annuals of *Modern Photography*. Spender would have been familiar with the new German photojournalists' crisp serendipitous photographs in the *Münchner Illustrierte Presse* and *Berliner Illustrirte Zeitung*. He later worked for the Munich weekly's orchestrator, Stefan Lorant, and alongside German émigré photojournalists, Tim Gidal, Kurt (Hubschmann) Hutton, Walter Suschitzky, and Felix H. Man (Hans Baumann) at *Picture Post*.[36]

Soon after graduating from the Architectural School in 1934, during the worst period of the economic "slump," Spender very briefly worked as an assistant to an architect, a Polish refugee named Landauer, who immediately gave him an assignment to do a perspective drawing for an interior in Berkeley Square, London. Rather than following standard procedure for the depiction of a posh interior design, Spender created a perspectival rendering with an ironic edge: an inverted focus on "frivolous events

garde photo-magazines and journals such as *Der Querschnitt*. It was in *Der Querschnitt* that he first saw Martin Munkacsi's high-angled street scene, *The Categorical Imperative* (1931), which had such a significant impact on his aesthetic at the time.[29] The bird's-eye view (and the worm's-eye view, made famous in the 1929 *Film und Foto* exhibition) became a hallmark of the "New Vision"[30] photography, tending to disorient the viewer's expected angle of perception and to reduce human beings and objects to patterns of texture, form, and light. This extreme angling of the camera, as well as technical manipulations developed during the period, such as new lenses and fast films, x-ray technology and stop-action, transmuted the familiar and

outside rather than on the interior."[37] Spender's recollection of his irreverently conceived interpretation reveals not only his lack of interest in the vocation of architect but also his keen involvement in the "New Vision" deeply-angled perspectives and his attraction to the unexpected spontaneity of daily life in the world outside. In fact, the aspect of Modernist architecture that had intrigued him most while a student and after was its functionalism for people: "It was the *beginnings* of a feeling that architecture should be much more about people's lives than about pomposity and the planning of grand vistas and public buildings."[38] The theme of concern for the ordinary daily and changing needs of people's lives would be played out in Spender's work as a photographer rather than at the drawing board.

Spender established a commercial studio on the Strand in London with fellow Architectural School graduate and friend, Bill Edmiston.[39] Although the two were successful early on with commissions from Edmiston's contacts at *Architectural Review*, *Harper's Bazaar*, and *Vogue*, Spender was bored with producing the slick and posed glossy photograph for commercial use.[40] It was at this point that Spender decided to accept a job offer as "Lensman" for the *Daily Mirror* in 1934. The newspaper's director, Harry Guy Bartholomew, ostensibly hired Spender to photograph "candid" English life, the chance encounters of the city and slices of real-life with which Spender was so intrigued.[41] But H. Rider-Rider, the *Mirror*'s art editor, insisted on the staged and pastoral "artistic" photograph, concerned solely with the reverie elicited by thatched-roof cottages, cobblestone walks, and rolling dales. The imperatives of Rider-Rider, to whom Spender was obliged to report, have recently been described by the photographer: "Occasionally, he [Rider-Rider] would say things like, 'If you're

at a loss, then find a pretty girl, put her on a horse, take her on the downs, clouds in the sky, hair blowing in the wind.'"[42] Spender fought for the right to use his lightweight 35-mm Leitz Leica over the objections of the *Mirror*'s art editor, who protested that the small negatives produced by his miniature camera did not allow for the "necessary" retouching of reality. Retouching and cropping were anathema to Spender's newly developing aesthetic, and so his work for the *Mirror* was typified by a constant series of battles and disagreements. Only a handful of Spender's *Daily Mirror* photographic prints have survived from this period; among them is a silhouetted portrait of a slate-quarry worker in Wales (cat. 13, ill.), which looks forward to Spender's later photographs of workers, though its posed quality he would later find unacceptable.[43]

Intent on investigating and documenting more extreme conditions of life in Britain, Spender, while retaining his job at the *Mirror* for economic stability, volunteered to photograph current economic and social conditions of the working class for friends who were probation officers or otherwise involved in projects exposing the plight of the unemployed to the media.[44] Through this work, Spender would develop his technique, his aesthetic, and his subject matter in photographs of life in London's East End, Stepney, and in the city of Newcastle in 1934, and of the Jarrow Hunger Marchers in 1936.

Like many of his generation, Spender became committed to helping give voice to the concerns of the underclass, which had been excluded from all debate and decision-making positions, invisible in the press or any other media, except perhaps as caricature. Spender has said of his political involvement during this period:

*I was in sympathy rather naively with an idealised version of Communism. I did not*

*align myself to the extent that Stephen [Spender] did, to the point of actually joining the Party; but I was certainly sympathetic. Our family background was strongly Liberal —my father had stood as a Liberal candidate for Parliament—so that's where my sympathies lay: Liberalism and the left.*[45]

Indeed, Humphrey Spender's father, Harold Spender, and his uncle, J. A. Spender, were well-known Liberal journalists. Many of Humphrey Spender's friends and colleagues were equally leftist, upper-middle-class members of the Auden generation; among them were his brother Stephen, Christopher Isherwood, Louis MacNeice, Humphrey Jennings, Bill Brandt, Tom Harrisson, and William Coldstream. All were to take up professions during the Thirties as journalists, photographers, or filmmakers, in an attempt not only to make a living but also to expand the content and meaning of their creative lives. These materially privileged and highly educated young men seemed acutely aware of their social and political isolation, of their ignorance of the conditions in which most people lived, and of the urgency of changing the laissez-faire policies of the government.[46]

The themes of "narrowness" in upbringing and a "caged" bourgeois mentality appear often in Stephen Spender's and W. H. Auden's essays and poems of the era. Stephen Spender wrote in the *Left Review*, and *New Verse*, of the "narrow environment" of his generation's upbringing, of "becoming boxed away from all others... imprisoning him [the artist] in his own personality."[47] Realist painter (and Mass-Observation colleague of Humphrey Spender), Graham Bell would write in a review of "Paintings in the London Group" from December 1937, that Robert Medley's naturalistic paintings

*echo the forlorn cry from the distressed areas— "Something must be done." They might inspire a well-meaning rentier to reach for his cheque*

*book, or an undergraduate to take up social service. But a certain narrowness, which becomes all the more apparent if these pictures are compared with work...in which there is a wider humanity, seems to take from their value as works of art.*[48]

An inclusive and participatory aesthetic had evolved at the service of social change. In the same month, *New Verse* published Auden's poem "In Memory of W. B. Yeats" which included the self-revelatory line, "And each in the cell of himself is almost convinced of his freedom."[49]

The necessity to escape from the confines of upbringing and to come into contact with the realities of the lives of the underclasses was a leitmotif for the Auden generation during the 1930s. Many of these young men departed for the industrial North of England, joined the Communist party, or committed themselves to leftist political and reform causes.[50] While on the pilgrimage to socialism, some like Guy Burgess and Donald MacLean, went "over" permanently to join the anti-Fascist and class struggles as empirical Marxists, going undercover, spying on their own bourgeois ruling class.[51] The anti-establishment, anti–Fleet-Street sentiments of the Auden generation allowed a critical maverick status and a social consciousness to erupt in their work.

In the aftermath of the destruction of World War I and the emergence of Soviet Russia, traditional cultural values, moral codes, and economic paradigms collapsed. The search for new artistic meaning was tied to a reevaluation of all forms: aesthetic, economic, social, and political. Thus the challenge to overthrow an anachronistic, habitual set of "givens" was intensely felt and acted upon by the members of the Auden generation; the struggle to wrestle with meaning and form was transferred to all aspects of life.

# STEPNEY, NEWCASTLE, AND JARROW, 1934–1936

In the working-class district of Stepney in London, Spender documented living conditions for Clemence Paine, a probation officer for liberal magistrate Basil Henriques. He spent several days at a time among the people he photographed to study their environment, language, and habits in order to document accurately their daily routines. His photographs of the environments of London's East End children and families were used as material evidence in the courtrooms of Henriques and William Clarke Hall to support the sociological analyses of Paine and others, which causally linked children's petty crimes to their poor living conditions.[52] In this way, Spender's photographs of individuals in particular situations were accepted as visual representations of the reality of people's living conditions, in combination with Paine's verbal evidence.

The visual testimony of photographs employed to represent life in the slums had its genesis in the mid-nineteenth century when high-density housing (which disregarded the health and comfort of its inhabitants) was cheaply constructed to accommodate the influx of industrial workers and immigrants as the pace of the industrial revolution accelerated. By 1868 slum clearance acts and housing reforms had been ratified, but it took photo-documentation such as Willie Swift's in D. B. Foster's text *Leeds Slumdom* of 1897 to initiate action to ameliorate the devastating conditions.[53] These unpicturesque and unposed photographs were explicated by texts with statements by physicians and social workers, much as Spender's photo-documents relied on the elaboration of Clemence Paine to fully explain the specifics of family situations which gave rise to crime.

Social documentary photographs are not neutral "universal" objects as August Sander and others had hoped they would be. Surveillance of slum sectors and their inhabitants by means of the photograph could be employed either for liberal social reform or for reactionary control.[54] Social documentation retained the potential to aid and support the urgency of social change and build public awareness, which was the intention of liberal magistrates like Henriques and Clarke Hall.

While still working for the *Mirror*, Spender spent as much time as he could among Stepney residents. He gained their trust and became "invisible" as his work as a documentary photographer began. His intuitive sensitivity to the underlying language of movement and to subtle gestures of expression was acute and poised; he developed the patience to wait for significant moments of stillness or reflection. Evidence of the level of trust and Spender's degree of "invisibility" is particularly apparent in the interior photographs. Distilling the natural light, Spender rhymes the asymmetry of an attic room with his framing of an old man extending his spectacles to read the newspaper (cat. 10, ill.). The viewer is close enough to note the telling details—the transparency of his shadowed face, thin hands, and textured sweater done up with a safety-pin—and yet hovers at a distance to allow a self-contained moment, an invisible periphery of concentration for the old man. The crucial distance and angle of vision which Spender has chosen, and his sharp-focus definition of his subject, establish the empathetic but unsentimental tone.

Equally moving and intimate are his photographs of the numbing drudgery and mindlessness of strenuous daily chores evident in washerwomen's glazed expressions (cat. 7, ill.) and the comfortable and cozy familiarity in the gestures of a mother and daughter (cat. 8, ill.). By tightly framing the mother and daughter within a vertical framework, Spender strengthens the impact of the close relationship. In showing the washerwomen's exhaustion within an equally narrow vertical framework, Spender doubles the effect by pairing two women surrounded by a drab and dreary environment. Focused on particular living conditions and family relationships set within these environments, Spender's photo-documents helped to build Paine's case. In addition, the photographs were self-consciously composed with formal qualities in mind. Spender was developing his "eye," while attempting to reconcile an aesthetic awareness with the detail and specificity of documentation.

Spender's angle of vision in these photographs from Stepney is usually eye-level with the participants and at a diagonally acute angle, at once placing us within their space but at a discreet distance. Throughout his career as a photographer, Spender rarely exposed more than one or two frames of a single scene or event which was usually unposed (unless intimate family relations were required, as here in Stepney).[55] Attuned to the balance between an unfolding personal drama and the moral implications of his task, Spender would invariably opt on the side of an instinctive understatement, never belittling or imposing "gloom" or falsely ennobling a situation or subject by pictorialist or technical interventions. His tact and respect for people are consistently evident in his choice of camera-viewer perspective and composition, which generally insert us unobtrusively into the scene.[56]

Standing at the corner of the street—a sight all too common in Newcastle
*Photograph: Humphrey Spender*

FIG. 2   HUMPHREY SPENDER, PHOTOGRAPH FROM *THE LISTENER*
DECEMBER 5, 1934

The BBC journal, the *Listener*, published a series of articles in 1934 on the causes and reverberations of the Great Depression that included interviews with "families in distress."[57] Within these articles, a selection of BBC radio reports from all over the country was compiled on the status of local remedies to help alleviate the immediate suffering and deprivations. "Listeners and the Unemployed" included Spender's photograph of a line of unemployed men in Newcastle (fig. 2) which had been rejected by the *Daily Mirror* as unpicturesque and disturbing.[58] The men wait aimlessly against the brick wall of a street corner, obscured by the shadows of an afternoon sun that lights up the drab architecture surrounding them, highlighting their benighted isolation. Standing across the street, the photographer has, at this very moment, been detected, as the stares of several of the men indicate. Spender had attempted to become "invisible," obscuring his lightweight Leitz Leica under his jacket, his first foray as an "unobserved observer."[59]

Spender's photograph of these men is paired with a "Darwen News" photo-agency shot of a long table of smiling, unemployed women

"making slippers for Christmas from old felt hats." The agency photograph attempts to convey an optimistic gloss, a busily active response, and has the quality of an amateur photo-album snapshot. It serves as a demonstration of temporary ameliorative make-work projects. While Spender's image is intent on specific details of people and their environment, he is simultaneously conscious of the patterns and geometry of light, shadow, and textures that heighten the photograph's claim as a slice of reality. His photo-document is employed as evidence of the demeaning condition of unemployment, intended to provoke compassion. The lonely anonymity of the cloth-capped man isolated in the center of the photograph echoes the feelings of desolation expressed in the letters that the *Listener* received from unemployed people in Newcastle. The photograph serves to reinforce the journal's "golden rule" solution to unemployment expressed in the excerpted letters. The poignant stories of poverty and misery recounted from the radio broadcasts precipitated listeners' charitable offerings of food, money, and emotional support in the form of regular visits or letters sent to "distressed families." Richard Clements's report from Birmingham summed up the tone and nature of the *Listener*'s efforts:

*Some have given pounds, others could afford only to give a few pence each week. In each case one can feel sure it made all the difference to families sick with anxiety as to how to make ends meet. It is the thought that someone cares that means so much. It makes the struggle a little easier.*

The *Listener*'s emphasis is on a moralizing appeal for readers to "take a personal and direct interest in someone less fortunate than themselves."[60] Although Spender's photograph depicts a particular historical and local situation accompanied by letters from the unemployed

that are deeply personal in nature, the cumulative effect of the three-page story veers toward the expression of an ontological or universalist condition of poverty, without stressing the failures of the economic system or possible solutions. This ontology is reinforced by the editorial statement immediately preceding "Listeners and the Unemployed" entitled "The Causes of the Great Depression," which, in the space of a half-page, rallies support for free-market laissez-faire economics:

*it is not the system of private enterprise and free markets which is responsible for this phenomenon: it is the suspension of that system. It is not capitalism: it is [government] interventionism, and monetary uncertainty, which are responsible for the persistence of the slump.*[61]

This manipulation of the intent of Spender's documentary photograph by means of text, selection, and placement is a recurrent problem for the documentary photographer. Spender's aim was to record specific information, such as the numbers of unemployed men, to support statistical records and at the same time appeal to the emotions of readers; thus it was necessary to publish these photographs in order to reach a wide audience. But as a photojournalist, Spender had no control over the use and reinterpretation of his photographs by editors and writers once he had submitted his images.

In December 1936 the *Left Review* covered the story of the Jarrow Hunger Marchers, two thousand men from all over Britain organized by local labor organizations, who converged in Hyde Park on November 8 for a mass demonstration demanding jobs, "humane conditions of existence," and relief from hunger for their families.[62] For many of the Auden generation, the marchers' sweep from the North down through Cambridge and its university was their first glimpse of the working class.[63] The fact

that this march would have been a first encounter with the underclass for an upper-middle-class youth such as future Soviet spy Donald MacLean, then a Cambridge student, testifies to the isolation of the classes and the absence of depictions in the Fleet Street press of the working classes.[64] According to the editors of the *Left Review*, the working class represented "the forces of progress taking the offensive against international and national reaction, against pessimism and against apathy."[65] In the editorial that immediately preceded Spender's photographs of the Jarrow Hunger March, the marchers were identified with the "victorious Russian Revolution" and the "heroic defense of Madrid" against Franco's Fascists.[66]

In a double-page spread, "The Men Baldwin Would Not See," four of Spender's photographs were used to illustrate the march (fig. 3):[67] one, a distanced, oblique-angled perspective which emphasized the size of the demonstration; one over-the-shoulder photograph of the marchers eating lunch in Wealdstone; and two vertical close-up candid photographs of individuals carrying banners and interacting, representing the Scottish and Welsh contingents. Spender's upbeat, action photographs are followed by a series of essays entitled, "What Life Means to Me," written by individuals from across Britain who were "winners" in a competition organized by the *Left Review* to focus attention on "actual conditions of life." Though similar to the effort mounted by the *Listener* to build its BBC audience's awareness of the disastrous economic plight that the Depression had wrought on individuals, the *Left Review*'s "personal" testaments were meant to elicit yet another kind of reader reaction: "to launch a counter-attack of proportionate severity…[as] a matter of life and death." Associated with the newly formed Artists' International Association (1934), the

## THE MEN BALDWIN WO ULD NOT SEE

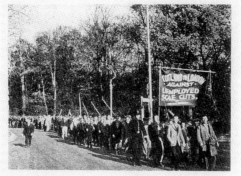

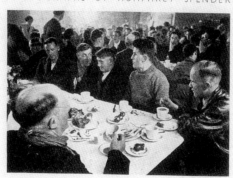

PHOTOGRAPHS BY HUMPHREY SPENDER

On Saturday, November 7th, 2,000 Hunger Marchers in seven separate contingents from all over Britain converged on London. On Sunday, November 8th, a Mass Demonstration was held in Hyde Park.

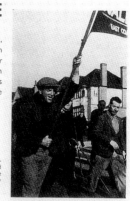

*On the right :*
Standard-bearer of the Scottish contingent as it marched into Wealdstone, where the men were given lunch by local labour organisations

*On the left :*
At lunch in Wealdstone

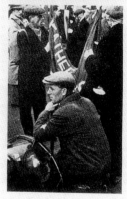

*On the right :*
As the Welsh contingent halts during its march, the band rests outside Marylebone Town Hall

FIG. 3    "THE MEN BALDWIN WOULD NOT SEE" FROM *THE LEFT REVIEW*, DECEMBER 1936

*Left Review* was a radical journal which often published articles by Marxist authors and theoreticians; thus, its stories of desperation and despair were not meant as catalysts for sympathy and "charity" alone, but as triggers to political activity.

> *I have my say in the lodge meetings of the Miners' Federation. I sit in the library and travel in company with Jack London; hate in sympathy with Upton Sinclair, Sinclair Lewis and Dos Passos; ignore the froth of the "popular novelists" and the fairy tales in the* Daily Express.[68]

Spender's photographs in this case are actively involving; their point of view is set in the midst of instantaneous events instead of passively empathetic, distanced, and meditative as in the *Listener* photograph. The photo-documents are framed by texts which recreate in words the "sensation of living" and render in detail the conditions of life in working-class neighborhoods. The captions explain the specific activity shown and identify the contingents represented. Spender's candid fragments of the momentary are more snapshot-like and less overtly aestheticized than in the Newcastle photograph. They are more concerned with simply conveying the situation and circumstances of the unposed moment—the hallmarks of the social document.

Between 1934 and 1937, while Spender worked in frustration as 'Lensman' for the *Daily Mirror* and volunteered for assignments and

19

projects like Stepney, Newcastle, and Jarrow, the dire economic conditions of unemployment and inflation did not abate. Strikes and violent riots continued, particularly in the North, where industries had been moving investments and jobs out of the country since the twenties.[69] At the same time, by 1936, Hitler occupied the Rhineland, Mussolini entered Abyssinia, the German government signed a pact with the expansionist Japanese Empire, and the Spanish Civil War exploded. These crises, national and international, were not being covered adequately or accurately by the Fleet Street press in Britain.[70] The silence by the press on critical domestic and world issues in large part accounts for the success of documentary books like J. B. Priestley's *English Journey* (1934), which graphically depicted the poverty and suffering of the North. In fact, Priestley's text served as a prototype and handbook for many of the documentary-minded of the Auden generation as they made their way to Northern England, explorers within their own country.[71] Priestley rendered the lifelessness of antiquated heavy industry decaying into industrial slums and the inhabitants trapped within:

> *They live, in short, in a workshop that has no work for them. They are the children of an industrialism that has lost its industry, of a money-making machine that has ceased to make money…they do not vanish as tragic figures.*[72]

Priestley traced the tyrannies of the English class system and its anachronistic backward glance, ignoring the present crises:

> *Are we really saying: "Here, you nuisances, take this. It isn't much—just enough to keep you alive. A little more or a little less and you'd start kicking. With this you'll be alive but not kicking. And now get out, and let us forget about you."*[73]

# FORMS OF BRITISH DOCUMENTARY

As the British documentary movement evolved, during the confluence of multiple crises, Paul Rotha published his classic 1935 book, *Documentary Film*, outlining the philosophy and methodology of the film movement which would simultaneously appear in the documentary aesthetics of photojournalism, radio, literature, and visual arts. Rotha wrote of the symptoms of social, economic, and political decay, laying "open to criticism many of the principles upon which our modern society is built." His goals in documenting were didactic in seeking to establish a "social consciousness among a small but increasing minority." Through a campaign to "spread knowledge about the simple workings of government and the essential facts of our economic and social ways and means," discussions "of social, industrial and political reform would be raised to a higher plane of insight and fruitfulness."[74]

Thus the GPO (General Post Office) Film Unit was born with a utopian educative program, recruiting director John Grierson,[75] realist painter William Coldstream as well as W. H. Auden and Benjamin Britten, to work on the films *Coalface*, *The Song of Ceylon*, and *Night Mail*. These documentary films derived their general approach from the daily events represented in the travelogues of Robert Flaherty's groundbreaking *Nanook of the North* (1921) and *Moana* (1925). With a parallel strategy, focusing his camera on British culture, Grierson and his crew set about "the beginning of an adventure in public observation."[76] Grierson also stressed education, public awareness, and civic participation in a 1937 article in the *Listener* as "part of a wider movement which aims at persuading the public towards better citizenship."[77] If the mass of society and their

day-to-day struggles had not been accounted for as a visible part of British culture, except as caricature or stereotype, then the documentarians were going to give them the spotlight and the microphone within their own environment. From the revelation of this reality was supposed to evolve a total and equal participation from all segments of society toward a more open society and responsive political structures.

The recording of life observed in city slums by Arthur Elton and Edgar Anstey in their film for the British Commercial Gas Association, *Housing Problems* (1935), strove to present "reasoned argument and the perspectives behind events."[78] Ruby Grierson, John Grierson's sister, interviewed resident slum dwellers before the camera-eye, combining visual evidence with narrative.[79] This strategy of on-the-spot visual and verbal "realism" echoes the methodology of the BBC's *Listener* and the *Left Review* essay "competitions." Elton's 1936 essay in the *Left Review*, "Realist Films Today," examined the process of working in the documentary manner as well as outlining a brief history of documentary. Participants in this new kind of film were asked to:

> tell it in their own words, unguided and unrehearsed…Here the audience was transported inside the skin of the subject… for a racy intimacy with men and women which we hope will blow away the romantic cobwebs of an earlier vision. It [the realist film] will move, we hope, from introversion and love of process for its own sake, to an attempt to put audiences in touch with the people of the everyday world around them.[80]

Evident from Elton's words, in addition to the strategies employed by both the *Listener* and

the *Left Review* (for different outcomes), is the realization that the shock embedded in the combination of visual images and verbal assertions and discussion was more potent than either element separately presented. The starkness of the "authentic" graphic image coupled with the elaboration of an "authentic" voice telling a personal story had the power to elicit deep emotional responses and empathy, as well as unconscious fears and associations. Anecdotes and guided exposés informed middle-class readers and viewers that "others" were much worse-off and that the plight of "others," displaced by shifts in the economy, might be transferrable to themselves, or at least might breed more radical political action in slum residents due to the lack of response by Parliamentary means.[81]

Individual conditions of "misfortune" were documentable, while the underlying economic and political causes of "distress" were much more complex to document. However radical the filmmaker's strategy of revelation, he nevertheless was beholden to the interests of the funders of his projects: British Commercial Gas or the General Post Office. Therefore, the paradoxical nature of documentary might be designed to bring the viewer "in touch" with a testimony of local living conditions that could precipitate liberal, reformist action, or reactionary fear and anxiety—or it could drift into an aestheticized "tourism" or an emblematic "universality" of the human condition.[82] Because this shifting and slippage of the social documentary photograph into the aesthetic, scientific, and humanistic occurs so easily at all stages of production, the social document and its claim to re-present the "real" remained problematical and often contradictory.

Another member of the GPO Film Unit by 1939, Humphrey Jennings, wrote concisely of the perceived aesthetic formulas and stalwart belief in the methods of the documentary to reinforce the idea of the real:

*taking a real person, not an actor, placing him in a situation very like that in which he might find himself in real life, and allowing the rest of everyday life to go on around him…In that way the individual is situated in society—he is part of that life we are talking about.*[83]

Jennings's documentary film technique would permeate the aesthetics and methods not only of Humphrey Spender's work but also of the new photojournalistic story, radio programs like BBC Manchester's *Harry Hopeful* (1935), and the poetry of Stephen Spender, Louis MacNeice, W. H. Auden, David Gascoyne, and many of their peers.[84] Even the innovator of experimental, pure formal photography, Laszlo Moholy-Nagy, was in London producing documentary books such as *The Street Markets of London* of 1936. In his preface, Moholy-Nagy wrote of the same concerns as his British neighbors:

*I am convinced that the days of the merely "beautiful" photograph are numbered and that we shall be increasingly interested in providing a faithful record of objectively determined fact…This method of studying a fragment of present-day reality from a social and economic point of view has a wide general appeal.*[85]

The new documentary literature, such as George Orwell's *The Road to Wigan Pier* (1937), was accompanied by anonymous documentary photographs intended to reify the verbal descriptions. Orwell described himself and his "lower-upper-middle-class" colleagues temporarily camped in the North as "the class functionaries that constituted the shock absorbers of the bourgeoisie."[86] As the interlocutor, he went undercover disguised as a miner to experience the living conditions that Jennings

and Moholy-Nagy described above. The writer lived among the people he observed, capturing with words the subtle nuances of expression and body language, rituals, and relationships. The progress from verbal description to empathy to social awareness as a catalyst to political change was often hindered by the realities of class differences:

*I lived entirely in coal-miners' houses. I ate my meals with the family, I washed at the kitchen sink, I shared bedrooms with the miners, drank beer with them, played darts with them, talked to them by the hour together. But though I was among them…I was not one of them, and they knew it even better than I did. However much you like them, however interesting you find their conversation, there is always that accursed itch of class-difference…this curse of class-difference confronts you like a wall of stone. Or rather it is…the plate-glass pane of an aquarium.*[87]

The social and economic issues of class difference would plague many of the members of the Auden generation, who were defining their creative work as a link to the masses within the broader documentary movement.[88] If Orwell was correct in assessing that "the upper-middle-class is done for,"[89] then where, among whom, and how would the Auden generation define itself? The quest for self-definition and an ambivalent identification with the working classes and disenfranchised would become an unstated but implied part of the documentary process for the Spenders, Orwell, Auden, and others in their milieu, who would observe, study Freud and Marx, and employ the rhetoric of the "objective" documentary distilled through an individual sensibility.[90] The frustrating transparency of Orwell's pane of glass or the lens of the documentarian's camera separated the flow of the "real" from the privileged point of view of the observer. Despite their intentions and

pronouncements, the barriers of class difference and the critical division between the observer and observed would remain problematic issues for Spender and his colleagues.

In March 1936 the publisher Victor Gollancz, John Strachey, and Harold Laski established the Left Book Club, another manifestation of British documentary.[91] The LBC was affiliated with the Soviet Communist Party and supported the experiments of the new Soviet society until the 1939 Hitler-Stalin Pact. The emphasis was on education and the dissemination of information on foreign and domestic affairs in a staunchly anti-Fascist stance. The LBC offered monthly book subscriptions, a newsletter, *Left News*, discussion groups, lectures, films, and trips.[92] Although socialist rhetoric ("a People's Front") sometimes highlighted the LBC's exhortations, Gollancz's philosophy as stated in his newsletter and lectures was more attuned to the liberal Humanist approach, the sentiments of which are present across the board in British documentary at this time:

*men [are] capable of applying their goodness in the national no less than in the personal sphere, and in the international no less than the national. And this can be done in one way only—on the basis of knowledge: knowledge of facts; knowledge of ideas; knowledge of the motives that have moved human beings and still continue to move them, often so obscurely. Without it a man is at the mercy of any unscrupulous demagogue or shrieking newspaper.*[93]

Consistently stressing "liberal goodwill" and Enlightenment values, stopping short of articulating and organizing political involvement or programs for specific changes, Gollancz's LBC, like its documentary companions, would not be a vehicle for leadership in the political sphere but would raise the level of social consciousness in order to initiate social and political reforms.[94]

In fact, the information provided by LBC publications was available from no other source, as Spender recently noted while reflecting on the readings that influenced his political positions:

> *The German involvement* [in the Spanish Civil War], *the bombing of Guernica in* 1937, *together with reading books from the Left Book Club which disclosed the machinations of the armament manufacturers—these influenced me greatly.*[95]

# MASS-OBSERVATION

Added to the general anxiety regarding the threat of war, the Abdication Crisis of 1936 ushered in another form of documentary that would directly influence the development of Spender's work and the scope and character of the popular illustrated weekly *Picture Post*. The abdication of Edward VIII to marry American divorcée Wallis Simpson, followed by the assumption to the throne of George VI, proved a shock to the British people, having been kept in the dark once again concerning the workings and fate of their government. The populace questioned with increasing frequency whether Britain was a genuine participatory parliamentary democracy and who, in fact, was accountable in the making of governmental decisions.[96] It was in reaction to this crisis that the Mass-Observation survey project would take shape.

The obsessive thirst for "facts," the "need to know" and to categorize "scientifically" which appears again and again in documentary, achieves its apotheosis in the vast but haphazard social surveys and public-opinion polls of Mass-Observation from 1937 through the post-war years.[97] M-O departed from the sole dependence on academic questionnaires and statistical methodologies of the period by employing full-time "professional" observers and part-time volunteer diarists, painters, poets, and a photographer, Humphrey Spender, to document life, local customs, and habits during this early period, primarily in Bolton, Blackpool, and the Blackheath district of London. M-O's findings were to be published intermittently and used as a general popular resource for gauging public opinion, cultural and habitual trends, and the rituals of daily life in British communities.

The concept for Mass-Observation began in the pages of the *New Statesman and Nation*, on January 2, 1937, when Charles Madge, a Cambridge graduate then working for the *Daily Mirror* (like Spender, dissatisfied and frustrated with the proscriptions of its editorial policy), responded to a letter written by Geoffrey Pyke, a Cambridge schoolmaster, who had called for an analysis of the public's reaction to the Abdication Crisis with an "anthropological study of our own situation," referring to the power of "myth" in British national politics as evinced by the constitutional/monarchical crisis.[98] Madge called for mass volunteer observers to record everyday events, which he described as "mass wish situations" sublimated in popular culture and social habits within an "ultra-repressed society."[99] In the same issue appeared a poem by Tom Harrisson entitled "Coconut Man, a Philosophy of Cannibalism, in the New Hebrides." Newly returned from Melanesia, where he had been on an anthropological expedition in the spring of 1936, Harrisson had moved to Bolton. There he disguised himself as an ordinary worker in cotton mills and as a truck driver, while setting about surveying the populace for anthropological study.[100]

Harrisson, who was already immersed in his study of Bolton, immediately contacted Madge and Humphrey Jennings, a surrealist painter, and all three wrote to the *New Statesman and Nation* on January 30, 1937, to recruit volunteers for their project, which they characterized as "anthropology at home."[101] They listed their random and disconnected categories of research as follows:

*behavior of people at war memorials, shouts and gestures of motorists, the aspidistra cult, anthropology of football pools, bathroom behavior, anti-Semitism, distribution, different forms, and significance of the dirty joke, funerals and undertakers, female taboos about eating, the private lives of midwives.*[102]

This wildly varied and vaguely surrealist assortment of themes was eventually subsumed under the more general archival headings of politics, trade unions and strikes, religion, money matters and shopping, reports on leisure, health, housing, factory conditions, clubs and holidays, and wartime and post-war file reports.[103]

Concerned with the Fleet Street press's "foisting on the masses…ideals and ideas developed by men apart from it," the three hoped to publish accurate records of opinions, diary excerpts, and observed behaviors of Bolton's, Blackpool's, and Fulham, London's, residents.[104] In their introductory pamphlet, *Mass-Observation*, February 1937, they wrote:

*As a result of the Abdication Crisis…we realised as never before the sway of superstition in the midst of science. How little we know of our next door neighbor and his habits. Of conditions of life and thought in another class or district our ignorance is complete. The anthropology of ourselves is still only a dream.*[105]

By recording exterior behaviors, specific human interactions, and the mass culture created by this intersection, M-O believed its findings would eventually help to shape an anthropological picture of life in British cities.

Appearing at the outset is the theme of a search for identity (to identify "mass-man" and themselves) embedded in "the anthropology of ourselves." The definition of "ourselves," as members of a crumbling British Empire, was complicated by the inculcated rigidity of the class system, by a lack of communication in either the public sphere of culture or the private sphere of language (dialects and accents often

being mutually incomprehensible).[106] It is essential to note as well that Harrisson had been born and brought up in Argentina, the son of General G.W. Harrisson, Director of Argentine Railway construction, and that Madge, a South African, was also brought up on the fringes of empire and shuttled to boarding schools and foster families during holidays, as was Harrisson. Orwell, who was fatherless and homeless (and who experienced lengthy stays in Burma), was shipped off to Eton, never having developed close family ties or a sense of belonging to any community. M-O's realist painter, Graham Bell, a South African, was early separated from his parents—as were the Spender children, through boarding schools, trips abroad, their mother's illness, and the death of both parents by early adolescence.[107] The unconditional and simple warmth of family ties seems to have been an absent feature of growing up for many of the Auden generation, including Auden himself.[108] That their search for a more nuanced and complex idea of the social contours of England and of their own place within that cultural structure (as they were no longer heirs to the "martial laureate," paternalistic structure)[109] should have been displaced within M-O and documentary is brought into sharp focus by a telling letter from Harrisson to Madge in 1939, in which Harrisson explains his motives as "dislike for…authoritarianism and father situations sublimated into sympathy for the mass of people…(a factor) present in the whole origins of MO."[110] By exchanging the imperial cultural role of their fathers, a relic of the nineteenth century still lingering at the time in figures such as T. S. Eliot (orphaned and adopted American expatriate),[111] the documentarians donned the civic role, while maintaining a moralizing and privileged perspective.[112]

The contradictions of the M-O project were complicated further by the differing interpretations of its goals by the three main players according to their interests, personalities, and philosophies. Madge, who lived in an eighteenth-century home in Blackheath, collected and collated the mass-observers' monthly reports and diaries.[113] He decided which excerpts to publish in M-O texts, often with the help of Jennings or Harrisson.[114] In the leftist journal *New Verse*, Madge characterized the typical observations of a volunteer Mass-Observer, "a recording instrument of the facts," as "(i) scientific, (ii) human, and therefore, by implication, (iii) poetic."[115] Madge's conclusions are a reiteration of the attempt to synthesize the antipathetic aspects of the documentary photographic project as defined by Saxon Mills: scientific, humanist, and aesthetic. While striving to situate M-O within the realist and scientific tradition, Madge wrote of the magical transmutation inherent in the artist's aesthetic point of view: "In taking up the rôle of observer, each person becomes like Courbet at his easel…the process of observing raises him from subjectivity to objectivity."[116] The artist's aesthetic distance (literally and psychologically) from his subject was believed to elide subjectivity—as though cultural constructs and the subconscious did not exist.

Humphrey Jennings's "realist" documentary intent derived its impetus from a highly poetical, surrealist point of departure. Intrigued by dream transcription and automatism, Jennings studied the avant-garde journals from Paris, *transition* and *Cahier d'Art*.[117] Like Madge, he sought to reconcile New Objectivity's "camera reality" with a poetic record of "objets trouvés" as examples of the objects of mass fantasy. Jennings's M-O colleague, the painter Julian Trevelyan has written,

*To Humphrey* [Jennings], *it* [M-O] *was an extension of his Surrealist vision of Industrial England; the cotton workers of Bolton were the descendants of…the dwellers in Blake's dark satanic mills reborn into a world of greyhound racing and Marks & Spencer* [the department store chain].[118]

A charismatic figure, Harrisson was, by his early twenties, a nationally known ornithologist with two studies already in print.[119] In 1937 he published a best seller, *Savage Civilisation*, describing his anthropological studies in the New Hebrides among cannibals.[120] Harrisson chose Bolton (or "Worktown," as he called it) ostensibly because it represented a link with Melanesia via imperial England's export of the Industrial Revolution in the form of chemical interests owned by Unilever. (Unilever's founder, William Lever, later to become Lord Leverhulme, was born in Park Street, Bolton.)[121] Harrisson wrote:

*What was there of Western civilisation which impacted into the tremendously independent and self-contained culture of those cannibal people on their Melanesian mountain? Only one thing, significantly, in the mid-thirties: the Unilever Combine.*[122]

Lord Leverhulme's family helped finance the M-O project along with northern industrialists Sir Thomas Barlow (Bolton cotton-mill owner) and Sir Ernest Simon, Dr. Louis Clarke, Michael Higgins, Harrisson's father, Gen. G. W. Harrisson, and Victor Gollancz, Orwell's and *Left Review*'s publisher.[123] Thus M-O was dependent, during these first years before the war, on the philanthropy of liberal goodwill.[124] Although the stated goals of M-O were to compile statistics, interviews, and photodocuments to undertake an "anthropology of ourselves," the systems and institutions that supported the project were responsible for engendering the economic conditions it represented in its findings.[125]

As opposed to the surrealist and poetical sensibilities of Madge and Jennings, Harrisson's

training as an ornithologist focused on the undercover detailed observation of minutiae within an environment for the sake of collecting quantities of catalogued "facts." By 1943, when M-O was working for the Ministry of Information during the war, Harrison rewrote his goals and methodology for the project in *The Pub and the People*, leaving behind Madge's and Jennings's more aestheticizing and humanist approaches for an emphasis on the purportedly "scientific":[126]

*Mass-Observation is an independent, scientific, fact-finding body, run from 82, Ladbroke Road, London, W. 11…It has a team of trained, whole-time objective investigators and a nation-wide panel of voluntary informants…It is concerned only: 1. with ascertaining the facts as accurately as possible; 2. with developing and improving the methods for ascertaining these facts; 3. with disseminating the ascertained facts as widely as possible [in a series of books, bulletins, broadcasts and articles]…the people it studies are people who can be interested immediately in the results, which often directly concern their everyday lives.[127]*

Harrisson maintained the contributions of photography within this documentary methodology: "It was because we distrusted the value of mere words that we were so keen to employ artists and writers, and photographers."[128] He stressed that "What people say is only one part—sometimes a not very important part—of the whole pattern of their thought and behavior."[129] Observers were to document precisely, like "cameras," the religious rituals, local pub habits, leisure activities (primarily in the seaside resort of Blackpool), political and social activities, shopping habits, public health and housing conditions, industry and entertainments.[130] Yet Harrisson, who had seen Spender's photographs in *Left Review* and through his

contacts with Michael Spender on expeditions, never gave his M-O photographer any written directives. His sudden, mercurial pronouncements about possible topics for photo-documentation were spontaneous and scattered thematically. According to Spender:

*There was a daily session which usually took the form of Tom seizing about half a dozen national newspapers, reading the headlines, getting us laughing and interested, and quite on the spur of the moment, impulsively, hitting on a theme that he thought would be productive. For instance, how people hold their hands, the number of sugar lumps that people pop into their mouth in restaurants, how much people stole things like teaspoons in restaurants, matches, bits of paper…you were working on your own, and one thing led to another.[131]*

After these informal breakfast gatherings, sparked by newspaper headlines, Spender worked on his own to explore Bolton with Harrisson's suggestions in mind.

Harrisson's goal of seeing objectivity in the rendering of life observed behind the transparent lens (and Orwell's aquarium glass), recalled a passage from Proust's *Remembrance of Things Past:* "[T]here was present only the witness, the observer…the stranger who does not belong to the house, the photographer who has called to take a photograph of places which one will never see again."[132] Here, the observer is equated with the stranger/photographer who records the evidence of existence as an outsider, identified with his anonymous transparent instrument, the camera. The inevitable past tense of the photograph lends nostalgia to the ontological readings of family photographs, while the observer who documents for specific social or environmental information attempts to instill a historical, evidentiary crispness in detail, uncropped and unposed. Rather than

invoking nostalgia or sentimentality, Auden and Eliot followed the lead of the photographers to seek a detached approach in their poet's spectral persona, the witness striving for "scientific" impersonality in the recording of mortality.

Abhorring any intrusion or interference in the flow of life, for fear of altering events and influencing behavior, the photographer-scientist seemingly avoided style. Thus, Margaret Mead, in her revolutionary anthropological studies done in the twenties and thirties, advocated the concept of a film camera on a tripod that was not to be touched. Howard S. Baker writes of Mead's strategy:

*The minute you touched it, she maintained, the individual biases of the investigator would inevitably take over…Mead seemed not to be aware that putting a camera in one place and leaving it there also represents the investigator's bias."[133]*

Within American documentary of the same era (and closer to Spender's own practice), Walker Evans photographed riders of the New York City subway surreptitiously with a "camera buttoned-up under his jacket."[134] Evans's strategy in his subway series was a random "sampling" of temporary, impersonal human encounters. James Agee wrote in the 1930s of the aims of Evans's hidden approach, stating that all human beings have "a wound and nakedness to conceal… Scarcely ever, in the whole of his living, are these guards down."[135]

In order to capture "unpolluted" actions and genuinely unconscious "naked" expressions, the hidden camera of the "unobserved observer" was employed by Spender for M-O's objectives. And yet, as Vicki Goldberg notes, "To observe others unobserved is temporarily to renounce the human condition."[136] This dilemma between the philosophy of the social documentarian and the methodology of science would plague

Spender from the earliest days of his M-O project work. He has recalled, "without doubt at that time I felt that knowing more about human behavior could only improve the general quality of life,"[137] and this type of documentary information had its highest degree of believability when it was recorded "unobserved." When people were aware of the photographer their behavior took on an "artificiality." But Spender was often overcome by the fear of losing that sense of linkage with a particular human condition: "And worst of all, when you're photographing people without them knowing—which is the form of photography that still interests me most—you eliminate *all* relationship."[138] As Spender was unable to relinquish his empathy at all costs, his task took on additional complications.[139]

# BOLTON AND BLACKPOOL, 1937–1938

Bolton in 1937 had a population of 170,400 that was decreasing at the rate of about 1,000 per year. The number of people in full time employment was 96,566 of whom 35,976 were women and 60,590 were men. Almost one-third of those employed worked in the cotton industry and sixty percent of those who dropped out of school went into cotton factories. The number of registered unemployed people was 10,758 or 11% of the working population as compared with the national average of 10.8% and 6.4% in London and the Southeast. The death rate was 14.2 per 1,000 or 25% higher than the national average. Bolton's Medical Officer of Health in 1937 (by whom these statistics were recorded) suggested that the high death rate was probably due to tuberculosis associated with the cotton industry.[140]

Spender's documentations of Bolton and Blackpool for Mass-Observation took place in the Spring of 1937 and 1938; because he was still on assignment for the *Mirror*, his half-dozen trips to the North usually lasted about five days. Spender's work for M-O was an extension of his Stepney, Newcastle, and Jarrow projects, allowing him to re-enter a world very different from his upper-middle-class upbringing of "nannies and governesses…had it not been for MO, I think I would have remained aware of the whole thing, described for example by Orwell [*Wigan Pier*], but would not have come into such close contact with this reality."[141] "This reality" of the conditions of the working class and the unemployed, often "frightening" and "depressing," would be the environment and stimulus for Spender's documentary projects, giving impetus to his commitment to photograph "the whole pattern of human thought and behavior" in order to disseminate these images as a whole body, as a kaleidoscopic document which would support social reform.[142]

The genuine emergence of a social consciousness reflected in Spender's attitudes and within the new picture magazines and photo-texts Stuart Hall has described as a "passion to present. Above all to present people to themselves in wholly recognizable terms; terms which acknowledged their commonness, their variety, their individuality, their representativeness, which find them 'intensely interesting.'"[143] Yet this fascination with presenting "people to themselves" in illustrated texts and magazines cannot escape the questions of class.[144] Most documentarians were middle- and upper-class, fascinated by the working class for a variety of personal reasons aside from social consciousness, ranging from class guilt to aesthetic stimulation.[145] The majority of the "people" photographed were the working classes and unemployed, who almost never gave their permission to be photographed.

The social exploration of aspects of working-class culture undertaken by M-O, and later in a different format by *Picture Post*, had its precedents in nineteenth-century literature. Peter Keating explains:

> In the mid-nineteenth-century there develops a distinctive branch of modern literature in which a representative of one class consciously sets out to explore, analyze and report upon, the life of another class lower in the social scale than his own.[146]

Disraeli's popular novel *Sybil* described the "two Englands," rich and poor, whose habits, thoughts, and feelings placed them in what appeared to be two different planetary worlds.[147] Harrisson would echo Disraeli when he stated that in the mid-1930s "nearly everybody who was not born into the working-class regarded them as almost a race apart."[148]

During his 1909 address to the National Conference of Charities and Corrections, "Social Photography, How the Camera May Help in the Social Uplift," the social documentarian Lewis Hine quoted George Eliot's *Adam Bede* (1857):

> *Paint us an angel, if you can…but do not impose on us any esthetic rules which shall banish from the reign of art those old women with work-worn hands scraping carrots…those homes with their tin pans…It is needful we should remember their existence, else we may happen to leave them out of our religion and philosophy, and frame lofty theories which only fit a world of extremes.*[149]

The "race apart" was documented with curiosity and suspicion in the mid-nineteenth century by Dr. James Spotiswoode Cameron, a physician who employed photography and statistical texts to support slum clearance in accordance with "God's sanitary law."[150] Cameron's richly indexed photo-document "interpreted" with textual statistics could support a viewpoint opposed to Disraeli's Humanist values.

The posed and pictorially influenced "urban picturesque" was an aestheticized version of documentary found in Thomas Annan's *Old Closes and Streets* of 1868.[151] Commissioned by the Glasgow Town Council City Improvement Trust, a public but self-financed body, Annan's photographs were the last record of slums slated to be demolished under the Trust's clearance scheme.[152]

The pioneering documentary photographer John Thompson and the writer Adolphe Smith collaborated in 1877 to produce *Street Life in London*, which visually documented working-class life on the streets of industrial England.[153]

In their preface, Thompson and Smith maintained: *the precision of photography in illustration of our subject. The unquestionable accuracy of this testimony will enable us to present true types of London Poor and shield us from the accusation of either underrating or exaggerating individual peculiarities of appearance.*[154] Insisting on photography's "precision" of surface detail as assuring "testimony" in support of written records, Thompson and Smith reiterated the camera's legacy as objective evidence. The "scientific" truth of photographs is the repeated rhetoric, while their claim as representations of "true types" disguises their intrinsic fragmentary nature as well as denying individual histories.

A parallel documentary movement with all of its attendant contradictions developed in America during the Depression as photographers such as Walker Evans, Dorothea Lange, Margaret Bourke-White, and Helen Levitt set about documenting America's rural and urban areas, sometimes with the help of Roosevelt's FSA or WPA programs. Meanwhile, Lynd and Lynd were undertaking a survey similar to M-O's in Middletown, Indiana, and Mildred Gavin Barwell's *Faces We See* documented the cotton yarn spinners working in North Carolina in 1939.[155] James Agee, who would collaborate with Helen Levitt in verbally documenting New York City life, wrote that he sought above all, "to tell everything possible as accurately as possible: to invent nothing."[156]

And yet, as in Spender's case, one needed to make choices of specific location and camera angle, whether to "hide" totally and operate as a "spy" or become a piece of the local "furniture," of what cropping, light source, and exposure would be necessary for which effects, and of what decisions would be made in the darkroom. Knowing that technical manipulation is limitless, Spender would weigh his subjective choices carefully: "You can become altogether

very tricky," and this trickery was to be avoided in favor of the untouched, uncropped, and unposed photograph.[157] The relationships revealed in the process of life unfolding were of the utmost importance. Elizabeth McCausland describes this balancing act in her essay, "Documentary Photography": "by the imagination and intelligence he possesses and uses, the photographer controls the new aesthetic, finds the significant truth and gives it significant form."[158] The attempt to reconcile the aesthetic imagination, Humanist "truth," and documentary evidentiary detail—to marry the form and content of the image—was the crux of this contradictory project. The photographer possessed a sensibility, a filter and an aesthetic, which he necessarily imposed; but actively to manipulate the continuity of life by posing or interrupting the moment's events would be out of the question. Spender struggled to analyze and evaluate this delicate balance between the photographer's selection of significant form conjoined with the significant moment and its moral and ethical questions.[159]

Within the variety of subject matter constituting the slices of life in Bolton and Blackpool, Spender tackled practical, technical, and ethical challenges. But while his goal to bring about change and reform was more immediately felt in the court cases brought before magistrates Henriques and Hall, his approximately nine hundred photographs of Bolton and Blackpool were never published in any of M-O's pre-World War II compendiums of questionnaire reports, interviews, and statistics.[160] Spender recalled that it was too expensive to reproduce his photographs in these publications, and that Harrisson had only vague ideas about their possible use outside of the haphazard mountain of information he was amassing.[161] While Spender had hopes for future publication of the prints, he always knew that M-O had no funding for

reproductions. Spender went on to note that "the main thing was that they were there," for future researchers of social anthropology.[162] Despite the lack of any concrete plans for publication, he proceeded with photo-documentation, convinced that the observation and collection of information would bring the knowledge to support change. Thus his photographs became adjuncts to the taxonomy of information and "facts" collected from approximately 400 observers (during 1937) to almost 3,000 volunteer observers (at its highest point in the 1940s).[163]

The M-O Archive photographs and texts are arranged chronologically and thematically and are inextricably woven into the general methodology and positivist philosophy of documentary. Critical verbal reports of specific events or situations clarify the possible readings embedded in Spender's photographs. For example, a holiday image of Blackpool (fig. 4, top right) removed from its original context may seem like a chance meeting at a snack bar, while in fact Harrisson discloses that the seated girl is paid to sit there and attract business.[164] This seemingly direct photograph, with its film-still effect of informality and happenstance, nevertheless requires Harrison's report to be understood as a social document. We are thrust into the center of exchanging eye contact and conversation. The sense of an unfolding narrative, sequenced in time and space, of which we are somehow a part, is frozen before us, its social and economic meaning explicated by Harrisson's undercover investigations.

The seemingly innocent scenes of children playing in what appear to be birthday party hats (cat. 28, 30, ill.) are not so innocent. The children were dressed by their parents during local elections to parade through town in colored hats which indicated the political party the parents supported.[165] A number of scenes

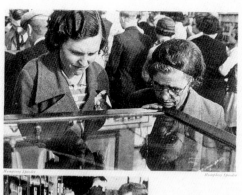

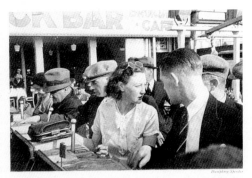

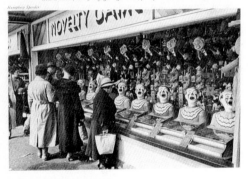

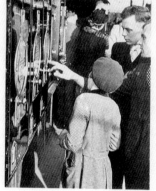

*Many working people have to save all the year for this one week's holiday. Even then they cannot afford to pay for pleasures all day long. Time must be spent looking at things, gazing down at the ever circling prize-objects on the rotary merchandisers—*

*—or doing mathematical problems of winning chances on the penny-luck machine*

*Attractive girl. She is paid to sit there and attract. Masculine fellows impress by putting plenty of pennies into her employers' slot machines. Or you can pat balls into the mouths of the hungry-looking clowns below, and if they get high marks, perhaps win a model monkey*

FIG. 4    FROM "THE FIFTY-SECOND WEEK, IMPRESSIONS OF BLACKPOOL" IN *THE GEOGRAPHICAL MAGAZINE*, APRIL 1938

of children (cat. 26, 27, 29, ill.), who came to accept Spender as a part of the local landscape, show pastimes which can be read in metonymic, representative terms.[166] These photographs document daily living situations as well as decaying, sterile environments, while more distant panoramic views of Bolton depict the overall starkness and dinginess of mill complexes flanking housing (cat. 42, ill.). Within the archive of the M-O project these photographs depict specific areas and situations, but the same images viewed outside of the project's context might slide into iconic representations of the slums' universality (and inevitability) were it not for Spender's focus on individual expressions and gestures of communication among people or

between Spender and his subjects.[167] The jumble and chaos of children's games and pranks contrast with the vistas of their row houses seen from afar. Spender's wide-angled views of chimneys spewing smoke are framed by silhouetted leafy branches which somehow survive the menacing gray haze. The desolation of the repeated rectilinear forms of row houses and factories is heightened by the organic outline of jostling leaves and veils of smog. These bleak unpeopled panoramas frame our point of reference as we study the close-ups of life in Bolton.

Few interiors of homes or factories exist, because Harrisson demanded that the photographs be candid and unposed. These were areas

of investigation better suited to the diarists or undercover observers, although one family did request to be documented (cat. 39, ill.). This intimate view of evening rituals was, of course, taken with permission, but it has a relaxed quality similar to that of the Stepney photographs. Father, mother, and the baby being bathed are each connected visually to the right side of the fireplace by hand and arm gestures encircling or touching one another. The light from the fireplace casts a warm glow on the domestic scene and unifies the composition, lifting it out of the darkened interior. The alert, wide-eyed infant gazes away from the viewer, while mother and father are intent on his bath. Thus Spender's aesthetic decisions focus attention on the dignity of an individual family in a scene which manifests the naturalness of a daily ritual. Harry Gordon, a Bolton resident and Mass-Observer (while he was an unemployed fitter), fills in the details of the family's economic status:

*This is a tiled fireplace* [i.e. costly], *which weren't in a lot of houses at that time, or when I were younger. Now Davenport Street* [M-O's headquarters was at 85 Davenport], *they used to be people as could afford that…The people who lived in Davenport Street then* [when Gordon was a youngster], *they weren't middle class, but they were on that side…But when Mass-Observation were there, it were going down then, going down rapidly. And instead of one family living in a house, you might have two or three families, working class people.*[168]

The few interior factory photographs are primarily of women, who were usually operating reeling machines. These photographs were frustrating for Spender because they were necessarily posed and supervised:

*You have to get permission, clearly; and from the word go, you've got a foreman or deputy manager or some functionary asking himself,*

*"Is there anything we don't want to get publicised? Are we breaking any regulations? Photographs might be used in evidence against us."*[169]

Diarists and undercover observers recorded conversations in the mills, while quantitative tallies outside the Bob Mill in Davenport Street (cat. 35, ill.), were jotted down:

> 12.19 *pm Male, 40 trilby and gloves comes in;* 12.21 *Female 17 goes out, runs up street, comes back with fish and chips...*1.6 *pm coming in female, bareheaded, mac;* 2 *females, both bareheaded—blue coats; female beret and raincoat.*[170]

The anonymous quantitative tallies contrast with the individual character evident in Spender's photo-documents which frame in detail the particular gestures between people, within their distinctive tasks and environments.

The humane "dignity" maintained in these photographs of households and factory workers contrasts with the more raw depictions of children's rubble "playgrounds" and the exterior scenes of factory complexes. Any number of scenes may slip into the ontological sphere unless we refer to specific historical and local conditions explicated in resident diarists' texts. A photograph of a funeral (cat. 40, ill.), may be read as an iconic representation when removed from textual archives; it simultaneously specifies an era and class of row houses, while reflecting a form of universal mourning and loss. Once again Spender employs an asymmetry of visual weight and tonality as well as a deep perspective to draw the viewer into the scene, this time for the funeral cortege, with a Mass-Observer at our elbow to the right.[171] The solemn black funeral cars move at a deliberate diagonal toward us down Davenport Street and will exit away from us to the lower left on their way to the cemetery. The single iron lamppost at the center of the photograph anchors the composition, whose spokes move out in predictable, repeated rows of attached houses, pavement bricks, and cobblestones. The slow pace, aptly implied by these formal devices, contrasts with the swift and fragmented movement of children playing or factory workers exiting from under an archway in other Bolton photographs. Thus Spender's composition heightens the commanding emotional pull and weight of the subject matter, visually interprets the actual rhythm and mood of the event, and echoes the sadness of the mourners in the shapes formed by the contrasting tones.

The Vault (cat. 22, ill.) was a pub frequented by unemployed men.[172] Though the man in the light cloth cap at the bar appears to be waving a sign of greeting, he is making an offensive gesture, both attempting to protect his identity and graphically indicating to Spender to "get lost."[173] This man was unemployed and on assistance relief; if he were identified in a pub his payments would have been terminated. In this case, Spender had not disguised himself well enough and he was breaking a taboo of privacy which might have threatened the man's financial survival. Spender, out of deference for people's vulnerability, could not always venture where the Mass-Observers with pad and pencil could go more freely.[174] This slip-up is indicative of the underside of photography's graphic power as a potent medium in surveillance and criminal law enforcement, a heritage from its earliest days.[175] Here the photographer's point of view is one of isolation as opposed to inclusion; Spender is located at the top of a step and is standing above the darkened scene. The asymmetrical wide angle converges away from the photographer to focus on the man's warning gesture. Dogs are playing and men are chatting, but the photographer himself is caught in the act and excluded from intimacy as the backs and the sidelong glances of the men indicate. The exposure of the

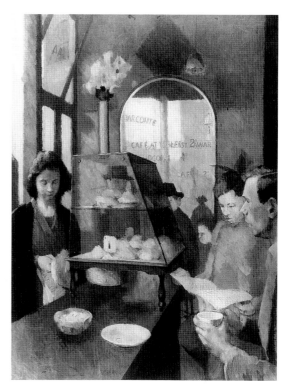

FIG. 5   GRAHAM BELL, *THE CAFE*, 1937–38, OIL ON CANVAS
MANCHESTER CITY ART GALLERIES

photographer-as-observer, as an outsider from another class attempting to peer through Orwell's pane of glass, points to the difficulties not only of maintaining anonymity but of fully comprehending the feelings and situations inherent in life "on the other side," especially if the methodology is one of detached "scientific" scrutiny.

The immediacy of the film still, an aesthetic evident in many of Spender's photo-documents, became a desired realist effect for painters like Graham Bell, who worked with the Mass-Observation crew in 1938. In Bell's painting, *The Café*, 1937-38 (cat. 45, fig. 5), the daily ritual of artists gathering for breakfast at a café in Goodge Street is depicted, employing a snapshot-like cropping of figures and informality of pose. William Coldstream, Bell's fellow

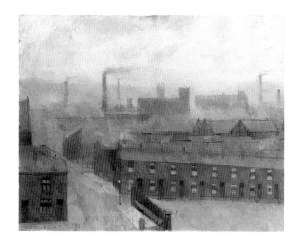

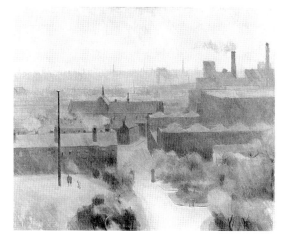

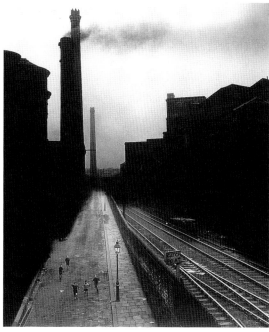

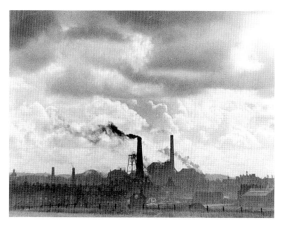

"realist" and M-O participant, is sliced in half by the picture frame, while the painter Victor Pasmore is hidden by a glass case containing pastries; and fellow artist, Claude Rogers, is obscured, a "fade-out" in the background.[176] The more sharply focused individuality of the young girl drying dishes contrasts with the anonymity of the customers, equally lost within private worlds. Thus Orwell's pane of glass intrudes again, as obvious class differences isolate individuals psychologically, even though they share the same physical space. By manipulating focus and framing angle, Bell composes an informal scene whose subject matter and composition echo Spender's photographs of Bolton window-shoppers and snack-bar customers (cat. 36, ill.). As a "slice of life" and "social document," Bell's *Café* parallels the concerns of the Mass-Observer in order to reach a wider audience.[177]

During the same year Bell and William Coldstream joined Humphrey Spender on the roof of the Bolton Art Gallery to paint over-views of industrial Bolton's smoky silhouette, a scene which Spender captured with his camera (cat. 42, ill.). Spender also recorded Coldstream in the process of painting (cat. 41, ill.). The stark, eerie dark-on-light silhouetting of the northern industrial city in Coldstream's *Bolton, 1938* (cat. 43, fig. 6) and Bell's *Thomasen Park, Bolton* (cat. 44, fig. 7), has a compositional link to photographic images of this period which use the same conventions. Anonymous photographers, as well as the young Bill Brandt and noted filmmakers from the 1920s and 1930s, employed the dramatic contrast of patterns of dark-on-light within a sharply angled perspective of an empty, desolate horizon (figs. 8, 9).[178] From Coldstream, Bell, and Spender's roof-top vantage point, the scene is deserted and lifeless and, according to one Bolton resident, "typical of here, on a dirty and mucky rainy day."[179]

Both Coldstream and Bell were committed realist painters by this time. Having assimilated their encounters with photography and their experiences of life in Bolton, they moved on to open the realist-oriented Euston Road School of Drawing and Painting in London, counting Stephen Spender among their students.[180]

As the Munich Crises of 1938 and 1939 approached, while Hitler annexed the Sudetenland and the Spanish Republic succumbed to Franco, M-O printed its fourth and most popular compendium of detailed observations of public opinion and daily conversation, *Britain by Mass-Observation*, selling 50,000 copies in twenty-four hours and listed as a Penguin Book Special.[181] The social consciousness of M-O became a damning critique of Fleet Street, the news media, and the government: "The masses are not given the facts or are deliberately misled."[182] M-O went on to state, "Fact is urgent—we are cogs in a vast and complicated machine which may turn out to be an infernal machine that is going to blow us all to smithereens."[183] Harrisson concluded with a disquieting analysis describing a "sense of helplessness which makes it seem to one in every two that there is nothing we can do about it."[184]

As M-O continued to gauge public opinion and record aspects of popular culture, it came under attack from the press, as Woodrow Wyatt's analysis of press reactions showed: "Scientifically, they're about as valuable as a chimpanzees' tea party at the zoo," quipped the editors of *Spectator*, November 19, 1937, while W. Hickey from *Daily Express*, June 5, 1937, found "fine objective reporters." the *Times Literary Supplement*, October 3, 1937, stated that M-O evinced "too great a preponderance of left-wing thought," Others bemoaned a lack of conclusive analysis: "Tends to stop at a collection of fact," wrote Geoffrey West for *Time and Tide*, September 25, 1937. Evelyn Waugh declared M-O "a great deal of pseudo-scientific showmanship," in *Night and Day*, October 14, 1937, and the *Bolton Standard* editors went directly to the heart of the matter on September 3, 1937, when they wrote, "surprising where the money comes from for these investigations," referring to Lord Leverhulme's financial backing.[185] Indeed, just prior to the war, writer James Hanley, a Liverpudlian, alleged that misery had become "a marketable commodity." In Hanley's own study, *Grey Children: A Study in Humbug and Misery*, he quoted a resident of South Wales, John Jones:

> the men down here, in fact all the people down here, have grown very, very sensitive about the enormous number of people who come down here from London and Oxford and Cambridge, making enquiries, inspecting places, descending underground, questioning women about their cooking, asking men strings of questions about this and that and the other…they object to all these people coming down and asking questions. That's all. They're not animals in a zoo. That's what it is.[186]

Thus, the utopian goals of M-O and the documentary movement to create a "collaborative museum"[228] of texts and images revealing the interstices of British culture, to educate, and spur reform, would not be realized fully by their detached, "scientific" methods. Even so, despite M-O's flawed methodology and often contradictory philosophical underpinnings, a social consciousness was coalescing, given a voice by Mass-Observers and an eye by Spender through the publication of his images in magazines and journals. And according to Tom Jeffrey, the M-O project did ultimately contribute, along with *Picture Post*, to the development of war radicalism and post-war reforms leading to a "more participatory social democracy within the overall limits of a capitalistic system."[187]

# SURREALISM AND BRITISH DOCUMENTARY

*Not from imagination I am drawing*
*This landscape, (Lancs), this plate of tripe and*
  *onions,*
*But, like the Nag's Head barmaid, I am drawing*
*(Towards imagination) gills of mild,*
*The industrial drink, in which my dreams and*
  *theirs*
*Find common ground. I hear the clattering clogs,*
*I see the many-footed smoke, the dance*
*Of this dull sky.*
(from Charles Madge, "Drinking in Bolton")[189]

Surrealism, present in both American and British documentary, was brought into relief in Britain by the 1936 International Surrealist Exhibition at the New Burlington Galleries in London.[190] André Breton's preface for the catalogue to the exhibition, translated by poet David Gascoyne, stated that surrealism would "reconcile" both "perception" and "representation…in bridging the gap that separates them." Breton hypothesized that the individual's subjective perceptions could be synthesized or seamlessly meshed with the world's objects; the object of fantasy could be uncovered in the "objet trouvé" by means of the unconscious associations intuitively discovered by the artist. Breton stressed the "objective precision" brought to bear in rendering the "'visual remains' of external perception." In an attempt to reconcile Freud's theories of the unconscious with Marxist dialectical materialism, Breton urged the "organisation of perceptions of an objective tendency" which would call forth correspondences "from exterior reality," whose conflation he characterized as revolutionary.[191]

Herbert Read reiterated Breton's points in his introduction to the catalogue in which he wrote that "a new synthesis" of "the conscious and the unconscious, the deed and the dream, truth and fable, reason and unreason" would be forged in the new artistic creativity of the age, i.e. surrealism. Read concluded his introduction by invoking England's claim to nineteenth-century proto-surrealist ancestors: "A nation which has produced two such superrealists as William Blake and Lewis Carroll is to the manner born."[192] The contradictions and paradoxes of the documentarians' project to join scientific objectivity, Humanist values, aesthetics, and the imagination are echoed by the British followers of surrealism, who were often documentarians themselves, like Jennings and Trevelyan, co-organizers of the Surrealist Exhibition.[193]

Within documentary, chance and uncanny juxtapositions provided a level of richness and complexity which transcended objective fact.[194] The city, or metropolis, was rife with such magical encounters of haunting ambiguity, and an artist such as Jennings often employed the camera to capture such encounters, whether in photographs or films.[195] Although Spender was not himself allied with the surrealists, one of his closest friends and colleagues, John Banting, was an enfant terrible of British surrealism.[196] Therefore, the aesthetic and conceptual frameworks of surrealism were not unknown to Spender; and as David Mellor has shown, surrealism and New Objectivity were both a part of the general avant-garde consciousness by the mid-thirties.[197]

The many advertising signs and graffiti Spender captured in a jumbled array are ironic enigmas gleaned from cities, consonant in their visual impact and mood with surrealist imagery. Banting would be an influence in developing Spender's sense of the uneasy drama of deep perspectives and his notions of the uncanny visual incident hidden in urban landscape, which at times only the camera was able to penetrate and isolate.[198] These elements are found in those Bolton photographs in which signs such as one declaring "Earth Around Is Sweeter Green," appear in desolate streets (cat. 32, ill.). Drab signs, which might be passed unnoticed while walking or riding by, are highlighted in Spender's images by their whiteness against dark walls and their closeness to the viewer, contrasted to the deep perspective. The women around the corner from the "Sweeter Green" sign encounter nothing "sweet" or "green" in any direction.

Equally ironic but more overtly humorous is the "hair specialist" who appears in need of more help than the patient victim seated before him (cat. 38, ill.). The "professor's" intensity and seriousness of expression, with his ointments and bars of special soaps arranged behind him, contrast with his comically wild hair as his deep concentration contrasts with the bustle of the Bolton market around him. Using asymmetry and a shallow perspective, Spender emphasizes the details of the "hair specialist" and his sign, while including the activity and mood of the surrounding context. This scene of visual humor contrasts with the disquieting and ambiguous nature of the street scene with the "Christ Is Risen" sign or the strangely powerful image of wash on the line, with inflated pillowcases floating above the street like tiny dirigibles (cat. 25, ill.).

Unusual in Spender's œuvre is an image without the interaction of people. Only the images of images, photographs of Hollywood stars Bing Crosby and Carole Lombard, occupy an empty bedroom in Stepney (cat. 11, ill.). They are windows on a world of glamour in a room of unmade iron beds and clothes scattered

in drawers and on top of torn pillow-ticking. Although no human being is in the room, a human presence is felt in the distinctive disarray of the curves and folds in the clothes and sunlight warmth on the pillows, indented from sleep.[199] Walker Evans, in a 1935 photograph (fig. 10), offers a similar depiction of advertising's consumable and packaged hopes grafted onto the reality of life.

The poignancy of these two images, taken by photographers entering unfamiliar "foreign" territory and looking in from the other side of Orwell's glass wall, is dependent on the uncanny juxtaposition of inanimate objects chosen by the absent "presences" from the storehouse of our consumer society, typified by Madison Avenue and Hollywood. In both cases the chance encounters seem paradoxical within environments which speak of material deprivation and the vain hope that dream and reality will literally intersect. The ironic, irreconcilable elements of subject matter reflect the external and interior psychological realities of the absent dwellers. Spender's selection of details and choices in cropping and angling the depth of field, so that the viewer enters the scene as though walking in the photographer's footsteps, and his decisions of tonality, light, and emphasis of focus, contribute to the subtle emotional force projected by the image. Thus the photographer recognizes the importance of the clues he has stumbled upon, while he uncovers and interprets the intimate scene by means of his aesthetic choices.

The unconscious and uncanny juxtaposition of "visual remains," like those found in Spender's photographs, were sought out by Charles Madge and Mass-Observation writers. Madge deemed the uncanny as exemplifying "collective unconscious" cultural traits, hidden in the details of British life. As Paul Ray observes:

*M-O assumes that the objects and images of our world are the concretization of inner states and seeks to uncover those inner states by using objects and images as signposts...M-O tries to recover the imagination that produced the vulgar objects and images of the everyday world.*[200]

The writers strove to create a synesthesia of montage-like elements plucked from the real in collaged word-images. They combined the "found objects" or "visual remains" with their own poetic voice; their aesthetic choices represented bits and pieces from the real world. Madge's Blackheath Mass-Observers would write daily in their diaries:

*The changing colors in the street, the changing shapes of tombstones, these visual elements caught the eye of these observers for whom such observation was not just an amusing exercise in triviality. Some sort of net had been spread to catch that fleeting, glistening apparition, the essence of time.*[201]

The jumble of elements caught in a "net" and locked within real life, much like Lautréamont's "chance encounter, on an operating table, of a sewing machine and an umbrella," was quickly grasped by the photographers, poets, and filmmakers under the influence of readings from Freud and Jung. Focusing on the chance encounters documented by twelve observers within the Oxford "landscape," Madge initiated the "Oxford Collective Poem," a collaborative verse derived from observed fragments: "The red garment of a woman. Stone steps leading to a stone building. Shoes. Trees against the skyline. The ticking of a clock. Smoke issuing from a pipe."[202] In collective fashion, the observers' notes were integrated into a single poem by the participants; montage-like fragments were spliced together to form a single unit, presumably reflective of twelve points of view in the observation of a social fantasy called an Oxford "landscape with figures."[203]

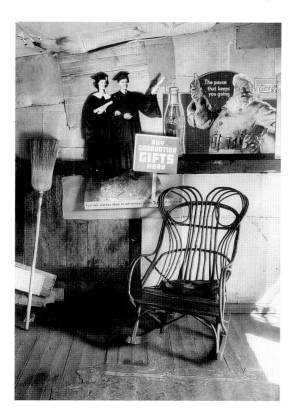

FIG. 10  WALKER EVANS, *INTERIOR OF WEST VIRGINIA COAL MINER'S HOUSE*, 1935, GELATIN SILVER PRINT, THE MUSEUM OF MODERN ART, NEW YORK

The sensibility of the chance encounter would be tragically transformed into everyday "surreality" once war and the "blitz" of Britain began. Writer Bert Lloyd would later remark in a text accompanying Bert Hardy's photographs for "The Warning of Plymouth," in *Picture Post* on May 17, 1941:

*They know what they will see then, realities that make the fantasies of surrealism seem commonplace: buses blown on to roofs of houses, a tree hung with women's clothes, the huge tinted photograph of a Boer War soldier, with waxed whiskers and an enormous medal, which hangs alone with glass unbroken on the enormous wall of a house, whose other walls have disappeared, so that no one can even guess their geography.*[204]

# PICTURE POST PHOTO-STORIES

Humphrey Spender's continuing disagreements with the editorial policies and moral center of gravity of the *Daily Mirror* caused him to be fired from his job as 'Lensman.' But almost immediately, in October, 1938, he joined the Hungarian journalist and editor, Stefan Lorant and Tom Hopkinson, a young Oxford graduate and journalist, at the newly formed *Picture Post*, a weekly illustrated magazine. Hopkinson had been Assistant Editor of *Clarion* and had worked as caption writer for Lorant at *Weekly Illustrated*; and he had seen Spender's M-O photographs of Bolton.[205] *Picture Post* combined the German-born "candid camera" aesthetic (with Lorant's bringing on board the German photojournalists Felix H. Man, Kurt Hutton, and Tim Gidal), the British fact-finding explorations of M-O (employing writers who were involved in M-O such as Tom Harrisson), and British journalism (through Hopkinson and his Oxbridge connections).[206] Hopkinson, like so many of his upper-middle-class Oxbridge colleagues, was also a reform-minded advocate of the Left. During his stint with Lorant, they both came "to recognise photography as a journalistic weapon in its own right, so that if—like myself at that time—you are determined to promote causes and affect conditions, photographs can be a potent means for doing so."[207]

Lorant's liberal democratic views were nurtured in his native Hungary, where he worked as a journalist and a film cameraman. Opportunities to experiment with the new picture-story narratives in Berlin and Munich journals brought Lorant success and recognition as the leader, in both style and content, of the emerging popular weeklies. In Germany he edited the successful *Münchner Illustrierte Presse* from 1930 to 1933, until he was arrested

by the Nazis as a Jewish editor. The Hungarian government secured his release shortly thereafter, and on his return to Budapest, he edited the picture magazine *Pesti Naplo*. He left Hungary to visit London in 1934 in connection with the publication of his book *I Was Hitler's Prisoner*, and once there, he judiciously decided to make his home in Britain.[208] There he edited the short-lived *Weekly Illustrated* as well as *Lilliput*, an arts and letters journal visually similar to the more seriously literary *Der Querschnitt*. His innovative layouts of illustrated stories—in which visually sophisticated compositions created cinematic spatial-temporal continuums spread over several pages—brought a new concept to magazine narrative. His layout technique guided the reader's eye by varying the scale of photographs according to significance of subject matter and formal qualities; he inset and overlapped photographs sometimes employing cropped circular formats within rectangles; he rhymed visual rhythms by the repetition of patterns, textures, and tonalities at intervals; and he created montage-like effects within gridded symmetrical frameworks, privileging the visual story over the text, which was minimal and occupied a fraction of the page.

Lorant's layouts were achieved behind closed doors. Hopkinson, who wrote the captions, hired the writers, and edited text, wrote of Lorant's temperament as autocratic, adding that "Lorant's way of working was both a revelation and a nightmare."[209] In a 1970 interview, Lorant shared insights into the working methods at *Picture Post*, stating that, "Editors were individualists; they were prima donnas. An editor had the function of a good conductor…The editor was the sole arbiter. I usually locked myself into my room with the pictures."[210] As the singular

orchestrator of the magazine, Lorant effectively usurped the interpretive function of the author by exerting control over the selection, placement, and scale of the photographs' context. Lorant's picture layouts and Hopkinson's text editing led to an unprecedented success of 1,350,000 subscriptions by the fourth month of sales.[211]

The extraordinarily popular content of *Picture Post* included a visual cacophony of picture stories of everyday life, movie stars, royalty, dance crazes, serialized novels and reviews, close-ups of occupations from all walks of life ("a day in the life of…"), unemployment and housing problems, health issues, and interviews with national and international political and cultural figures. The mix of story content was as varied as M-O's studies, and the insistence on "uncovering" natural "real life" stories just as powerful. Thus, as Dominique Baqué has written of French illustrated magazines, they "rendered public events more intimate, turning the private into the public," by exposing in close-up photographs the private gestures and expressions of public figures.[212] The ordinary working lives of "common" people were also made public, juxtaposed with images from the lives of international film stars or politicians, fostering "the democratization of the subject in photojournalism."[213] The problems of the modern world, unemployment, the economic depression and displacement, and the rise of Fascism, were given space along with serialized fiction, general reportage, and advertisements for consumer products. As in the M-O project, the LBC and GPO Films, the underlying premises were those of education, dissemination of knowledge, civic participation, and reform, with *Picture Post* adding the entertainment

element as a palliative against the tensions of modern life. Baqué has concluded that in the illustrated magazines the conscious philosophy and belief of the editors was that "the use of the image, in accordance with the humanist ideal, would allow the enlightened reader to think independently, and because of this free thought, to think the real."[214]

Spender's work for *Picture Post*, with Tom Hopkinson's giving a free rein on ideas and methods, allowed him to continue his focus on human interaction in the big cities of Britain and to expose the living conditions in the "depressed areas."[215] "The writers and photographers, who tended to be radically inclined, were allowed much more scope to put their own view of things [than at the *Daily Mirror*]."[216] In 1938 and 1939, the "Big Town" series of stories on Birmingham, Tyneside, Glasgow, Bristol, and Portsmouth, as well as London's Whitechapel and Lambeth, allowed Spender the time to study the environment for many days, and to work on large-scale photo-sequences, stories six-, eight- or ten-pages long with minimal text. Other photographers on staff, such as Felix Man, also worked on this series documenting city life. The expansive number of pages afforded these narratives was a significant factor for Spender, who realized that the frame excluded much more than it was able to include. Telling the story visually, with more pictures, allowed Spender to surround a particular moment or fragment with other photographs, so that an entire series had the potential to offer a richer sense of a neighborhood or place. Spender was aware that the images produced would be open-ended enough to encourage multiple readings, that one could "interpret photographs of people in so many different, so many more ways." He went on to elaborate, "I was at pains not to caricature people. It was a question, really, of recording normal behavior."[217]

On December 31, 1938, Spender's seven-page photo-story of "Life in Lambeth Walk" appeared in the *Picture Post*, with a text by a local resident of Lambeth, Ada Barber.[218] The subtitle reads:

*All over Britain, people talk about Lambeth Walk, the dance. Here is Lambeth Walk, the place. In spite of severe poverty it has a racy and vigorous life of its own. Ada Barber, who lives there, tells you what it's like.*[219]

Like most of *Picture Post*'s photo-stories, the text is dictated by the images. It was the usual practice for Spender to venture out on assignment alone (or sometimes with the story's writer, though Spender photographed alone) and to take his photographs first; then, after Lorant had reviewed the photographs developed in the darkroom by Edith Kay, Hopkinson would often hire a writer to compose a text in response to the images.[220]

With his small Contax camera and wide-angle lens, Spender employed various means toward taking photographs unnoticed, unobserved; focus and depth of focus could be adjusted by pretending interest in a direction other than that of the intended subject; settings of shutter speed and f-stop could be done under a raincoat with holes in the pockets. The final sighting of the viewfinder was the critical moment, sometimes disclosing the unanticipated gesture or unexpected glance; often in these situations, while patiently waiting and observing, there arose the need for very long, hand-held exposures of up to one second.[221]

Although his photographs in darkened pubs are reminiscent of the gestures, body language, and expressive interaction found in Erich Salomon's photographs of diplomats (fig. 1), Spender's focus is on intimate conversations among the working class. Individual expression and meaning embodied in gestures are at the heart of Spender's "Lambeth Walk" picture story. Nearly all of the photographs involve relationships between people articulated through camera angle, isolation in framing, and available ambient light, tightly focused on imminent gestures as well as the expressive spaces between people surrounded by their familiar environments. Lupino Lane, the comedian who made the Lambeth Walk dance craze famous, stated emphatically that, "The cockney is well known for his wit, grit, guts and humour, and these are expressed in his walk. If you'll go deeper in the matter, the walk will tell you the nature of any man or woman."[222] Spender's task was to seek out this embodiment of "wit, grit, guts and humour" in a variety of Lambeth haunts and street scenes.

Table-height photographs of mothers feeding children at the eel and hot pie saloon (cat. 74, ill.) bear resemblance, in subject matter and candid quality, to American Depression-era automats in WPA documents, and street scenes of skipping Lambeth residents are similar in sensibility and aesthetic to Helen Levitt's images of New York neighborhood activity from the same period—evidence of a shared documentary aesthetic. The photographs captioned "Expressions in the Street Market" (fig. 11), images of curious and wary consumers, convey their involvement and concentration as well as an intuitive knowledge on the part of the photographer of the variety of facial expressions which indicate interior questioning and judgment, weighing and hesitating. Spender's close-ups of turning faces and gesturing hands, framed by cropped figures jostling for advantageous views of consumer goods evoke the claustrophobic character of these encounters. Shop windows provided ideal opportunities for moving in closely to people and studying subtle expressions without being noticed.[223] Lorant composed this page of shoppers symmetrically, filled with framed and gridded close-up images of hustle

and bustle stilled. Although each of Spender's individual images operates as an intimate opening onto a specific scene, mounted together on a double-page spread, they gather the force of accumulated moments occurring within a cohesive community.

> Lambeth you've never seen,
> The skies ain't blue and the grass ain't green.
> It hasn't got the Mayfair touch,
> But that don't matter very much.
> We play the Lambeth way,
> Not like you but a bit more gay,
> And when we have a bit of fun,
> Oh, Boy—
> (from Douglas Furber's lyrics,
> Me and My Girl)[224]

The informal "dancing" typography of the title page (fig. 12) alerts the viewer as to the content and pace, and the large close-up photograph of two Lambeth women locked, tête-à-tête, in rapt conversation immediately involves us intimately in their private world. The smaller photograph symmetrically placed below, with its deep perspective, implicates us as eavesdroppers, who in walking down the street overhear three women talking. The telling expressions of the two women in profile allow a reflective "doorway" into the scene. The photographs as a series convey a warm, spontaneous sense of community and engaging comradery, gossip and business, qualities which are reiterated by Ada Barber's conversational narrative.

It is significant to note that Lorant placed this first page of the "Lambeth" story opposite the last page of a convivial group of popular dance-hall and cabaret performers in black tie and tails entitled, "Concert Artistes Give Themselves a Party." Although the formal and elegant dress within London's Park Lane Hotel is certainly in marked contrast to that of the Lambeth residents, the concentrated and animated

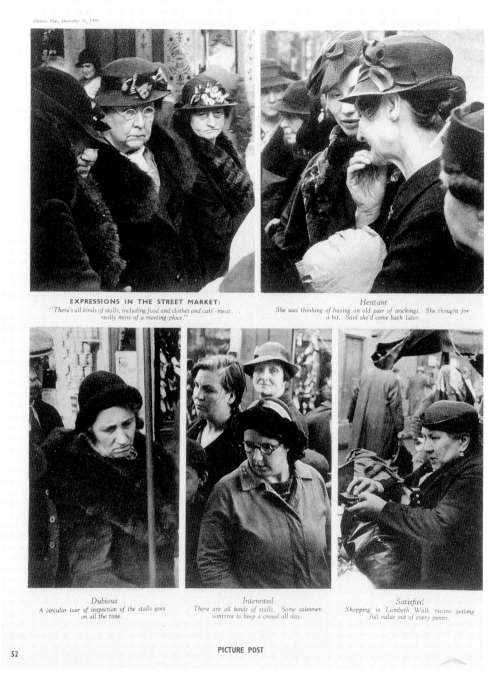

FIG. 11 FROM "LIFE IN THE LAMBETH WALK," *PICTURE POST*, DECEMBER 31, 1938

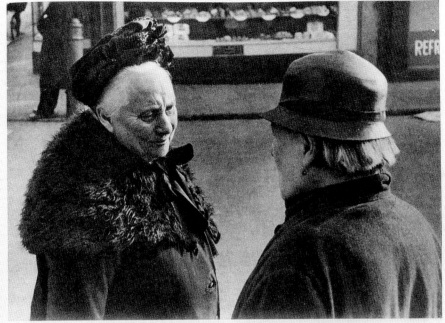

*Fashions in the Lambeth Walk—the Street after Which the Dance is Named*
*In south-east London is the famous Lambeth Walk. It runs from China Walk to Princes Road. The Walk is lined with shops, 208 in all.*
*Mostly grocers, butchers, greengrocers, drapers and bakers—with a few pawnbrokers and eel-pie saloons, one cats'-meat man and a herbalist.*

# Life in the Lambeth Walk

**All over Britain, people talk about Lambeth Walk, the dance. Here is Lambeth Walk, the place. In spite of severe poverty it has a racy and vigorous life of its own. Ada Barber, who lives there, tells you what it's like**

WHEN I was born they put me in an orange box under the table in our room round the corner from Lambeth Walk. Then, when I was a bit older, I used to play in the Walk itself. Then I went to school, and on Saturday night my mother took me shopping in the Lambeth Walk street market. So all my life has been around our street.

My dad is, I should think, about the oldest London coster who still sells in the street. He used to have three stalls but now he is eighty-eight. He just sells straw bags, 2d. each, Fridays.

You might say he was Lambeth Walk almost, because unlike me—I go away to work—he just lives every hour here. Everybody knows him and he knows everybody.

Sundays my dad goes to church. At least, it's a sort of

*Taking the Lambeth Air*
*The air is not so very fresh in Lambeth, but, as it's the only air there is, it's best to take it.*

half-church and half-cinema. The Rev. Tiplady runs it and it's called the IDEAL. You put a penny in the plate on Sundays and threepence in the week, and then you get a free party at Christmas and an outing in the summer. Dad always goes.

Then there's Mr. Bradbrook, the black man; his place is Spencer Hall, and the children like him very much. He shows them coloured lantern pictures of the Bible and the Holy Land. And, of course, there's the ordinary cinema also where I go.

Our chief pub is "The Feathers." They talk about pubs being the poor man's club, but just as many women go to "The Feathers," and one of the bars is practically the women's bar—but of course men can come in if they really want to.

I suppose pubs are about the

FIG. 12  FROM "LIFE IN THE LAMBETH WALK," *PICTURE POST*, DECEMBER 31, 1938

gestures as they chat and gossip are much the same. While the differing social milieu of film stars and working people are always evident in *Picture Post*, the human dramas played out in the photographs often align and democratize varying social groups, reflective of a Humanist approach.

Spender's photograph of a woman cleaning her doorstep (cat. 75, ill.) is typical of the unposed, serendipitous photograph of ordinary activities which give an authenticity of voice to the Lambeth story without contrivance in pose or sentimentality in mood. The intention of this candid shot, for example, is different from Bill Brandt's composed and atmospheric, almost pictorialist photograph of the same activity in *East End Morning, September 1937* (fig. 13), less a documentary photograph than a deliberately posed, mental construct of East End life. In Spender's photograph the point of view, looking down onto the pavement, echoes that of the woman concentrating on her chore. The asymmetrically large semi-circular sweep of her activity is the focus, while she is anonymously profiled against the pavement and doorway. The sense of movement is rhymed by her body's thrust, the diagonal of her arm, and the curved path of her cloth. The muscular gesture and curve of her body are contrasted with the cool, unforgiving geometry of the pavement and brick wall. The sheer physical effort and determination of an often repeated task is the subject matter. Spender's focus in this photograph on her individual chore is juxtaposed in the picture story with a close-up of laundry on the line (linking the two images narratively), a gathering to hear a Sunday sermon, an interior family scene at tea-time, and a deep-perspective image of a side-street accordionist and resident doing the Lambeth Walk. This layout creates a narrative which seems to link the photographs thematically, as though all of the photographs

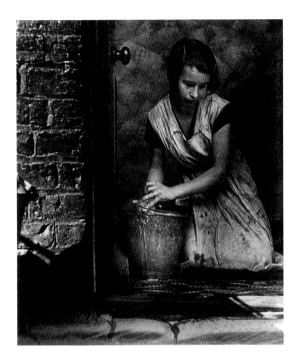

FIG. 13  BILL BRANDT, *EAST END MORNING, SEPTEMBER 1937*
GELATIN SILVER PRINT, BILL BRANDT ARCHIVE LTD.

sheets, but Lorant selected this confrontation, perhaps because it spoke of "authenticity" or involved the viewer in spying on a private drama.[225] The pub was a personal neighborhood sanctuary, and as Spender noted, "in a pub, there was a kind of community feeling, the feeling of a lot of people who knew each other, and who were happy to know each other."[226]

Spender continued to be concerned about the ethical and moral questions arising from his work, "A constant feature…was a feeling that I was intruding, and that I was exploiting the people I was photographing, even when [in Stepney or for M-O] the aim explicitly was to help them."[227] The conflicting issues raised by his work were many: a genuine belief in the value of the photo-document as an addition to human self-knowledge and understanding, however subjective it might be; the self-reflexive issues of identity and class; the ethics of intruding on private dramas and exposing these dramas to the public; and the exhilarating challenges of capturing the fleeting moment. These were to remain unresolved contradictions for Spender, until his work was curtailed when he was drafted into the Royal Army Service Corps during the Second World War.

were taken during the same day and in the same neighborhood block—which is not necessarily the case. As a "story" is implied by Lorant's layout, Spender's photographs (which have been enlarged, cropped, or diminished in size) are visually linked, and their individual aesthetic and thematic potency is lessened by the visual variety—although the overall effect of the layout is one of candid naturalism.

The intrusiveness inherent in the kind of photography Spender practiced—an aspect of his work that troubled him—is evident in one of the Lambeth pub images (cat. 73, ill.). A man at the bar catches the photographer in the act of taking his picture and confronts him with an angry grimace. It is another image, like that of the pub in Bolton (cat. 22, ill.), where a hostile awareness of the photographer's presence imparts an edgy dynamic. There were many Lambeth pub images on Spender's contact

*The corroded charred*
*Stems of iron town trees shoot pure jets*
*Of burning leaf. But the dust already*
*Quells their nervous flame: blowing from*
*The whitening spokes*
*Of wheels that flash away*
*And roar for Easter. The city is*
*A desert. Corinthian columns lie*
*Like chronicles of kings felled on their sides*
*And the acanthus leaf shoots other crowns*
*Of grass and moss. Sand and wires and glass*
*Glitter in empty, endless suns…*

(from Stephen Spender, "Easter Monday")[228]

*Smoke from the train-gulf hid by hoardings blunders upward, the brakes of cars*
*Pipe as the policeman pivoting round raises his flat hand, bars*
*With his figure of a monolith Pharaoh the queue of fidgety machines*
*(Chromium dogs on the bonnet, faces behind the triplex screens).*
*Behind him the streets run away between the proud glass of shops,*
*Cubical scent-bottles artificial legs arctic foxes and electric mops,*
*But beyond this centre the slumward vista thins like a diagram:*
*There, unvisited, are Vulcan's forges who doesn't care a tinker's damn.*
*…*
*On shining lines the trams like vast sarcophagi move*
*Into the sky, plum after sunset, merging to duck's egg, barred with mauve*
*Zeppelin clouds, and Pentecost-like the cars' headlights bud*
*Out from sideroads and the traffic signals, crème-de-menthe or bull's blood,*
*Tell one to stop, the engine gently breathing, or to go on*
*To where like black pipes of organs in the frayed and fading zone*
*Of the West the factory chimneys on sullen sentry will all night wait*
*To call, in the harsh morning, sleep-stupid faces through the daily gate.*

(from Louis MacNeice, "Birmingham")[229]

Collaged bits and pieces from the everyday modern world combine in often jarring and uncanny juxtapositions in the poems of Stephen Spender (1935) and Louis MacNeice (1934). Written in the midst of the economic "slump," both poems reflect, in vivid visual imagery, the mood and atmosphere of the Depression era in Britain's old industrial cities. Anonymous shop girls, bank clerks, and the dispossessed populate a dreary urban "desert," filled with broken-down machines, anachronistic architectural ruins, and fractured lives. A sense of hopelessness and a degree of numbness pervade the scenes, their fleeting visual images fixed in a disjunctive narrative flow. These fragmented poetic depictions of ordinary life beset by disturbing real and dream-like implications were situated within the broader developing cultural dialogue of British documentary, which often paralleled the atmosphere of these poems in picture stories of the industrial cities in the North.

In December 1938 Humphrey Spender and poet Michael Roberts traveled separately to Tyneside to report on the extreme conditions of poverty and unemployment in the Newcastle region, the city on the River Tyne with its surrounding "distressed areas" of Jarrow, Felling, and Hebburn. Drawing on his experience at M-O, Spender consistently sought out a broad representation in documenting neighborhoods: a variety of work and leisure activities; unique local rituals or habits; city government; civic organizations and street life in the hubs of activity or in more isolated areas. Lorant and Hopkinson counted on Spender's technical expertise, his ability to compose photographs formally with high contrast, and on his intuition both in seeking out many kinds of human

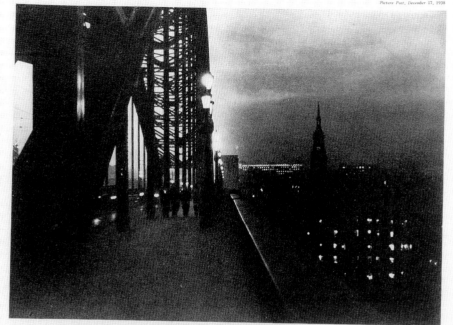

*Picture Post, December 17, 1938*

*Newcastle: Evening On The New Bridge*
*Twilight is kind to Newcastle. The bold lines of the New Bridge stand out sharp against the sky. The lights in factories and offices show bright against the gathering light. All that is commonplace or mean fades out of sight.*

# TYNESIDE

A Picture Post cameraman spent a week in Tyneside. He saw grand, but gloomy, views. He saw some poor architecture, but splendid engineering. He saw some prosperity. But he saw much more poverty. He saw the irrepressible spirit of the North; but he saw stagnation, too, and a looking-back to days that will not return

SOMETHING like a million people live on Tyneside, and most of them have never been to London—it costs a lot of money by train or bus, and by sea it takes about as long as it does to get to Hamburg. And anyway the Tynesider doesn't like travelling. He is proud of "the North," anything beyond York is "the South," and his capital is "canny Newcassel."

There is a lot of Scottish blood in the Tynesider, but "canny" doesn't mean to him what it does on Clydeside. It means something small and friendly and with a fascination of its own. And Newcastle, with its quarter of a million people, its quays, shipyards, sweet-factories, flour mills and markets, is always "canny" to the Tyneside Geordie.

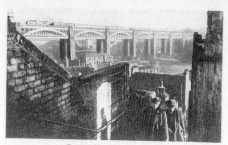

*Coming Up From The River*
*The changes in level provide fine views, allow the air that comes up from the river to circulate through the city.*

Newcastle stands on the north side of the river—in the old days the Castle guarded the only bridge in those parts, and there is still no bridge or tunnel across the river on the ten-mile stretch from Newcastle to the sea—but along both sides of the river, all the way down to North and South Shields, and for some five miles upstream, there is nothing but slipways, quays, staithes, ropeworks, warehouses and all the variety of grimy prosperity and grimy stagnation.

The middle classes and the wealthy live in Gosforth and Jesmond, suburbs of Newcastle, or up the river at Hexham, or down on the coast at Whitley Bay. Geordie lives beside his work, or the place where he used to work. All the big stores, the business-men's clubs, the

**PICTURE POST**

23

FIG. 14  FROM "TYNESIDE," *PICTURE POST*, DECEMBER 17, 1938

encounters and in waiting for the equipoise of the significant moment. Spender, however, had reservations: "I very often hesitated too much, because I didn't want to introduce another element into what perhaps I was interpreting as their suffering."[230] This penetrating self-knowledge, an awareness of psychological as well as social-class frameworks, would make for a keenly perceptive photographer but would exacerbate conflicts of an ethical and moral nature, especially when Spender had little or no control over how his photographs would be manipulated by means of selection, cropping, layout, captions, or text.[231]

Michael Roberts's text from the December 1938 issue informs the reader of Newcastle's devastation by the economic depression, and by the earlier loss of the export trade that had been the lifeblood of its shipbuilding and coal mines. Hopkinson's headline reads:

A Picture Post *cameraman spent a week in Tyneside. He saw grand, but gloomy, views. He saw some poor architecture, but splendid engineering. He saw some prosperity. But he saw much more poverty. He saw the irrepressible spirit of the North; but he saw stagnation, too, and a looking-back to days that will not return.*[232]

The headline rhetoric highlights the contradictions of the liberal-minded *Picture Post* project which combined a positivist view with Humanist ideals and a call to social reform. The *Post*'s strategy deploys the shocking juxtaposition of images from an upper-class world with images of the poor. The warning to ameliorate the situation is clear.

Roberts reported that out of a population of about one million people, over 55,000 or 21% were unemployed (for the rest of England the figure was about 13%). Of those working, 76% had incomes of under four pounds a week.[233] (As a comparison, Spender's Zeiss Biogon lens

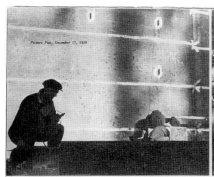

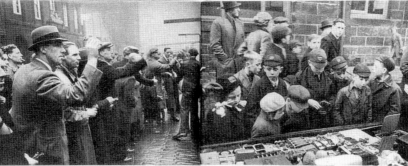

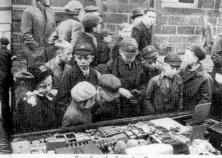

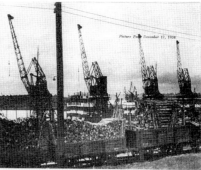

**LIFE ON TYNESIDE :** *The Lucky Ones Have Work*
*A riveter at work. Newcastle has nearly 18,000 unemployed. South Shields 10,000; Gateshead 8,200.*

*Market on the Quayside*
*A big feature of Newcastle life is the Sunday market on the quayside. Its sideshows are always crowded.*

*Spending the Saturday Penny*
*Newcastle makes sweets, and while their elders throw darts or do the shopping, the children spend their pocket-money.*

*Tyneside Scenery*
*In the foreground Scandinavian pit-props. In the background cranes, and the river which once was full of shipping.*

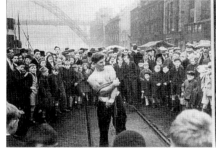

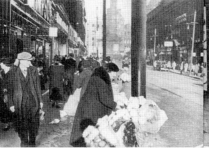

*One Way to Make a Living*
*Once there was a living for every Tynesider that wanted work in the shipyards. That was years ago.*

*Looking Up Grainger Street*
*Flower-girls and chromium-fronted shops are refinements you find in Newcastle. There's no room for them in Jarrow or Gateshead.*

*They go Cycling on a Sunday . . .*
*Girl cyclists in their club uniform. But there's no mass-exodus from Newcastle as there is from Manchester.*

*. . . And They Go On Parade*
*Sunday brings out the Girls' Brigade. They parade through the empty streets of Newcastle with their banners.*

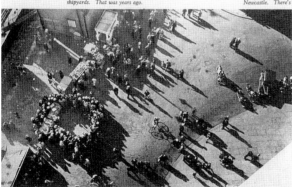

*Looking Down from the New Bridge on the Sunday Market*

off its women folk).

In these one-class towns the bosses and the managers come from Hexham or Monkseaton, and go back home by motor or electric train.

There are thirteen local authorities on Tyneside, some of them very active and public-spirited, but what can you do to build up a properly-balanced local government in a place like Jarrow, where more than half the "working" population were out of work for years, and where the middle class does not exist?

Facts and figures will give the clearest idea of the condition of Tyneside to-day—not of its morale; not of what it hopes for; not of what it would like to be; but of what it is.

Within ten miles of Newcastle, in an area that includes Sunderland, South Shields and Gateshead, there is a population of over 1,100,000.

In the Tyneside area, out of a total of 268,210 insured persons, 55,538, or 21 per cent, were unemployed in October of this year—as compared with a figure of 13 per cent for the rest of England and Wales.

In other words, unemployment was half as bad again in Tyneside as it was over the country as a whole.

Chief cause is the decline in shipbuilding.

In 1913, in the yards of Newcastle, South Shields and the Tyne Ports, there were 182 vessels being built, with a gross tonnage of close on 700,000.

In 1937 in the same yards there were 102 vessels being built with a gross tonnage of about 211,000.

There are some families who can talk of prosperity, but not many.

In Newcastle, in 1934, 2,200 families, constituting 3 per cent of the population, had a chief income-earner who received £10 a week or more; 15,100 families, 21 per cent of the population, had a chief income-earner who received £4 to £10 a week. 54,600 families, 76 per cent of the population, had a chief income-earner making less than £4 a week.

In Gateshead, 78.5 per cent had a chief income-earner making less than £4.

In Hebburn, out of a population of 24,000, the last census showed less than fifty persons belonging to the employing class. There were no professional men, except the doctors and clergymen whose work compelled them to live in the town. The rest had all moved on.

The Tyneside Council for Social Service does a lot of uphill work, but this segregation of classes makes it almost impossible to get some

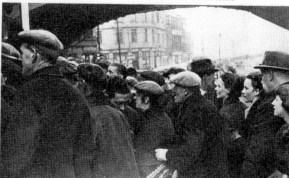

*Weekdays: Trying to Go Home, the Scramble for a Tram*

FIG. 15  FROM "TYNESIDE," *PICTURE POST*, DECEMBER 17, 1938

FIG. 16   LASZLO MOHOLY-NAGY, *FROM THE RADIO TOWER, BERLIN*, c. 1928, GELATIN SILVER PRINT THE ART INSTITUTE OF CHICAGO

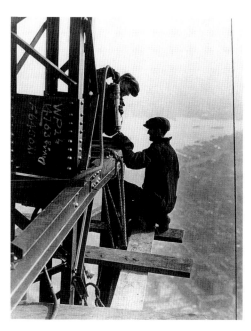

FIG. 17   LEWIS W. HINE, *STEELWORKERS, EMPIRE STATE BUILDING, NEW YORK*, 1931, GELATIN SILVER PRINT GEORGE EASTMAN HOUSE, ROCHESTER, NEW YORK

cost about twenty-eight pounds, and the weekly salary of a *Picture Post* staff photographer at the time was from forty to fifty pounds, secured by Lorant for his photographers from *Post* owner, Edward Hulton, as a salary level corresponding to the pay his photographers had received at the *Münchner Illustrierte Presse*.)[234] The text includes statistics as well as generalizations from anecdotes regarding the Tynesider's character:

> Mixed up in his character there is indepen-
> dence, courage, self-satisfaction and lack of
> enterprise, and even in this he doesn't differ
> from the men who once made fortunes out of
> coal and ships. And Geordie [Tynesider] knows
> it: he is proud of his direct way of talking (he
> wouldn't call anybody 'Sir' or 'Gov'nor') and
> he no more likes asking for help than he likes
> turning to a new job.[235]

The pairing of "courage" and "independence" with "self-satisfaction" and "lack of enterprise" carries the implication of laziness and inability to adapt to change and modern technology. Such equivocations characterize the photo-stories of some of the weeklies regarding the unemployed and working classes.[236] And yet, in this case, Roberts is attaching his generalizations to the wealthy industrialists as well as to the under-classes. Although the texts of the photo-stories are usually ancillary, "illustrative" of the photographs already chosen by Lorant, Roberts draws his own conclusions which are not necessarily present, explicitly or implicitly, in Spender's series of photographs. There is an abrupt visual polarity between the worlds of the upper class and the poor, highlighted by a stark division between images in the first five pages as opposed to the last four pages. Lorant's layout tells the tale of the two worlds, one of clean, engineered, and luxurious spaces and bowler hats, the other of filth, loneliness, and decay.[237] It is the disruptive cumulative impact of this juxtaposition which Lorant and Hopkinson seem to rely on to

counteract complacency.[238] By exposing these specific indignities of poverty, the editors hoped to affect social reform.

The bold typeface of Tyneside and the larger, half-page photograph of Newcastle, taken from the New Bridge in deep-angled perspective, immediately pull the viewer from his armchair into the tale (fig. 14).[239] The emphasis on the symmetrical Constructivist, or the engineer's, vertical-horizontal grid is a feature of Lorant's layouts for this series. The geometric layout echoes the broad theme of the modern city and architecture (also a theme in Spender's training and education) and helps organize the variety of human-interest images within. Lorant consistently balances the variety of textures, tonal qualities, rhythmic intervals, and lights and darks of Spender's photographs into this grid to achieve order. Another smaller distant view "coming up from the river" balances the first page, which is our entry into the picture story.

In the following double-page spread Lorant moves in "cinematically" on the civic and business leaders, the bourgeoisie in bowler hats reclining in Chippendale upholstered chairs and leather sofas. Just as a filmmaker might cut abruptly from a deep-angled or panoramic contextual view to focus on an interior human drama to signal a switch in perspective of the theme of a narrative, so too does Lorant lay out his progression from the city of Tyneside to its leaders ensconced within clubby, smoky atmospheres. The immediacy and intimacy of conversations among the powerful is reminiscent of Salomon's work once again, featuring compelling, tentative, or concealing gestures. Some of Spender's images are close-up, casual, and private, while others are taken at a slight distance to encompass more figures in bowlers and fedoras, repeating endlessly the anonymous businessmen surrounded by carved columns, oil paintings, or art-deco ornament. Lorant's layout

is perfectly symmetrical; the photographs are bled to the edges with a single enlarged image consuming the upper portion of each page, while underneath are two smaller photographs rhymed to each page. The grid reinforces a solid, stable, and predictable regularity.

Though containing immense variety thematically and formally, the next spread of photographs of the bustling life of the ordinary citizen is composed into a harmonic aesthetic whole on Lorant's symmetrical grid (fig. 15). There are photographs taken from high above looking directly downward to dizzying patterns of people and shadows (echoing Moholy-Nagy, fig. 16, as well as Munkacsi's work), dramatically silhouetted men at work in cloth caps (echoing Lewis Hine's technique, fig. 17),[240] boys avidly peering into shop windows, street performers, cyclists, parades, and giraffe-like cranes in rows on the river, emphasizing an emptiness where, "once full of shipping," the docks had been congested.[241] As in the Lambeth story, the dynamic energy of Spender's photographs is harnessed by Lorant within the over-all harmonious scheme of his layout, while draining the singular images of their individual power of expression and focused subject matter.

In stark contrast to the busy streets, the following double-page spread depicts living conditions in much the same manner as Spender's Stepney evidentiary images. The caption to a photograph of an interior describes the dim light and scarce food on the table: "A broken mantle allowed just enough light for the picture to be taken. The room otherwise— a basement room—was permanently dark. The bread and cake on the table was all the food they had. There were other children not in the picture."[242] Spender's point of view is that of the standing guest who attempts to absorb the entire context as social observer. A temporary gas light illuminates the table contents as well as the

mother's and sibling's rapt attention to the younger child by a single brass bed. The fact that this space is the sole living area for the three, with no father present, is evident even without the caption, although the text's description of more children multiplies the impact of the signs of poverty and deepens our understanding of the vulnerability of this family.

Above this interior scene is an enlarged photograph of men searching the slag heaps for coal (cat. 69, ill.), the text remarking that if the men are found out, they will forfeit their state relief. The image is representative of the desperate situation of unemployed miners put out of work by technology and the effects of the worldwide Depression. The indignity and anonymity (obscuring their faces protects their identity) of scavenging on hands and knees becomes a demeaning detail eloquent of the condition of the poverty in which they live. The miners' rumpled and soiled cloth coats and caps become nearly absorbed by grey rock shards, dirt, and background landscape, their humanity obscured by their condition.

The search of the slag heap is contrasted on the opposite page with the silent wait for relief and the silhouetted isolation of a man alone on the waterfront horizon. Again Lorant employs symmetry in pairing images on adjoining pages. The passive waiting in the "Social Centre" for "relief" is a scene of "victimhood," as is the silhouetted cloth-capped man on the dock who takes on iconic status as a readable sign of the Depression in the North.[243] The desperate activity of the slag heap scratching and the woman's and children's feeble anticipation is opposed to the static, quiescent scenes on the right-hand page. In the midst of the depictions of dire conditions, Lorant overlays two smaller, optimistic, and active close-ups of two men working for social-service organizations. Their unpaid busy-work is an ironic parody of

meaningful work, and their inclusion, which obscures part of the two bottom images, dilutes the complex and subtle impact of the photographer's other images.

The last two pages culminate in two large symmetrically placed images, one of an empty monotonous "desert," a row of slum houses (reverberations of Stephen Spender's and Louis MacNeice's poems), and on the opposite page two children playing in their own world, a heap of stones and dirt, until startled by the man with the camera (cat. 70, ill.). The boy looks quizzically at us. Simply by noticing "us," he pulls "us" temporarily into his world and into his condition by the shock of the encounter with physical devastation.[244] And yet we, like Spender, remain behind Orwell's wall of glass, the observer separated physically and psychologically from the observed as a result of class. The smaller photographs underneath reiterate both worlds, the fine engineering feats, the "hope" of clean, precise bridges, and the poverty of blackened grass and mud, the path of a Tynesider "going home." Here Lorant more successfully pairs old and new, poverty and technology, despair and hope, with the impact of poverty being the dominant visual theme. The irreconcilable contradictions of the messages and formal means embodied in the photographs brought together within these pages jolt the viewer to the recognition that these polarizing conditions exist within the same city. In the captions charity and philanthropy are invoked alongside social reform, while Spender's individual images document the despair as well as the material achievements.

Stephen Edwards has recently stated that the unconscious codes which surrounded such "iconic" crystallizations of poverty tended to implicate the residents in their own predicaments (as Roberts's generalizations imply), and that the filth, disease, and decay which

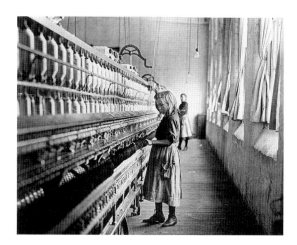

FIG. 18 LEWIS W. HINE, *CAROLINA COTTON MILL*, 1908, GELATIN SILVER PRINT, THE MUSEUM OF MODERN ART, NEW YORK

surrounded the cloth-capped inhabitants became associated with *their* bodies and with *their* character, as people who threatened the social order.[245] In support of his point, Edwards cites Hopkinson's caption, "A Problem for the Local Councils," paired with the image of the two children playing in rubble surrounded by the slum in which they live.[246] But the text under the caption goes on to ask relevant questions about the renovation of damaged sites left by industries which have abandoned the population and the problems of local councils in raising funds for renovation when there is no middle class to tax or to organize fund-raising activities.[247] The contradictions within the article itself and between the photographs and the text remain unresolved, not glossed over or synthesized—despite Lorant's attempts within a harmonious layout to create a cohesive visual narrative. Thus, Edwards's contention that documentary realism is solely a "unified discourse," which "can not depict the world as contradictory," is unfounded in the case of Spender's photodocuments within *Picture Post*'s narratives.[248] The deep-seated causes of the economic and social problems remain invisible and unarticu-

lated (although alluded to in Roberts's text), while the visible symptoms of a collapsing capitalist economy are pictured in conjunction with a hope and belief in the power of science and technology to solve these problems.

The December *Picture Post* article provoked the Lord Mayor of Newcastle to protest to the editors about its negative characterization. This in turn caused the magazine to send Spender and, this time, John Langdon-Davis back to Tyneside.[249] The mayor's statements were printed in the March 4, 1939, issue on Tyneside, and the editors replied:

> A *few weeks ago we published a series of photographs of life on Tyneside which the Lord Mayor of Newcastle and several other high officials stigmatised as unfair. We offered to send a journalist and a photographer to see Tyneside under their direction. Here is the result of their visit.*[250]

In this Tyneside layout the predominant theme is ostensibly one of progress and optimism in deference to the Lord Mayor's criticism, yet the text belies that theme or calls its premises into question. We enter the Lord Mayor's congenial chambers in a dominating first-page photograph of an interview underway, putting heads together to discuss "our" problems. On the next page is the "problem," people waiting impotently with overt anxiety and frustration for new housing, while the inserted bottom photograph repeats a now familiar row of slums. In the top photograph we are eye-level participants in an emotionally charged meeting of the city architect, in a well-tailored suit and tie, and a man and woman who recoil and stiffen in his presence (cat. 81, ill.). The light falling on the stone walls and doorway, framing the cramped woman, only adds to the couple's isolation and apprehension regarding the message from the visiting architect. The deeper perspective of ramshackle row houses at the

bottom of the page is our frame of reference for this close-up image and helps to explain the couple's distress.

The following photographs present the solution as represented by factories, renovated streets, and new housing. Factory precision and crisp light resonate visually in repeated rhythms much like Lewis Hine's images of factory girls working in receding rows of machines mirrored to infinity (fig. 18) or the mechanistic subjects of the German photographer Albert Renger-Patzsch or the American Charles Sheeler. Yet, in the text technology is seen as itself at the heart of the problem:

> It is nothing human that is wrong with Tyneside. The havoc has been done not so much by men as by the machines they have created. Or, rather, by the fact that men have not understood how to take advantage of what machines can do.[251]

The "hope" embodied in the photographs of engineering feats, orderly architecture, and busy factory machines is contradicted by the article's content. Langdon-Davis not only fills in more damning statistics after the opening plea by the Mayor that he is doing all he can, but he also quotes health-care workers and people involved in the community: "We live in Pre-Pankhurst days up here. It's a man's world," when quoting child mortality and "girl labour" statistics. "Our problem is to liquidate a dead state of economic organisation. We are saddled with the burden of the past," states the Medical Officer.[252] This "burden of the past," so explicitly confirmed in the text, is reflected not only in slum houses but in the contrast of the photograph of the Lord Mayor in his anachronistic ceremonial garb and that of huge modern cranes waiting for workers to operate them. The Mayor in his costume is no more a symbol of the new than is the old ship, the "Berengaria," waiting to be dismantled in a smaller photograph in the lower right corner.[253]

"We see it is not the men who are at fault. From the Lord Mayor down, they are fighting against fate. Tyneside is caught between a dying old world and a new world not yet grown to power."[254] Here again is the fatalism and "hopelessness" found by Tom Harrisson in M-O surveys published in 1939. This apathy is paralleled in many of the poets', painters', and intellectuals' retreats from activity in 1938 and 1939, with the fall of Spain, the continuing Depression, and the repeated capitulations of Chamberlain. According to Samuel Hayes, "There was a general withdrawal from action evident among English intellectuals, as they came to see no alternative to waiting for the end."[255] And again in Graves and Hodge, "Like everyone else in the last two peace years, the poets in general were in a state of expectant, fearful, inactive confusion."[256]

John Taylor has noted of *Picture Post*'s philosophy and tactics of Humanist engagement that "Hopkinson felt that a tragic sense was a spring for action, but this transference was not certain—there is always in tragedy a current of inevitability."[257] Though the devastating photograph from the earlier Tyneside article of two children playing in a pile of rubble confirms a palpable, "real" fact of life for two particular children, it is presented against a backdrop of other photographs which suggest that some steps have already been taken to alleviate the "problem," which might let "us" off the hook. As does the aestheticizing of suffering mentioned earlier by Spender and elaborated by Walter Benjamin in his 1934 essay, "The Author as Producer": "Making misery itself an object of pleasure, by treating it stylishly and with technical perfection."[258] In Cartier-Bresson's well-known photograph from 1933 of children playing in the ruins of Seville, Spain (fig. 19), there lingers the danger of focusing on the formal aesthetic quality of composition removed from

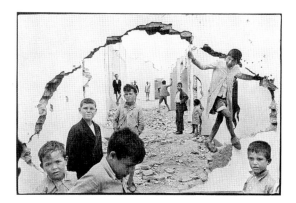

FIG. 19 HENRI CARTIER-BRESSON, *CHILDREN PLAYING IN RUINS, SEVILLE, SPAIN*, 1933, GELATIN SILVER PRINT, MAGNUM PHOTOS, INC.

its contexts and intent and imputing a "universal humanity" to the image, thus denying "the determining weight of history—of genuine and historically embedded differences, injustices and conflicts."[259] In the context of *Picture Post* Spender's photographs function not as detached aesthetic objects but as part of a series of markedly contrasting images of wealth and comfort versus poverty and isolation (as in Bill Brandt's tactic of juxtaposing the same types of visual contrast condensed into an accumulated effect in *The English at Home*, 1936), to which the text adds another dimension of critique. If Spender later realized the limitations of the commercial and class-determined enterprise of which he was a part, at the time he was intent not to belittle or ennoble but to remove his own preconceived constructs as far as was consciously possible to let life unfold before his camera:

*I believed that I was recording social history, revealing sociological truth. Only later did it dawn on me that the editorial policies behind the big town surveys were connected more with circulation and advertising than with serious anthropological research.*[260]

It is not the synchronized repetition of machines and bridges from the second more visually

sanitized Tyneside article that resonates most powerfully, but Spender's photograph of the harrowed couple in the alleyway staring with trepidation at the city architect.

Within *Picture Post* the "Big Town" surveys were packed among the varied array of interviews, reviews, and stories of movie stars, diplomats, artists, and zookeepers. The actual impact of these picture stories is not ascertainable; but as Stuart Hall notes, *Picture Post* developed a "distinctive 'social eye'" which evolved into war radicalism and, through Sir William Beveridge, Julian Huxley, and others, to the election and reforms of the Labour Party in 1945.[261] Although *Picture Post* "lacked the necessary language and political consciousness to make invisible social relations visible" it did help to create, along with M-O, a more open parliamentary democracy.[262]

Mass-Observation's Tom Harrisson teamed up with Humphrey Spender in April 1938 to write a text which accompanied Spender's photographs of Blackpool in "The Fifty-Second Week: Impressions of Blackpool," for the *Geographical Magazine*.[263] Unlike *Picture Post*, the *Geographical* did not run the gamut of diverse popular picture stories. It featured not mass entertainment but serious and more specialized in-depth articles written by professionals in the field. Paralleling the *National Geographic* magazine in America, the *Geographical Magazine* was supported by the Royal Geographical Society, which invested half of the funds from the sale of the magazine for geographical research. Therefore, the *Geographical* approach to the northern town of Blackpool, studied by the Mass-Observation crew, differed greatly from that of the *Picture Post* in format and visual emphasis.

The *Geographical*'s format size was nearly half that of *Picture Post*, making the photographic reproductions smaller in scale and, as a result, not as dominant visually. Although there are twenty-six of Spender's photographs in the story, the impact of text and image is not as forceful or as closely integrated as in Lorant's highly aestheticized layouts. Lorant's graphic acuity created "cinematic" or "narrative" storytelling sequences which visually overshadowed the text and seemingly surrounded the viewer's periphery, with the enlarged photographs bleeding to the edges of the pages; whereas the layout of pictures in the *Geographical* is more staid, static, and predictable, with margins around each picture, formally distancing us. The *Geographical*'s photographs were normally reproduced in only two standard sizes, and they were never overlapped or cropped in layout to

form collage-like units as in the *Post*. In addition, the photographs which are paired on a single page, or are face-to-face in a double spread, are arranged in terms of their matching subject matter rather than by their visual rhymes or related formal elements which reverberate regardless of content.

The text is conceptually and intellectually a more important element in the *Geographical* than in *Picture Post*, which usually would have subordinated it to the picture story. The nearly ten pages of Harrisson's text offer a lively and sustained encounter with the "vacationland" of the North and elaborate his theories of the cultural anthropological roots of mass behaviors, likes and dislikes, belief systems, and habits.

The story begins not with an image but with two pages of text and an explanatory introduction:

*Everyone has now heard of Mass-Observation …This survey included a summer's special study of Blackpool, and here he [Tom Harrisson] gives a preliminary and personal statement of part of its results. Many part- and whole-time observers co-operated, including painters and photographers under the general direction of Mr. Humphrey Spender.*[264]

Harrisson's article plunges us into textual excerpts from the Mass-Observers' personal tales of their stays in Blackpool, the summer vacation spot for the working classes of the northern industrial cities, including Bolton. Their unpaid, one-week vacation, the "Fifty-Second Week," was spent amidst a crowded carnival atmosphere, an endless cacophony of whirling amusements: sideshows, vaudeville acts, dancing, restaurants, children's rides, beaches, and fun houses. A map of northern

Britain orients the reader, as Harrisson outlines by what means the travelers arrive at Blackpool and what they will find once they arrive.

By the third page the photographs begin to follow sequentially the content of the text, starting with a full-page bird's-eye view from Blackpool's famous rising Tower. Neither sky nor horizon line is apparent, as the entire page is overtaken with caravan lines of automobiles paralleling the winding beach, packed with ant-sized bathers.

Two more pages of photographs follow, two photographs to a page, moving us closer to the arrival of the vacationers, placing us in the tram queues and on buses moving into the city. The bustle of the crowd is registered close-up as well as at a distance. The next few pages pair text and one photograph to each page: an overhead image of the horizonless beach packed with snack bars and horse-drawn carts filled with surf sightseers, and a vertically oriented over-the-shoulder, eye-level image of a couple viewing the sea from the boardwalk.

Harrisson's text describes the sideshows and attractions in detail, concluding with a warning that the character of Blackpool "is the price England pays for industrialisation—a price which is expanding everywhere" (including Harrisson's distant Melanesia by way of Leverhulme).[265] In support of his observation the midway's populist extravaganza is laid out in four photographs on two pages: horizontally paired close-ups of sideshow signs featuring "Fire Eating Arabs, Kiddies Ride, The Headless Woman, The Crown Jewels," and the "Cow With 5 Legs" (fig. 20). The focus on absurdist advertising signage is a feature of documentary which allies it with the Surrealists' urban grab bag of "found objects." The alternative reality

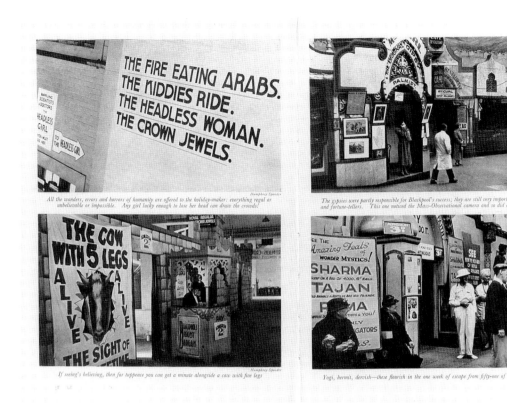

*All the wonders, errors and horrors of humanity are offered to the holiday-maker: everything regal or unbelievable or impossible. Any girl lucky enough to lose her head can draw the crowds!*

*The gypsies were partly responsible for Blackpool's success; they are still very important as magicians and fortune-tellers. This one noticed the Mass-Observational camera and so did a little palmistry*

*If seeing's believing, then for tuppence you can get a minute alongside a cow with five legs*

*Yogi, hermit, dervish—these flourish in the one week of escape from fifty-one of industrial reality*

FIG. 20  FROM "THE FIFTY-SECOND WEEK: IMPRESSIONS OF BLACKPOOL," *THE GEOGRAPHICAL MAGAZINE*, APRIL 1938

FIG. 21  EDWARD WESTON, *HOT COFFEE, MOJAVE DESERT*, 1937 GELATIN SILVER PRINT, THE MUSEUM OF MODERN ART, NEW YORK

offered up by the content of signs can create uncanny juxtapositions of text and setting, as in Edward Weston's *Hot Coffee, Mojave Desert*, 1937 (fig. 21) or Spender's own images of posters in the bleak streets of Bolton (cat. 32, ill.); while the signs themselves display qualities of line, shape, and texture which yield their own meanings. The two adjoining horizontally formatted photographs are taken at a distance to afford an integrated view of vacationers and the mass of signage and variety of exotic attractions. These images follow the point of view of a pedestrian wandering through the maze of sideshows, acutely angled and asymmetrically weighted visually to offer the casual stroller a passageway into deeper space.

Harrisson's text notes the vacationer's obsession with time: "There are few clocks or time-reminders in Blackpool, but observation showed that the amount of looking-at-watches or asking-the-time was tremendous."[266] While enjoying only one week's unpaid vacation, visitors would likely be aware of the passage of time and hence their eagerness to compress as much inexpensive entertainment as possible into a brief span of time. The compelling mechanical laughter of the "Big Clown" at the "Fun House" sets the tone of relentless gaiety, as seen in Spender's close-ups of mesmerized children and smiling adults unaware of the photographer's eye. Following these vertical images are familiar close-ups of women shoppers confounded by the array of goods in a vitrine and potential players

sizing up their chances on arcade machines (fig. 4). Harrisson's text reveals the reason behind this tentative window-shopping: on the average, five pounds is the total amount saved to spend on a week's vacation for a family of four. The impact or "price" of industrial, consumer society is evident in Spender's photographs in these pages.

The pictures loosely follow Harrisson's basic description of amusements, while his captions prove indispensable to explain underlying meanings or details of information not present in Spender's photographs. For example, the context of the Blackpool fairground hostess's image mentioned above (fig. 4, top right), a candid shot seemingly caught in the midst of activity, is clarified by Harrisson's caption: "Attractive girl. She is paid to sit there and attract. Masculine fellows impress by putting plenty of pennies into her employers' slot machines."[267] The providential appearance of a beautiful girl is a "plant," a fact we would not know without Harrisson's caption, thanks to his Mass-Observers' eavesdropping. Distanced photographs of "Noah's Ark," a children's ride, an eclectic, quasi-Baroque-cum-fantastical

"Casino," and a sleek modernist art-deco structure graphically represent Harrisson's verbal sketches of family entertainments. The bright summer sunlight renders people and their surroundings in brilliant light/dark contrast, with raking light endowing crisp outlines to volumetric forms. Spender employs this graphic contrast to create repeated rhythms and patterns which suggest a lively atmosphere and sense of visual movement as the story of Blackpool unfolds.

The article aptly draws to a close with a series of four small vertically stacked images of illuminated tableaux in which cascades of midway lights create outlines depicting fairy-tale characters and fragments from their stories. Spender's camera flattens their circles of light into follow-the-dots pictures. Concluding the visual narrative is another evening photograph with deeply-angled perspective indicated by curved bands of light receding into the distance (cat. 55, ill.). Harrisson ends his text on a slyly ironical note, describing Blackpool's Town Hall with its "superb bank of flowers around the feet of a less superb statue of Queen Victoria" and the city's motto, "Progress, 1867–1937." Once again inserting his own sociocultural concerns and theories about the city's obsessions with "Time" and "Death," Harrisson's text is generally subjective and personal, though it does include excerpts of opinions and survey information from Mass-Observers which aid in building context. Spender's photographs, in fact, seem to present a much less biased, less manipulative visual statement overall because they can be interpreted in so many different ways, optimistically or pessimistically. As Spender noted:

> *Tom Harrisson might wish to prove various things, but I was not going to get involved in that. I was aware that he was being attacked, very frequently, for trying to manipulate his observations, so I was taking great pains not to produce photographs merely as illustrations to theories of my own or theories Tom Harrisson had.*[268]

# PICTURE POST, WORLD WAR II

Seventeen months after World War II broke out, Humphrey Spender was drafted into the army to be trained for tank warfare in the Royal Army Service Corps. Soon he was commissioned (Second Lieutenant) as a War Office Official Photographer, and in late 1943, he was transferred to Photo-Interpretation, eventually working in the Theatre Intelligence Service. In the early 1940s, however, Spender worked on several war stories for *Picture Post*.

Early in the course of the war *Picture Post* produced a series of morale-boosting stories designed to bring the civilian populace to a closer understanding of the daily lives of their husbands, fathers, and sons fighting in the armed forces on all fronts. Spender's series of picture stories, "Life of a Coastguard," "A Day on a Minesweeper," "A Day with a Fighter Squadron," and "Life on a Destroyer" were each organized to present "inside," intimate accounts of daily routines, much like the civilian stories of doctors, nurses, parliamentarians, and diplomats which had been a feature of *Picture Post* prior to the war. Inevitably, the military censor had to vet all sensitive materials, but in every other respect these stories reflect an ongoing reportorial style begun by Lorant. And once again, Spender's training in the Mass-Observation project gave him the technical and conceptual skills to gauge accurately the nature of the specific challenges of these assignments. He would need to gain acceptance and trust, which in this case was quite easy, given the fact that the fighting men wanted their loved ones to see them alive and functioning in their new environment. But equally, it would be imperative that Spender not become an obstacle in the smooth running of a ship or a liability during an actual attack. In short, Spender was placed in

the role of a war correspondent, a dangerous, tenuous, and ethically-charged position. As Spender later noted, "I was lucky to have humorous sympathy and unpatronizing tolerance from the crew for whom I was an additional responsibility."[269]

In "Life on a Destroyer," July 20, 1940, Spender, working the usual week or more on assignment, set about his job by deciphering the varieties of tasks needed to be accomplished on a destroyer during the course of a day. Because of the cramped quarters he was unable to disguise his presence. Unless able to capture a candid photograph from above or behind the action, he was obliged to pose self-conscious sailors or attempt to become a "furniture" piece, striving to photograph some of the unconscious body language that develops among men working and relaxing together. Douglas MacDonald Hastings, who joined the full-time staff of *Picture Post* during this period,[270] wrote the text for the story, combining a factual laundry list of the specifications of the destroyer class and its capabilities, with a propagandistic, Empire-strengthening exhortation.[271]

Hopkinson, newly assigned as general editor with the departure of Lorant for America in July of 1940, consumed nearly the entire opening page of the story with Spender's photograph of a group of destroyer men huddled in their cramped, claustrophobic quarters, their faces betraying uneasiness and the intense anxiety of their jobs (fig. 22).[272] Although one smiling sailor is leaning back casually with his hand supporting his tilted head, the others glance off, looking away from the camera into the distance, pensive and preoccupied. Despite the fact that this is a posed group, the extreme stress of the conditions under which they live are revealed in

facial expressions and body language. The horizontality of the image, its tight framing, the spare lighting falling on the rhythmic forms of benches, shelves, and hammock, all increase the claustrophobia of the compressed, uncomfortable living situation. The following double-page layouts feature the hard work and diligence of the crew, their interaction with each other and with their "lethal machinery" of anti-aircraft guns and depth charges, and the dominating presence of the sea.

MacDonald Hastings's text emphasizes the strength and fighting power of the destroyer-class vessel, with its ability to defend merchant ships while annihilating enemy ships, aircraft, and U-boats. The destroyer is lightly armored, allowing it to travel at fighting speeds of forty miles per hour; hence its constant pitch and roll and corkscrew motions, which at times made life aboard a combination of seasickness, toil, and confinement. The sense of inclusion within that life is reinforced in the accompanying photographs by Spender's attention to point of view, framing, tones, and textures.

MacDonald Hastings assures his readers that German U-boats are not the sure annihilators they once were in the previous war due to the mysterious "Asdic," "the wonderful instrument which searches out the U-boats...Mr. Churchill has told the world—and the U-boats have learnt too late—that our ships are equipped with a mysterious something which probes out the enemy under the sea."[273] The bolstering of civilian morale called for MacDonald Hastings to emphasize new secret technologies to detect the U-boats, which were, in reality, a continuing and devastating menace to British ships and all sea vessels in the area. In fact, July 20, 1940, the date of this "Destroyer" issue, marks the date of

departure of "the last ship on which it would be possible for private individuals to book a passage"; the Atlantic had become too dangerous for travel. This last ship was the *Britannic* and among its passengers was Stefan Lorant heading for America.[274]

Spender's last two double-page spreads focus not on the gun-power of the destroyer but on the leisure activities on the ship: close-ups of men reading in bed, playing checkers, sewing, shaving, and smoking their naval-issue tobacco. The concluding two pages present the captain reading in his quarters, the coxswain selling tobacco and rum, officers asleep with their uniforms on, gunners reading and sunbathing, and sailors gathered on bunks, writing letters home to loved ones (fig. 23). Some photographs are obviously posed, while others focus on expressions caught unawares and unself-consciously. This final choice of photographs, featuring a semblance of stability, predictability, rest and relaxation, is the reader's last glance at the world of the sailor on his destroyer. These quiet, tranquil scenes are anomalous events in "a day in the life of a sailor" in wartime, but Hopkinson's selection for closure of the story reflects a concern for the worried families on the home front and the continued building of a social consciousness.

The arrangement of Spender's photographs for this series suggests the palpable feel of a strictly confined space, of uncomfortable conditions below, and of the imminent dangers as well as the overwhelming beauties of being on deck.[275] Close-up action photographs are arranged in double-page spreads to compress the rhythms and the sense of work, movement, and activity with more harmonious scenes grouped to offer a visual and mental relief from the tensions of the preceding shots. While we may be certain that many photographs were taken with the participants' full awareness, the effects

Vol. 8    No. 3.    PICTURE POST    July 20, 1940

**THE MEN WHO GUARD THE SEAS :** *Listening to the News in the Fo'c'sle of a Destroyer*
*Their job is to hunt U-Boats, to convoy our merchantmen, to patrol the coasts, to scout out the enemy. The nation looks to them to drive off the invader. But they've time to listen to the news first.*

# LIFE IN A
# DESTROYER

**In our island we prepare to face a siege. But the seas of the world are still open to us. And the task of keeping those seas clear of enemies and safe for our own ships falls, largely, on the men in the destroyers.**

NO island that commands the sea can ever be besieged. No Empire which has full access to the world's resources and which retains sea-power can finally be defeated. The Germans know this. The British would do well to remember it. The Germans showed that they knew it during the last war. They saw that we were too strong for them upon the surface of the sea, so they decided to go under it. They took to submarines. They built a vast under-water fleet. The under-water fleet was nearly successful—but not quite. After one of the narrowest shaves in our history we found the answer to the submarine. We kept our hold on the sea-routes of the world.

9

FIG. 22 FROM "LIFE IN A DESTROYER," *PICTURE POST*, JULY 20, 1940

**ABOARD A DESTROYER AT SEA** : *The Captain's Sea Cabin*
*The Captain has spacious quarters—two rooms and a bunk—but, at sea, he lives in a cubby hole on the bridge, eats when he can and sleeps with his clothes on.*

*The Coxswain's Stores : Tobacco for the Month is Issued*
*The Coxswain makes the daily rum issue and sells the monthly issue of naval tobacco to the crew. Each mess table in the fo'c'sle chooses a man to collect and pay for the issue.*

*Quiet Time in the Ward Room*
*The Ward Room is the officers' quarters, where they eat and sleep between watches. There is an ammunition store directly underneath them.*

*An After-Dinner Job*
*Above them swing their sleeping hammocks. Behind property. The table is where they eat—and when destroyer return*

*Writing A Letter Home*
*them are the compartments where they keep their their letters home. They will not post them until the to its base.*

—the rivets loosen under the strain in three years. Fuel costs, which are most economical at 20 knots, are trebled at 30, and quadrupled at 35 knots. At high speeds, a modern destroyer uses about 250 tons of oil at £3 a ton, a day.

In addition to fuel, the weekly wage bill for the crew is about £500. Food and ship's stores take another £250 a week. Altogether, a destroyer costs between £300,000 and £400,000 new (not much when one remembers that a battleship costs a cool 11 million) and, say, £100,000 a year to run (for a battleship, £400,000 a year). Our whole destroyer force has cost over £50,000,000.

As compensation for the discomforts of destroyer life, the commanding officers receive an extra one and sixpence a day "hard lying" money (up to the end of the last war, he was also privileged, on commissioning his ship, to draw a cask of pickled tongues). But it's not the additional pay that compensates him for the rigors of the life. It's something to do with destroyers.

Destroyers weave a spell over the men who sail them which outweighs all other considerations. The envy of the battleships say it's because the destroyer men are untidy devils who dislike dressing up in impeccable uniforms and submitting to the stern etiquette of life on the big ships. It's certainly true that the crews of destroyers dress for comfort rather than appearance. But that's not the reason.

Destroyer men are born, not made. They have a longing for little ships and an uncanny gift—denied to many a battleship captain—of managing their sensitive craft. Destroyers are personable ships which behave like mules if wrongly treated, and respond like blood horses in understanding hands. The men who man them know the exhilaration of thrashing a thousand tons of steel at 40 miles an hour through the seven oceans. Their ships are shaping history so far. This is a destroyer's war.

Douglas Macdonald Hastings.

*A Siesta for the Gun Crew*
*The gun platform of a destroyer is not the most comfortable spot for a sun bathe. But, on a destroyer, it's the only place to go.*

FIG. 23 FROM "LIFE IN A DESTROYER," *PICTURE POST*, JULY 20, 1940

are rarely stilted; the feeling of the "natural" or the "authentic" is present due to the photographer's technical skill and patience in choosing the exact moment of nuanced release or relaxation. Spender's varied experiences with the M-O project and the "Big Town" series at the *Post* had allowed him the time to develop his technique and aesthetic as well as honing his intuitive strategies, so that he was ready to deploy these skills under the stresses imposed by war photojournalism. Because of the quality of Spender's images, Hopkinson was able to compose a visual story which seems a natural, understated sequence of fragments, snapshots of everyday life, small particular moments which recur day after day on board a destroyer with individuals each playing their crucial roles.

In contrast, MacDonald Hastings's text is full of information about the destroyer vessel as a part of naval strategy, with no individual interviews or quotations from sailors or officers. The invincibility of "Empire" is underlined; and, finally, the destroyer's men are characterized in mythic terms as opposed to Spender's quite human and individual images:

> *Destroyers weave a spell over the men who sail on them which outweighs all other considerations…Destroyer men are born, not made. They have a yearning for little ships and an uncanny gift…of managing their sensitive craft. Destroyers are personable ships which behave like mules if wrongly treated, and respond like blood horses in understanding hands…These ships are shaping history so far.*[276]

The ship itself is anthropomorphized by MacDonald Hastings, and the men, "born, not made," metamorphose into mythic figures tied to their lethal ocean-going machines which are the *shapers* of history. No such native or natural tie is suggested by Spender's photographs. MacDonald Hastings's image of destroyers,

which are somehow capable of weaving "spells," parallels the myth of the Tynesider's machines, able to weave "spells" over men in Langdon-Davis's (or Tom Harrisson's) complex and often contradictory characterizations of men and their machines. The problematical relationships of men with their mechanical creations is a leitmotif for many thirties writers. In Valentine Cunningham's analysis of thirties' literary motifs and themes in Britain, he quotes Stephen Spender's 1933 *New Country*: "the action of the machine is really a model of the action of the human will."[277] The utopian pairing of human and mechanical wills is declared as well in Charles Madge's identification of the human body with machines and technological energy, which in turn burst into natural form in his Marxist-inspired 1933 poem, "Instructions":

> …
>
> *Our joy shall be as strong as the wheels of Dnieprstroi*
> *Deep in the racing blood revolving and dissolving*
> *Hard lumps of pain, electrolysing slumps.*
>
> *Along our cables flowing and in our streets going*
> *Into the houses breaking and the doors banging and shaking*
> *Marching along with drums and humming high in the pylons comes*
> *Power and the factories break flaming into flower.*[278]

# PICTURE POST, "DIEPPE," 1942

One of the greatest tactical miscalculations of the war occurred on August 19, 1942, at Dieppe, a small town set on the cliffs of the French coastline. Although the unnamed author of *Picture Post*'s article, "Dieppe: The Full Story," summarized the Dieppe raid as an "encouraging experience," in actuality the raid incurred heavy casualties (over 4,000 allied losses) and failed to attain most of its goals;[279] the strong defense system of the German occupiers of the Dieppe area was left solidly in place. The disastrous Dieppe raid had to be accounted for in the press, and *Picture Post* devoted ten pages to carrying "The Full Story," as the article was captioned.[280]

*Picture Post*'s critiques of laissez-faire government policy in the economic and social spheres, and its early criticism of the "Old Gang's" handling of civilian mobilization and the mismanagement of the early years of the "phoney war," committed the *Post* to a continuing activist responsibility to inform the public about issues which concerned their civic roles and government policies.[281] But once the war became a struggle for Britain's very existence, *Picture Post*'s policy tipped towards building civilian morale and tempering its criticism of the government's war strategies. And yet, as the Dieppe story unfolded, contradictions arose in the photo-story and questions were posed for the government by the *Post*'s writer.

The Dieppe "story" was featured on the cover of the *Post*, September 5, 1942 (fig. 24). The cover is a detail of a photograph by Spender, one of many he took of troops in formation as they arrived home, their ranks decimated from the nine-hour raid (cat. 99, ill.). In Spender's original photograph the walking wounded line up with other fortunate survivors from Lord Lovat's fourth commando section, which had engaged in fierce hand-to-hand combat. This section of the raid was one of the few successes in an otherwise devastating abortive nine hours.[282] Spender's point of view brings the viewer close enough to read details of individual gesture and expression, while his framing of the image by cutting-off the feet and the tops of the heads of the foreground figures pulls the viewer into the military line-up. The anonymous visual rhythms of the repeated shapes of boots and rifles belies the personal confrontation with the faces of the men, some of whom stare back at us.

Hopkinson decided to crop Spender's cover image to focus on an extreme close-up of the profile of one wounded commando whose head is bandaged. This close-up focuses the reader on a single individual, wounded but standing, a survivor who had taken blows but remains alert, symbolizing the indomitable will of the British people. Rather than allowing the disturbing thematic complexities and strong aesthetic energy of Spender's original photograph, Hopkinson distilled from it an image of iconic power which was more easily digestible as wartime propaganda.

The story itself opens with a three-quarter-page photograph looking down on the soldiers disembarking onto home soil after the raid. Stunned and exhausted, they glance up at Spender's camera, while waiting officers attempt to assess the damage and organize the survivors. Shock and disarray are communicated by body language and composition in an image which once again involves the viewer emotionally. The caption declares Dieppe the "biggest landing in Europe by the forces of freedom since France fell" but states that the raid "raises many questions. Some for the military authorities; Some for us all."[283] The rationale for the raid, according to *Picture Post*, was the need to test strategies for a Second Front, an allied invasion of German-occupied territories,

*a job which cannot be done on paper…We have admitted high casualties during the raid; we lost over ninety aircraft; we know that not all the objectives of the raid were attained… Was it worth the price in order to land on enemy-occupied soil for nine hours?*[284]

The answer offered by the text is that to "win the necessary knowledge and experience" to expel the Nazis from the continent, even "higher prices" may be called for. The *Post*'s perspective on the Dieppe defeat prepared the British for further high death tolls and sacrifices, while proposing that a strategy for invasion could be gained only through small-scale trials of various tactics.[285]

Continuing to "trace in pictures the whole course of action," the next double-page spread presents the preparations and early moments of the British offensive at Dieppe. In order to piece together and feign a semblance of "wholeness," the chosen photographs include a variety of close-ups of munitions' preparations along with distant air photographs of naval landing craft and hovering aircraft. The cinematic arrangement of close-ups contrasted with long panoramic sequences of action (probably agency photographs)[286] emphasizes the coordination of all the armed forces in an enormously complex effort. Spender's eye-level close-ups place the reader in the midst of preparation, while the agency photographers' panoramas are stock military views which geographically locate the troops and targets for the viewer. The following double-pages offer more of the same mix.

Despite the alertness and vigilance emphasized in Spender's close-ups of the attackers, the text reveals that the Germans had early on detected the approaching raid and immediately struck severe retaliatory blows. As the author stresses, "the wonder of the battle was the amount of success we won, not the elements of disappointing setback."[287] Highlighting the aircraft cover given the troops, at a tremendous cost of over ninety aircraft, a large reconnaissance photograph of Dieppe Harbour (with numbered and identified target areas annotated) is presented in conjunction with two focused moments: "Two soldiers are rescued by a sailor" and "The rescued men come aboard." The images must have been a painful reminder of Dunkirk only two years earlier.[288] Though pictures and captions are sequenced for the audience, implying an orderly series of events, chaos and confusion were rampant in actuality and were captured by Spender in candid action images of the hurried rescue and retreat presented in the closing double-page spreads.

"The Landing Force Returns" is a large-format photograph extending over two pages (fig. 25). The viewpoint is on the deck of a destroyer, caught in a tangle of ropes above the sea as a landing craft pulls up alongside. The precariousness of this position (ours and Spender's) conveys the feel of crossing over the water from one small perilous craft to the relative safety of another. To the lower right is a vertical photograph from a slightly higher vantage point, looking down as the wounded on stretchers are taken on board. The confusion is made palpable, and the intersecting angles heighten the drama. Two smaller horizontal views balance the spread at opposite corners, one of a Free-French fighter helping the troops aboard and another of a bandaged casualty being aided by his compatriots. The acute angles, the framed compression of elements,

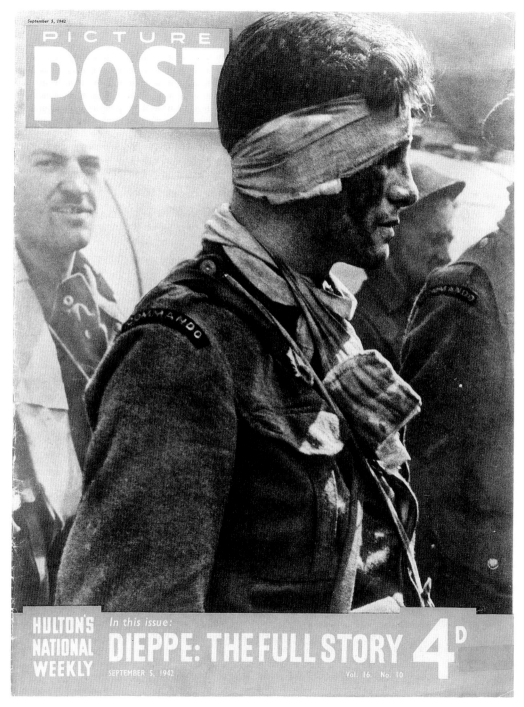

FIG. 24 COVER FROM *PICTURE POST*, SEPTEMBER 5, 1942

**Casualties are Treated as the Evacuation Goes On**
*A wounded man has had his wounds dressed and bandaged before reaching the destroyer. Below him other wounded lie on stretchers.*

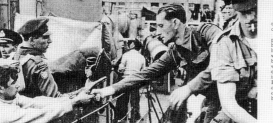

**THE LANDING FORCE RETURNS:** *Wounded Men Go on Board a Destroyer*
*These fighting men are torn and bleeding. Their rifles strew their landing craft. They climb to a destroyer whose lifeboat has been holed. But they have left the enemy with more deadly wounds.*

thud like the explosive growling of a volcano crater . . . "

While this section of No. 4 Commando was preparing to make the frontal attack on the German howitzers, its other section, led by Lord Lovat, had landed farther west by a wider dip in the cliffs with the object of trying to take the German battery in the rear. Suddenly there was a crash which Austin describes as the " father and mother of all explosions "; a mortar shell had landed slap in the middle of the German ammunition dump. Immediately afterwards, Lord Lovat's men swarmed over the battery from the rear. The men in front of the battery went in, noticing that the Germans had laid their barbed wire " carelessly ". But

" the battery defenders fought hard. To get at them the attackers had to cross open ground under fire from snipers. There fell two Commando officers, one killed and one seriously wounded, and several men. But once across the battery wire it was man to man in as fierce an all-in struggle as anywhere that day. Sniping from his office was Hauptmann und Batterie Fuehrer Schoeler, the battery C.O. A trooper kicked in the door and sprayed him with tommy-gun-bullets. ' Couldn't take him prisoner,' he said, ' it was him or me.' A trooper killed four Germans and got his section out of a nasty corner after his section leaders had been killed. It was as much a fight of bayonet as of bullet. Troopers barged in and out of battery

*Continued overleaf*

*(Left) One of the Fighting French*       *(Right) Stretcher Cases Arrive*

14

15

the ambient light, and the precarious positions from which Spender suspends himself and his camera insure the vitality and immediacy of the images, reinforcing the reality of a compelling rescue.

The vividness and personal focus of Spender's photographs are paralleled in the text by fragments of narration by Alan Humphreys, a Reuters Special Correspondent, whose words are highly descriptive of the frenzied activity and extreme urgency:

> I could just make out a figure silhouetted for an instant in the half-light. At the next moment we grounded on the shingle at full-tide, a few yards from the foot of the cold-looking, unscaleable, over-hanging chalk-white cliffs. That was the worst moment, as we all said afterwards. The assault craft grounded, hesitated, nosed a little to port, grounded again, and stayed put. As we blundered, bending, across the shingle to the cliff foot, a German machine-gun began to stutter from above. The Oerlikon guns from our support craft answered. Red-hot tracer bullets flashed past each other between cliff top and sea.[289]

The last two pages underline the quiet heroism and determination of the British soldiers as the wounded are helped to safety and the survivors "wait for trains to carry them back to camp," ready to fight again, as the article implies. Tank-landing craft are disembarked, most are empty, as tanks had to be abandoned and destroyed at Dieppe. Spender's photographs speak poignantly but indirectly of loss and death. The wounded shown are those able to walk. Blood and carnage are not a part of the visual story, only "weary men" and "exhausted commandos," who survive with the strength and resolve to fight another day. The message is clear:

> It would be rash on the score of a single battle to announce whether it proves that a Second Front is likely to succeed or not. What we can say of the Dieppe raid is that, for a single isolated battle, embarked upon with all the odds against us, it provided encouraging experience. That it provided evidence of the fighting quality of the troops we can send across the Channel when the real Second Front is opened goes without saying.[290]

By putting the "best face" on a disastrous raid for the sake of civilian morale, *Picture Post* narrated a palatable "story" of Dieppe during a dark period for the allied effort; on September 16 the Nazis marched to Stalingrad, while on November 8 the British and American forces invaded North Africa. The military censorship and self-censorship exercised during wartime tempered *Picture Post* policy towards criticism of the government's strategic role in the allied cause for the time being, securing the collective social consciousness in support of the larger struggle against Fascism. Spender's photographs for the Dieppe "story" supported, with visual "authority," the fact that a number of the troops had fought hard and survived. Hopkinson's layout created a sense of fullness and wholeness; the variety of images offered a sequenced visual "story" teeming with action and the evidence of the safe return of many soldiers. In addition, the accompanying text combined interview quotes, excerpts from Alan Humphreys's narration, and some factual information with a patriotic, anti-Fascist stance supporting the troops and the allied effort.

The popular reception of *Picture Post*'s World War II photo-stories was wide-ranging and deeply significant for some. As a youngster living in Bolton during the war, the son of a Mass-Observer, Larry Naughton, was one of many who perused *Picture Post* for current news from the front:

> PP was read by everyone who had 4d [fourpence] to spare. It must have been the publication most associated with the war, by far...I can recall clearly the photos of the war in Russia, the hundreds of thousands of Italian prisoners in N. Africa, and the first pictures of the Normandy landings...Its readership took in all classes, and its pictures—especially those of planes, tanks, bombing and bodies—attracted even the very young... Picture Post *complemented this idea of a more cohesive society working towards a better future.*[291]

# CONCLUSION

With an intuitive sensibility, a refined aesthetic eye, and a high level of technical skill, Humphrey Spender documented, for over two decades, the most ordinary of human relationships. Rare in his entire œuvre is the photograph of an empty street or an individual alone in a room. Spender's primary interest has been in the smallest details of interaction between neighbors, friends or foes, strangers, and families. As if taking a step back, with great deliberation, to peruse the scene for clues which might reveal the psychology at work or the threads of a narrative in progress, Spender has concentrated on the charged atmosphere between people and the communication of unspoken feelings expressed through gestures and the slightest articulation of movement. What happens in the physical and psychological spaces *between* people within a specific environment is a question which much of his work poses. The emphasis on the uniqueness of each human encounter and the open-ended quality of possible meanings are hallmarks of Spender's work as a photojournalist.

While the ambiguity and complexity of human relationships is Spender's favored subject matter, the technical properties of the camera and the aesthetic form which re-presents and interprets these transitory moments are of equal concern for the photographer. Intensive training in the technical aspects of his craft, including the printing of his own negatives, was begun at an early age with lessons from his older brother Michael, who worked for the Leitz Company. As Spender matured in the 1920s, the burgeoning "New Vision" aesthetic and the candid-camera approach of German photojournalism were critical in shaping his vision of what constituted a successful documentary photograph.

The predominant aesthetic and methodology of the "objective" or "disinterested" scientific approach was also an influence on Spender and his generation. Thus, Spender would early on provide photographic documentation in building probation cases. Information, equated with knowledge, could be accumulated by means of the camera, and the camera could become a tool for effecting social and political change. And yet, with this assumption arises the dilemma for the documentary photographer. Spender's aesthetic decisions, his arrangement of compositional elements, highlighted certain aspects of the scene, which in turn accentuated specific conditions and readings. These aesthetic qualities gave the images their memorable potency and rendered them effective instruments in evoking empathy, and thus in spurring reform. But how much aesthetic manipulation was too much? Spender opted for minimal technical intervention; averse to cropping, artificial light, retouching or posing, he preferred to wait for significant moments to occur spontaneously.

Spender attempted to the reconcile aesthetic imagination, Humanist ideals, and documentary evidentiary detail, recognizing at the same time that his perceptions and background shaded his split-second compositional decisions. The task was often contradictory and problematical. Spender was aware of his own class prejudices in the interpretation of situations for which he might have had no point of reference as an observer. The gulf between classes, between observer and observed divided by Orwell's glass wall, remained an impediment for many documentarians, Spender among them, despite their altruistic intentions. In addition, not wanting to intervene or influence the behavior of the observed, Spender was often forced to hide his photographic intentions. Although the goal was radical social reform, the duplicity of the means involved in the candid-camera approach often left Spender uneasy. Because he did not want to relinquish "all relationship" with those he photographed, Spender was left with moral and ethical dilemmas. These irreconcilable contradictions of means and ends were complicated further by the uses to which the documentary photograph could be put.

While Spender's nearly nine-hundred Mass-Observation photo-documents constitute, by any standard, a major photographic contribution to the period, much of this work went unnoticed or unpublished until the 1970s, when interest in Mass-Observation began to revive. As M-O could not afford to reproduce Spender's images, an entire body of work sat for many years, studied primarily by scholars of cultural anthropology or sociology. What *might* have been the effects of the publication of these visual images on British documentary as a whole we do not know. Their consistent aesthetic quality and acute observational nuances build a mosaic of hundreds of individual moments in the lives of Bolton and Blackpool residents. These invaluable, fragmented remnants accentuate the ephemerality of the lives, and a way of life, experienced in the tense and difficult period before the outbreak of World War II.

Spender's photography did reach the public through the photo-stories of *Picture Post*. While his work for publication explored much of the same industrial, urban subject matter that he had documented for M-O, many of his photographs for *Picture Post* were cropped, enlarged, or diminished in size. All those printed were arranged and captioned with accompanying text without the consultation of Spender and

without crediting him as the photographer until the mid 1940s. Although Stefan Lorant was a brilliant picture editor, his manipulation of Spender's photographs to form a cohesive story often altered their meanings or diluted their impact as individual pictures. By 1942 questions of the degree of conscious or unconscious aesthetic, social, and political coding, accompanied by concerns of the ethical and moral implications of these codings, made the job all the more conflict-ridden for Spender. As he noted in his 1982 interview with Jeremy Mulford, "I had to be an invisible spy—an impossibility which I didn't particularly enjoy trying to achieve."[292]

In addition, the war years had brought the death of his best friend and original studio partner, Bill Edmiston, as well as his brother Michael's death in an airplane crash the day after V-day. Most importantly, Spender's first wife, Margaret, died after a long illness in 1945, leaving in his care their young adopted son, David. These personal tragedies and concerns, together with the desire for new challenges, contributed to Spender's decision to return to painting and design after the war.[293] Only after a period of "stunned inactivity" did he resume freelancing for *Picture Post*, contributing sporadically to stories such as "The Windrush" (1947), "A Country of Dales" (1950), "The Best of Britain" (1950), "The Tropical Gardens of England," (1951), and "High Summer in Ageless Wiltshire" (1952).[294] As the titles for these stories suggest, the quiet pastoral splendors of the English countryside, thematically reminiscent of assignments for the *Daily Mirror*, were far from the issues and troubles of the industrial cities. The themes and tone of the social consciousness of documentary had altered after the post-war years, and Spender had moved on to develop other creative interests.

In 1948 Spender married the writer and actress Pauline Wynne, with whom he had a second son, Quentin.[295] He also had the good fortune to win a national textile competition in 1946, judged by Henry Moore. The design award gradually led to a career as a designer of textiles, carpets, mosaics, and murals. Spender devoted more and more time to designing textiles and painting until, in 1956, he became a tutor at the Royal College of Art in the Textile Department. He retired from full-time teaching in 1976 to paint in his studio in Maldon, where he continues to work in many media, exhibiting his paintings, drawings, and photographs.

Humphrey Spender played a significant part in the development and evolution of British documentary throughout the thirties and into the war years. His eager willingness to experiment, not only technically but conceptually, within totally unfamiliar, uncontrolled environments and situations marked his work early in his career. Spender contributed his own perspective to the new candid realism as well as to the refinement of the aesthetics of the photo-document. His continually honed technical ability allowed him to operate instinctively in varied surroundings.

In looking back on his work of the thirties, Spender recalls that his approach to photography was clear to him almost from the outset: "My feeling about the proper functions of the camera is that it should be primarily concerned with recording and providing information...The Worktown photographs were taken to provide information."[296] Thus, along with his aesthetic and technical concerns, Spender focused on the contexts of his work, on his vocation as a recorder of social situations. In order to transcribe this information as precisely as possible, patience, time, and technique are all significant factors: "What I admire most of all is something very rarely arrived at...expressed in a fusion of a profound knowledge of the capabilities of photography, the techniques of photography,

with the taking of a great deal of trouble." This philosophy and accompanying methodology have resulted in a body of work which Spender still views as very much embedded within its originating contexts, as a part of the fabric of the social document. Even today, the motivation for Spender to photograph arises out of this social need: "In so far as I still want to do photography in a public way, I want to use it to affect life, to improve life...I'm finding that pictures I've taken recently of the active destruction of the countryside have [prompted] me to carry on and do more, to go on using the camera."

His commitments to and sympathies with the people whom he photographed were profound and long-lasting. To this day he remains active in local and county-wide environmental groups and social and political causes. Spender recalls:

*just in normal living I do suddenly experience waves of identification and sympathy with certain people and situations that I see...I think perhaps that was a strong motivation in my photography...doing the job in Bolton, quite often I experienced that kind of sensation...It's a kind of identification that I experience most strongly if people are failing to do something.*

Humphrey Spender's brother Stephen would write in the autumn of 1938 of the new tasks, in such perilous times, of the creative writer, and one might infer, of all creative artists and photographers in equally dangerous eras:

*In what is essentially a revolutionary period, the task of the imaginative writer, whether he is a poet or novelist, is tremendous: it is to realise by every means at his disposal the nature of what is happening, and clarify this realisation for his audience.*[297]

In his photographs Humphrey Spender achieved his clarity of the "real" intuitively and empathetically, as an attempt to comprehend all that lay in front of and behind his camera.

# NOTES

1 Stephen Spender, "The Left Wing Orthodoxy," *New Verse*, no. 31–32 (Autumn 1938): 12.

2 David Mellor, *Humphrey Spender's Worktown Photographs of Bolton and Blackpool Taken for Mass-Observation, 1937–1938*, exhibition catalogue, Gardner Art Centre, University of Sussex, Falmer, Brighton, 1977.

3 Humphrey Spender, *"Lensman": Photographs 1932–1952* (London: Chatto and Windus, 1987); Ron Varley, *Mass-Observation* (Brentford, Middlesex: Watermans Art Centre, 1987).

4 *From Worktown to Our Town: Photographs of Bolton by John McDonald and Humphrey Spender*, Bolton Museum and Art Gallery, 1993; David Mellor, *Mass-Observation in Bolton: Humphrey Spender's Worktown Photographs*, exhibition catalogue (Bolton: Smithalls Hall Museum, 1994).

5 G. H. Saxon Mills, "Modern Photography, Its Development, Scope and Possibilities," *Modern Photography* (London: The Studio, Ltd., 1931), 9–10.

6 David Mellor notes Spender's visual references to *Modern Photography* in "London-Berlin-London: A Cultural History, 1927–1933," in *Germany: The New Photography* (London: Arts Council of Great Britain, 1978), 128; Spender, in perusing his copy of *Modern Photography* with the author on 1/26/96, noted the candid, slice-of-life qualities of Salomon's and Munkasci's photographs as being particularly influential.

7 Saxon Mills, 9.

8 John Keats quoted by Mary Price in *The Photograph: A Strange, Confined Space* (Berkeley: University of California Press, 1994), 166.

9 Saxon Mills, 9–10.

10 August Sander, "Lecture 5, Photography as a Universal Language," *The Nature and Growth of Photography*, typescript from a 1931 radio lecture, translated by Anne Halley in *Massachusetts Review* 19, no. 4 (Winter 1978), 675–76.

11 "New Objectivity" or "Neue Sachlichkeit" was a term coined in Germany in 1923 by Gustav Hartlaub, with general reference to a new painting philosophy which emphasized the rendering of concrete reality as opposed to a romantic, impressionist, or symbolist approach. An aesthetics of New Objectivity spread during the 1930s to Britain, as detailed by David Mellor in "Sketch for an Historical Portrait of Humphrey Jennings," in Mary-Lou Jennings, ed., *Humphrey Jennings: Filmmaker, Painter, Poet* (British Film Institute, 1982), 65–70.

12 Peter Galassi, *Before Photography: Painting and the Invention of Photography* (New York: Museum of Modern Art, 1981), 25.

13 For a detailed analysis of these issues see, Rosalind Krauss, "Photography's Discursive Spaces," *Art Journal* 42, no. 4 (Winter 1982): 311–19; Susan Sontag, *On Photography* (New York: Anchor Books Doubleday, 1977); Walter Benjamin, *Illuminations*, ed. Hanna Arendt (New York: Harcourt Brace Jovanovich, 1968), 217–51; Roland Barthes, *Camera Lucida: Reflections on Photography* (New York: Hill and Wang, 1994); and Mary Price, *The Photograph*.

14 Alan Sekula, *Photography Against the Grain: Essays and Photo Works, 1973–1983* (Halifax: Press of Nova Scotia College of Art and Design, 1984); Abigail Solomon-Godeau, *Photography at the Dock: Essays on Photographic History, Institutions, and Practices* (Minneapolis: University of Minnesota Press, 1991); Sally Stein, "Making Connections with the Camera: Photography and Social Mobility in the Career of Jacob Riis," *Afterimage* 10, no. 10 (May 1983): 9–16; Stuart Hall, "The Social Eye of *Picture Post*," *Working Papers in Cultural Studies*, no. 2 (Spring 1972): 71–120; John Taylor, "Picturing the Past," *Ten 8*, no. 11 (1983): 8–31; John Tagg, *The Burden of Representation: Essays on Photographies and Histories* (Minneapolis: University of Minnesota Press, 1988); Robert Taft, *Photography and the American Scene* (New York: Dover, 1964); Maurice Berger, *How Art Becomes History: Essays on Art, Society, and Culture in Post-New Deal America* (New York: Icon, 1992); Martha Rosler, " In, Around, and Afterthoughts (on Documentary Photography)," in *The Contest of Meaning: Critical Histories of Photography* (Cambridge: MIT Press, 1989), 303–40.

15 Saxon Mills, 9–10.

16 See critical analysis in Sekula, Rosler, and Berger as well as in period writings such as Siegfried Kracauer's, "Photography," in *Classic Essays on Photography*, ed. Alan Trachtenberg (New Haven: Leete's Island Books, 1980), 245–68, and Paul Nash's review of Karl Blossfeldt's photobook *Art Forms in Nature* in "Photography and Modern Art," in Mellor, ed., *Germany*, 22–24.

17 Ute Eskildsen, "Photography and the Neue Sachlichkeit Movement," in Mellor, ed., *Germany*, 111.

18 The term "photo-document" is used in this text to emphasize the fact that most of Spender's documentary photographs were intended for specific contexts, i.e., the Mass-Observation and *Picture Post* photo-stories.

19 Italo Calvino, "The Adventure of a Photographer," in *Difficult Loves* (New York: Harcourt Brace Jovanovich, 1984), 224–25.

20 "Significant Form" referred to the hierarchical importance of the isolated formal qualities of a work and was a term used often during the period; it is taken from Clive Bell's 1914 book, *Art*.

21 Lynda Morris and Robert Radford, *The Story of the Artists' International Association, 1933–1953*, exhibition catalogue (Oxford: Museum of Modern Art, 1983), 44.

22 For a detailed analysis of the influences and impact of British documentary on war radicalism and the 1945 elections, see Hall, 71–120; Tom Jeffrey, *Mass-Observation: A Short History* (Birmingham: University of Birmingham Centre for Contemporary Cultural Studies Occasional Papers, SP no. 55, 1978).

23 Humphrey Spender interviewed by Jeremy Mulford in *Worktown People: Photographs from Northern England, 1937–1938, by Humphrey Spender* (Bristol: Falling Wall Press, 1982), 21; this point was reiterated during the author's interview with Spender 1/20/95.

24 Mulford, 22.

25 Michael Spender was a photo-documentarian on the Oxford Expedition to the New Hebrides in 1932, where he joined Tom Harrisson, later of Mass-Observation, on an anthropological exploration; see David Mellor, "A Descriptive Chronology," in *Mass-Observation in Bolton*, 5; the Spender children were Michael, Stephen, Christine, and Humphrey; their mother became an invalid after giving birth to four children in too rapid a succession. She died by the time Humphrey was twelve years old, while his father died three years later (author's interview with Spender 1/24/96); Spender attended private schools in Worthing and Hampstead (Mulford, 11).

26 Author's interview with Spender, 1/24/96, at which time he stated that such life decisions were then in the hands of the adults of the house; his maternal grandmother was his guardian by 1925 because of his parents' early deaths.

27 Derrick Price, "Humphrey Spender," *Photography*, March 1989, 6–7; see also Mellor, "Chronology," 4–14; and Mellor, "London-Berlin-London," 113–31.

28 Spender has *Modern Photography* and *Photographie* in his Maldon studio.

29 Spender discussed Munkacsi's photograph in *Der Querschnitt*'s May 1931 issue with the author, 1/26/96; see also Mellor, "Chronology" and "London-Berlin-London."

30 In "New Vision" photography the camera delineated forms from new, unexpected, and unusual angles as well as employing the new technologies of the camera itself to expand the borders of human vision; see Maria Morris Hambourg and Christopher Phillips, *The New Vision: Photography Between the Wars* (New York: Abrams, 1989).

31 Valentine Cunningham, *British Writers of the Thirties* (New York: Oxford University Press, 1988), 230.

32 Author's interview with Spender, 1/26/96, at which time he perused his September 1931 issue of *Close-Up* (vol. 8, no. 3) and pointed out Lerski's portrait photographs on pages 222–23 and Lucia Moholy's portraits in *Photographie*; Lucia Moholy was a friend of his grandmother, who had introduced her to Spender (Mulford, 12).

33 Mellor, "Chronology" and "London-Berlin-London;" Spender still keeps many of these journals in his studio (1/26/96 author's interview with Spender); see Germaine Krüll's photographs employing over-the-shoulder views, high-angled views of the city, and deep one-point oblique perspective in Germaine Krüll, *100 X Paris* (Berlin: Verlag der Reihe, 1929), as indications of the pervasiveness of "New Vision" tropes.

34 These influences are cited by Mellor, "Chronology" and "London-Berlin-London"; and author's interviews with Spender, 1/20/95, 1/23/95 and 1/26/96; see also Van Deren Coke, *Avant-Garde Photography in Germany, 1919–1939* (New York: Pantheon, 1982).

35 Arthur Elton, "Realist Films To-day," *Left Review* 2, no. 9 (June 1936): 426–30; Paul Rotha, *Documentary Film* (London: Faber and Faber, 1935); Elizabeth Sussex, *The Rise and Fall of British Documentary* (Los Angeles: University of California Press, 1975).

36 Spender's correspondence with the author, 1/2/97.

37 Spender's correspondence with the author, 1/2/97.

38 Mulford, 12.

39 Michael Hallett, "Unobserved Observer," *The British Journal of Photography* (June 11, 1992): 14–15; Mulford, 13, Spender notes that he and Edmiston paid only six pounds a week for the studio in central London.

40 Author's interview with Spender, 1/25/96, at which time he indicated that, while photographing architecture as a student during this period, he recognized clearly the power of the camera "to lie" and to distort "reality."

41 Author's interview with Spender, 1/23/95.

42 Mulford, 14.

43 Author's interviews with Spender, 1/25/96, 1/26/96, and Mulford, 14. Ian Jeffrey notes that the *Mirror* discarded or lost all negatives and prints from this era in "Feeling for the Past," in Jennifer Hawkins and Marianne Hollis, eds., *Thirties: British Art and Design Before the War* (London: Arts Council, 1979), 110.

44 Mulford, 13; in the author's interview with Spender, 1/26/96, he referred especially to Clemence Paine, William Clarke Hall, and Basil Henriques. Spender explained that Clemence was the sister of the Spender children's "substitute mother," Winifred Paine. Winifred was not only responsible for the children but was an emotional tie for Humphrey, as both his parents had died early.

45 Mulford, 13; see also T. Jeffrey, 13; Spender exhibited in the Oxford Museum of Modern Art's exhibition of 1983, *The Story of the Artists' International Association, 1933-1953*, documenting a Leftist artists' organization.

46 Cunningham's chapter "In the Cage," 78–80.

47 Stephen Spender, "Fable and Reportage," *Left Review* 2, no. 14 (November 1936): 779; see also Stephen Spender, "The Left Wing Orthodoxy," *New Verse*, no. 31-32 (Autumn 1938): 12, and "Letter to Tom Harrisson," March 23, 1938, Mass-Observation Archive, University of Sussex, W43/G.

48 Graham Bell, "Escape From Escapism: Paintings in the London Group," *Left Review* 3, no. 2 (December 1937): 665.

49 Michael Roberts, ed., *Faber Book of Modern Verse* (London: Faber and Faber, 1965), 237, originally published in 1936.

50 Cunningham's chapter "Going Over," 211–40.

51 Cunningham, 260; Spender recounted an interesting incident to the author, 1/25/96, that sheds light on the issue of class and "going over" in which he and his colleague Geoffrey Grigson, while doing a story for *Picture Post*, "High Summer in Ageless Wiltshire," (August 23, 1952, 27–31) were detained for questioning and nearly arrested by the police, who mistook Spender and Grigson (presumably because of their accents, clothes, and demeanor) for the spies Guy Burgess and Donald MacLean.

52 Author's interviews with Spender, 1/24/96 and 1/25/96; Mulford, 13.

53 Tagg's *The Burden of Representation* discusses the evolution of photographs used to support liberal ameliorative reform movements, 129–47.

54 Tagg, 129–47; see also Stein's Jacob Riis essay in *Afterimage*; Sekula, *Against the Grain*; Solomon-Godeau, *Photography at the Dock*; Rosler, "In, Around, and Afterthoughts"; Berger, *How Art Becomes History*.

55 The author studied Spender's contact sheets, 1/23/95.

56 Mulford, 9–10, 16–17; author's interview with Spender, 1/23/95.

57 Councillor J. Ritson, Rev. Cecil Northcott, Richard Clements and George M. Lt. Davies, "The Listeners and the Unemployed," *Listener*, December 5, 1934, 942–44.

58 Mellor, "Chronology," 6; and author's interview with Spender, 1/24/96.

59 Author's interview with Spender, 1/20/95, and Mulford, 16–18.

60 *Listener*, December 5, 1934, 943–44.

61 "The Causes of the Great Depression," *Listener*, December 5, 1934, 942.

62 "The Men Baldwin Would Not See," *Left Review* 2, no. 15 (December 1936): 824–29.

63 Cunningham quotes Kathleen Raine, writing in *The Land Unknown* (London: Hamish Hamilton, 1975) that her future husband, Charles Madge, a founder of the Mass-Observation social survey, "had never seen the working class" until the day when the Jarrow Marchers came through Cambridge, where he was a student, 242.

64 Cunningham quotes MacLean from a 1978 interview in *Encounter* magazine that the Jarrow March was a turning point in his political education; he began to develop a psychological construct, the "cult" of the worker, as a substitute for an absent father figure, 242; Cunningham describes a "caring male proletariat" as a projection of sublimated needs for an absent, caring father figure for members of the Auden generation, 243–51.

65 Editorial, "The Turn of the Tide," *Left Review* 2, no. 15 (December 1936): 823 (the page preceding Spender's photographs).

66 Ibid.

67 In the author's interview with Spender on 1/25/96 he stated that he was not able to follow the entire march from Jarrow as he was working for the *Daily Mirror*, and so he followed the march only as it entered London.

68 "The Men Baldwin Would Not See," 824–25, 826, 823, 824–25, 829, 826.

69 T. Jeffrey, 8–12; see also Hall.

70 T. Jeffrey, 5–12.

71 Mellor, "Chronology," 5.

72 J. B. Priestley, *English Journey* (Chicago: University of Chicago Press, 1984), 232; this edition included photographs by Spender and other photographers; see also first edition (London: Heineman, 1934) (no photographs).

73 Priestley (1984), 305.

74 Rotha, 38, 39; see also Sussex, *The Rise and Fall of British Documentary*.

75 Solomon-Godeau, 299, cites Grierson as coining the term "documentary" in 1926 while reviewing Robert Flaherty's film *Moana*, which visually followed the daily routine of a Polynesian boy.

76 T. Jeffrey, 18, quotes Grierson; note also that Rotha's philosophy is reflected in Stephen Spender's essay "Left Wing Orthodoxy," which states: "Apart from the direct threat to freedom of expression, the writer is forced to realise that the liberal assumptions of progress and freedom which form the so respectable background of most bourgeois literature today, are being challenged by the violent and destructive methods of power politics. He must submit to this challenge, reconsider the moral assumptions that flow so easily into his writing, or come out with a new set of values...To put it bluntly, the orthodoxy which unites the writers of the Left should be a new Realism, a new realisation of the structure of society today, the relation of the society to the individual, an examination of the assumptions on which democratic societies exist...There is no more difficult problem to discuss than that of the nature of a writer's contact with reality...It is worth remembering that in such a world, truth is a land mine deeply tunnelled under every position and wherever it is struck, there is an explosion" (12–16).

77 John Grierson, "Documentary Films," *Listener*, August 14, 1937, 246.

78 Elton, "Realist Films To-day," 427.

79 Mellor, "Chronology," 6.

80 Elton, 430.

81 Ortega y Gasset's *The Revolt of the Masses* had been translated into English in 1932; Cunningham notes the emergence of the construct of "mass-man" during this period and the mania for recording "mass-man," 266–78.

82 See Berger, 12–18; also Solomon-Godeau, 176–81; Rosler, 304–25.

83 Quoted by William Abrahams and Peter Stansky, *London's Burning: Life, Death, and Art in the Second World War* (Stanford: Stanford University Press, 1994), 76.

84 Mellor, "Chronology," 6; in many of the period poems of Stephen Spender and Louis MacNeice as well as of Auden and David Gascoyne, the collaged fragments of concrete objects or everyday scenes are strung together abruptly as in a verbal montage; see also Geoffrey Grigson, *The Arts Today* (London: Bodley Head, 1935) and George Orwell, *The Road to Wigan Pier* (London: Gollancz, 1937).

85 John Taylor quotes Moholy-Nagy's preface in "Picturing the Past," *Ten 8*, no. 11 (1983): 8–31. Spender noted in correspondence with the author (1/2/97) that he "must have read Moholy-Nagy's preface, and been influenced by his remarks regarding the 'Beautiful' photograph, thus my abandonment of such pix (which I call B.P.s)."

86 Orwell quoted in Edwards, 17.

87 Orwell quoted in Cunningham, 236.

88 Stephen Spender, "Oxford to Communism," *New Verse*, no. 26–27 (November 1937): 9–10, see especially, 10, "From the point of view of the working class movement the ultimate criticism of Auden and the poets associated with him is that we haven't deliberately and consciously transferred ourselves to the working class. The subject of his poetry is the struggle, but the struggle seen, as it were, by someone who whilst living in one camp, sympathizes with the other; a struggle in fact which while existing externally is also taking place within the mind of the poet himself, who remains a bourgeois."

89 Orwell, *Road to Wigan Pier*, 154.

90 Nicholas Stanley discusses Tom Harrisson's directive to the Mass-Observers to become "cameras" in "The Extra Dimension: A Study and Assessment of the Methods Employed by M-O in its First Period, 1937–1940" (Ph.D. Thesis, Birmingham Polytechnic, 1981), 89.

91 Taylor notes that Gollancz financed Orwell's immersion into life among coal miners at Wigan Pier as well as Tom Harrisson's Mass-Observation survey in the thirties, 8–31.

92 For an account of the history of the LBC, see John Lewis, *The Left Book Club* (London: Gollancz, 1970); Gollancz also published Tom Harrisson's *Savage Civilization* in 1936.

93 Lewis, 17. Spender, a reader of LBC publications, noted that Lewis's statements reiterated his own belief that "photography was a good way of getting such knowledge," in correspondence with the author, 1/2/97.

94 T. Jeffrey quotes Gollancz's "liberal goodwill" and lack of structured political agenda, 11.

95 Mulford, 13.

96 T. Jeffrey, 2–4; see also Charles Madge and Humphrey Jennings, *May the Twelfth: Mass-Observation Day Surveys* (London: Faber and Faber, 1937).

97 Tom Jeffrey's *Mass-Observation: A Short History* traces the genesis and history of M-O through the post-war era and parallels M-O's development with other manifestations of British documentary. The Mass-Observation Archive at the University of Sussex in Falmer, Brighton, contains documents and manuscripts from M-O's inception through the present day.

98 T. Jeffrey, 2.

99 Charles Madge letter in *New Statesman and Nation*, January 2, 1937, 12–13.

100 Mellor, "Chronology," 7.

101 Harrisson, Madge, and Jennings, "Anthropology at Home," *New Statesman and Nation*, January 30, 1937, 155.

102 Ibid.

103 T. Jeffrey lists the headings from the Mass-Observation Archive, 50–52.

104 Harrisson, Madge and Jennings, "Anthropology at Home," 155.

105 Madge and Harrisson, Introductory Pamphlet, *Mass-Observation* (London: Frederick Muller, 1937), 10.

106 Harrisson noted how easy it was for him to go undercover in Bolton with his BBC accent by claiming "to have come from another dialect a few miles away," in Preface, *The Pub and the People* (Welwyn Garden City: Seven Dials Press, 1971), 6.

107 See T. Jeffrey, 2–4; Mulford, 6–8; Cunningham, 242–51; Mellor, "Chronology," 4–8; Edwards, 17–19.

108 Cunningham, 216–66.

109 Mellor's "Sketch for an Historical Portrait of Humphrey Jennings" discusses the role that this displacement and bifurcation played, having derived from the nineteenth-century moralizing traditions of Imperial culture, 170.

110 Mellor's "Chronology" quotes Harrisson's letter to Madge of September 23, 1939, from the M-O Archive, 5.

111 Cunningham discusses the "split-man" theme born of a crisis of identity (including Graham Greene and his protagonists) and quotes Eliot from his February 1924 article in *Criterion*, "We are, I know not how, double in ourselves," 218.

112 See Sekula's discussion, in *Photography Against the Grain*, 14–15, of Stieglitz's alienation from his narrow class upbringing, his rootlessness, and sublimation of identity.

113 Julian Trevelyan, *Indigo Days* (London: McGibbon and Kee, 1957), 81–83.

114 Tom Harrisson and Charles Madge, *First Year's Work, 1937-38* (London: Lindsay Drummond, 1938); Madge and Jennings, *May the Twelfth*; Harrisson and Madge, *Mass-Observation*; Tom Harrisson and Charles Madge, *Britain By Mass-Observation* (London: Penguin, 1939).

115 Charles Madge, "Poetic Description and Mass-Observation," *New Verse*, no. 24 (February/March 1937): 2.

116 Ibid.

117 Mellor, "Portrait," 65.

118 Trevelyan, 81–83.

119 T. Jeffrey, 3.

120 Tom Harrisson, *Savage Civilization* (New York: Knopf, 1937).

121 Mulford, 7; Mellor, "Chronology," 7.

122 Harrisson, *Britain Revisited*, 25.

123 Mellor, "Chronology," 7–9; Mulford, 7–8; *Pub and the People* (1987), xiv–xv.

124 In Sekula's *Mining*, 242, he notes that Pittsburgh's *The Survey*, which included Lewis Hine's documentary photographs of the urban poor, was dependent on the financial assistance of Paul Kellogg.

125 See T. Jeffrey's *History* and Varley's *Mass-Observation*.

126 During the war when M-O worked for the MOI assessing public concerns and morale, Madge left (in 1940) after disagreements with Harrisson over M-O's links with the government, Jennings was immersed in his work as a film maker, and Spender had left in 1938 to work for *Picture Post*. Madge later became Professor of Sociology at the University of Birmingham (Varley, 18–24; also T. Jeffrey, 37–44; Mulford, 8).

127 *The Pub and the People* (London: Gollancz, 1943), 2. Despite Harrisson's assertion of independence, at this time M-O was working for the MOI, especially Mary Adams, Head of Home Intelligence, Richard Crossman, and Lord Ritchie Calder, according to Varley, 19 and Mulford, 8.

128 *Britain in the Thirties*, 3.

129 *The Pub and the People* (1987), xvii.

130 T. Jeffrey, 22; also refer to Christopher Isherwood's use of the camera-eye in *Goodbye to Berlin* (Penguin, 1947), 7 (first published in 1930 in Isherwood's *Autumn Journal*), Mellor, "Chronology," 4.

131 Mulford, 15.

132 Mary Price quotes from Proust's *Remembrance of Things Past*, in her book *The Photograph*, 151.

133 Howard S. Baker, "Aesthetics and Truth," in *The Connecticut Scholar, The Creative Eye: Essays in Photographic Criticism*, Occasional Papers of the Connecticut Humanities Council, no. 4 (1981): 16.

134 Vicki Goldberg, "Ethics, the Camera, and Other Problems," in *The Connecticut Scholar*, 25.

135 James Agee quoted in Price, 121.

136 Goldberg, 25.

137 Mulford, 15; Spender even took a course in anthropology at the London School of Economics in preparation for a planned expedition to Borneo to record life, once again, for Harrisson's project (Mulford. 21).

138 Mulford, 21.

139 Ibid., 16–17; Spender recounts a determining incident for his leaving the *Daily Mirror*, when the art director insisted that, "If I tell you to go and photograph your brother in a pool of blood, you will do so," in Mulford, 14.

140 Mellor, "Chronology" quotes Bolton's Medical Officer of Health from his report to the Central Office of Information, 16.

141 Tom Picton and Derek Smith, "Humphrey Spender: Mass Observation Photographs," *Camerawork*, special issue, no. 11 (September 1978): 7; Mellor, "Chronology"; Barbara Ker-Seymour, photographer-colleague notes that Spender "moved in serious, literary circles," indicating Spender's milieu, 6.

142 Author's interview with Spender, 1/23/95.

143 Hall, 83.

144 Author's conversation with David Mellor, 1/22/96.

145 Mulford, 15.

146 T. Jeffrey, 19; see a discussion of issues of class in social observation in Taylor, "Picturing the Past."

147 *The Pub and the People* (1987), xi; Cunningham also discusses the literary realism of Charles Dickens's novels, 225.

148 Mulford, 7–8.

149 Lewis Hine, "Social Photography," in Trachtenberg, ed., *Classic Essays on Photography*, 113.

150 Tagg, 129–35.

151 "Urban picturesque" is Sally Stein's term for describing Jacob Riis's work as "altruistic commodity" in her revisionist study of documentary in *Afterimage*, 10.

152 Beaumont Newhall, *The History of Photography*, 5th rev. ed. (New York: Museum of Modern Art, 1982), 103.

153 *Creative Camera*, special issue, "The British Worker in Photography, 1839–1939," no. 197/198 (May/June 1981); see also *Creative Camera*, special issue, "Fifty Years of Picture Magazines," no. 211/212 (July/August 1982).

154 Thompson's and Smith's preface quoted by Newhall in *The History of Photography*, 103.

155 Varley, *Mass-Observation*, 5–27; see also Robert Lynd and Helen Lynd, *Middletown: A Study in Modern American Culture* (New York: Harcourt, Brace, 1929); Margaret Mead's *Coming of Age in Samoa*, 1927; and Bronislaw Malinowski's *Argonauts of the Western Pacific*, 1922, as long-term focused field studies, as opposed to armchair theory.

156 Sandra Phillips, *Helen Levitt*, exhibition catalogue (San Francisco: Museum of Modern Art, 1991), 33; see also James Agee and Walker Evans, *Let Us Now Praise Famous Men* (Boston: Houghton Mifflin, 1941), and William Stott, *Documentary Expression and Thirties America* (New York: Oxford University Press, 1973).

157 Picton and Smith, 6–7. Author's interview with Spender, 1/20/95; Spender developed his own films and made his own prints until recently.

158 Elizabeth McCausland, "Documentary Photography," *Photo News*, January 1939, 7.

159 Author's interview with Spender, 1/23/95.

160 See *May the Twelfth; First Year's Work, 1937-38; Mass-Observation* (London: Frederick Muller, 1937); *Britain by Mass-Observation*; Spender's photographs remained unused in M-O publications until a reprint of *The Pub and the People* in 1971 and in *Britain Revisited* in 1961. His photos were used in Tom Harrisson, "Fifty-Second Week: Images of Blackpool," *Geographical Magazine*, April 1938, 387–404; Tom Harrisson, "Whistle While You Work," *New Writing* 1 (Autumn 1938): 47–67; *Architectural Review*, March 1940; as well as *Listener* and *Left Review*.

161 Mulford, 8, 21; and reiterated in the author's interview with Spender, 1/24/96.

162 Mulford, 2.

163 T. Jeffrey, 28.

164 Ibid., 45.

165 Mulford, 127.

166 Author's interview with Spender, 1/26/96, in which he described becoming part of the "furniture" of a community; see also M-O Archive essays written by children concerning the topic of "Money" in Mellor, "Chronology," notes to photographs, 19.

167 See Tagg's discussions of slum imagery, 120–47.

168 Mulford, 125.

169 Ibid., 20.

170 Mellor, "Chronology," 9.

171 Author's interview with Spender, 1/26/96, at which time he recognized the Mass-Observer in the foreground.

172 Author's interview with Spender, 1/23/96; see Angus Calder and Dorothy Sheridan, eds., *Speak For Yourself: A Mass-Observation Anthology, 1937-1949* (Oxford: Oxford University Press, 1985), 21–22.

173 Mulford, 126–27.

174 Author's interview with Spender, 1/23/96.

175 Tagg, 129–48; Rosler, 304–8.

176 Bruce Laughton, *The Euston Road School* (Aldershot: Scolar Press, 1986), 137.

177 Ibid.

178 See Ian Jeffrey, ed., *Bill Brandt: Photographs, 1928–1983* (London: Thames and Hudson, 1993), images of Sheffield and Halifax, 124–27; see also Laughton film still from *Coal Face*, 112.

179 Tom Harrisson quotes residents of Bolton in "What They Think in Worktown," *Listener*, August 25, 1938, 399.

180 Mellor, "Chronology," 11.

181 T. Jeffrey, 31–34.

182 Harrisson and Madge, *Britain by Mass-Observation*, 77–78.

183 T. Jeffrey, 31.

184 Harrisson and Madge, *Britain by Mass-Observation*, 50.

185 All preceding critical responses quoted in Harrisson and Madge, *The First Year's Work, 1937-38*, 57–61. Spender noted in correspondence with the author, 1/2/97, that "W. Hickey was Tom Driberg."

186 Cunningham quotes Hanley's text, 225–26.

187 T. Jeffrey, 22.

188 T. Jeffrey, 36; note also that M-O, in 1949, became an independent market-research organization, T. Jeffrey, 46; Mulford notes that Harrisson had no qualms about beer manufacturers Guinness and Courage using studies published in *The Pub and the People* for their investigations of drinking habits, 8.

189 Charles Madge, "Drinking in Bolton," *New Writing* 1 (Autumn 1938): 46.

190 Paul Ray, *The Surrealist Movement in England* (Ithaca: Cornell University Press, 1971); Roland Penrose and Herbert Read, *International Surrealist Exhibition of 1936*, exhibition catalogue (London, New Burlington Galleries, June 11–July 4, 1936); *Britain's Contribution to Surrealism of the 1930s* (London: Hamet Gallery, 1971); Louisa Buck, *The Surrealist Spirit in Britain* (London: Whitford and Hughes, 1988).

191 Breton in Penrose and Read, 7–8.

192 Penrose and Read, 13.

193 Ray, 179.

194 Rosalind Krauss, *L'Amour Fou: Surrealism and Photography* (New York: Abbeville, 1985), 35, 85, 163.

195 Mellor, "Sketch for an Historical Portrait of Humphrey Jennings," 65–70.

196 Author's discussion with Mellor, 1/22/96.

197 Mellor, "Sketch," 66-69.

198 Mellor, "Chronology," 7; and author's interviews with Spender 1/20/95 and 1/23/95.

199 Author's interview with Spender, 1/26/96, at which time he recalled that seven people slept in this room at night.

200 Ray, 177–78; see also Raine, *The Land Unknown*.

201 Harrisson, *Britain Revisited*, 280; see also Charles Madge, "Oxford Collective Poem," *New Verse*, no. 25 (May 1937): 16–19; Madge and Humphrey Jennings, "Poetic Description and M-O," *New Verse*, no. 24, February-March 1937, 1–6; Julian Trevelyan's "Dreams," *transition*, March 1930, 120–23; and Trevelyan, *Indigo Days*.

202 Madge, "Oxford Collective Poem," 17.

203 Ibid., 16.

204 Bert Lloyd, "The Warning of Plymouth," *Picture Post*, May 17, 1941, 11; the author and photographer are not credited but verified by Spender in conversation with Bert Hardy's widow, Sheila Hardy, as noted in correspondence with the author, 1/2/97. Mellor in his "Chronology," 13, is in error in attributing Spender as the photographer and Harrisson as the author of the story.

205 Hopkinson had seen Spender's images of Bolton, Mellor, "Chronology," 11; reiterated in Mulford, with explanation of Spender's termination at the *Daily Mirror* for refusing to photograph Edith Sitwell in caricature fashion as an object of ridicule, 14; Hopkinson's role is discussed in Robert Kee's *The Picture Post Album* (London: Barrie and Jenkins, 1989).

206 Hopkinson's Oxbridge connections included, Harrisson, Madge, Jennings, Trevelyan, Bell, Gascoyne, Bronowski, Raine, Grigson, Auden, Stephen Spender, and Isherwood, among others.

207 Hopkinson quotes Lorant in Kee, *Picture Post Album*; in "The Men Who Started it All," Kee stresses Hopkinson's Oxford education and the influence of his father, a clergyman, n.p.

208 Hanno Hardt, "Pictures for the Masses: Photography and the Rise of Popular Magazines in Weimar Germany," *Journal of Communication Inquiry* 13, no. 1 (Winter 1989): 26; Tom Hopkinson, *Of This Our Time: A Journalist's Story* (London: Hutchinson, 1982), 148–74; and also Mulford, 14.

209 Tom Hopkinson, *Picture Post* (London, Allen Lane, 1970), 10.

210 Beaumont Newhall, "Photojournalism in the 1920s: A Conversation between Felix H. Man, Photographer, and Stefan Lorant, Picture Editor," in Newhall, *Photography: Essays and Images* (New York: Museum of Modern Art, 1980), 271–72.

211 Hopkinson, *Picture Post*, 11; Hardt, 26, notes that the first issue, October 1, 1938, sold out immediately at 750,000 copies, and that the number of pages increased from an initial 88 to over 100 before the war, with a circulation of 1.66 million in April of 1939.

212 Dominique Baqué, "Reality by Design: The Picture Press in France, 1920–1939," *Afterimage*, December 1989, 10.

213 Hall, 83.

214 Baqué, 10.

215 Stephen Edwards, "Disastrous Documents," *Ten 8*, no. 15 (1984): 12–23.

216 Mulford, 14.

217 Mulford, 12, 17.

218 Ada Barber, "Life in Lambeth Walk," *Picture Post*, December 31, 1938, 47–53.

219 Barber, Hopkinson's caption, 47.

220 Author's interview with Spender, 1/26/96, at which time he discussed the working procedure during the early years at *Picture Post*. Spender turned his film over to printer Edith Kay, with Lorant making the layout decisions. Little advice or direction was given about assignment goals or details by Hopkinson, whom Spender quoted as saying, "I want to learn from you, not you from me."

221 Author's interviews with Spender, 1/20/95 and 1/23/95, and in Spender's correspondence with the author, 1/2/97.

222 Tom Harrisson quotes Lupino Lane in *Britain By Mass-Observation*, 159.

223 Author's interview with Spender, 1/23/95; also reiterated in Spender, 'Lensman,' 9–22.

224 *Britain by Mass-Observation*, 140.

225 Author studied Spender's contact sheets, 1/23/95.

226 Mulford, 16.

227 Ibid.

228 *New Verse*, no. 17 October/November 1935): 16.

229 *New Verse*, no. 7 (February 1934): 3–4.

230 Mulford, 17.

231 Author's interviews with Spender, 1/20/95 and 1/23/95.

232 Michael Roberts, "Tyneside," *Picture Post*, December 17, 1938, 23.

233 Roberts, 26–27.

234 Hardt, 19; A. Corlett, *Mirror for the Masses*, exhibition catalogue (Newcastle: Newcastle upon Tyne Polytechnic, School of Art History, 1984), 10; and author's interview with Spender 1/23/95.

235 Roberts, 31.

236 Hall, 71–120; Taylor, 15–31; Edwards, 12–23; John Taylor, "The Meaning of Style," *Ten 8*, no. 9 (1982): 28–33; Huw Benyon, "Our Cultural History," *Ten 8*, no. 20 (1985): 4–13; Nick Hedges, "A Narrow Road," *Ten 8*, no. 5/6 (1981): 11–17; Ian Jeffrey, "Feeling for the Past, 109–20.

237 Note Bill Brandt's surrealist juxtapositions of rich and poor in his *The English At Home* (London: Batsford, 1936); see also Ian Jeffrey, ed., *Bill Brandt: Photographs, 1928–1983*.

238 Taylor, "The Meaning of Style," 28.

239 This oblique angle is very much a "New Vision" style; see Hambourg and Phillips, *The New Vision*.

240 See also "At Work on the Queen Mary," *Listener*, October 30, 1935, 751.

241 Roberts, 27.

242 Ibid., 28.

243 Solomon-Godeau, 176–79; Rosler, 307–9.

244 See Berger, 10–12.

245 Edwards, 15–17; and yet, see contemporary photographer Nick Hedges's photo-documents, which employ the same technique in "A Narrow Road."

246 Roberts, 17.

247 Ibid., 31.

248 Edwards, 22.

249 There is no author cited in the second article, but Spender remembers that Langdon-Davis was sent and wrote the text, author's interview with Spender, 1/25/96.

250 John Langdon-Davis, "Tyneside," *Picture Post*, March 4, 1939, 47.

251 Langdon-Davis, 53; poems of the period echo the human-machine parallel; see David Gascoyne's "Morning Meditation," in *New Verse*, no. 6 (December 1933): 11, "You are but one dot on the complex diagram." See also *Faber Book of Modern Verse*.

252 Langdon-Davis, 48–49; Emmeline Pankhurst (1858–1928) was an English suffragist leader.

253 It would seem more likely that Lorant and Hopkinson would opt for the archly ironic comment in support of Langdon-Davis's quotes from residents than in an unconditional surrender to the Lord Mayor's wishes.

254 Langdon-Davis, 51.

255 Samuel Hynes, *The Auden Generation* (London: Bodley Head, 1976), 264.

256 Graves and Hodge quoted in T. Jeffrey, 59.

257 Taylor, "Picturing the Past," 28.

258 Walter Benjamin, *Reflections*, ed. Peter Demetz (New York: Harcourt Brace Jovanovich, 1978), 230.

259 Taylor in "The Meaning of Style" quotes Sontag's *On Photography*, 31.

260 Spender, 'Lensman,' 21.

261 Hall, 89; Hopkinson, *Picture Post*, 14–15.

262 T. Jeffrey, 45.

263 Harrisson, "The Fifty-Second Week," 387–404.

264 Editor's introduction, in Harrisson, "Fifty-Second Week," 387. The editor was mistaken in stating that volunteers were under Spender's direction.

265 Harrisson, "Fifty-Second Week," 392.

266 Ibid., 396.

267 Ibid., 399.

268 Mulford, 15.

269 Spender, 'Lensman,' 21.

270 Hopkinson, *Of This Our Time*, 174.

271 Douglas MacDonald Hastings, "Life on a Destroyer," *Picture Post*, July 20, 1940, 9–19.

272 Hardt, 26.

273 MacDonald Hastings, 15–16.

274 Hopkinson, *Of This Our Time*, 171.

275 See Spender, 'Lensman,' 21: "Everything about those ships seemed menacing: the smells, the noise, stacked shells, torpedoes at the ready, the smoke, even sometimes the glittering sunshine. I was frightened and I was seasick."

276 MacDonald Hastings, 19.

277 Cunningham, 401.

278 Charles Madge, "Instructions," *New Verse*, no. 2 (March 1933): 5.

279 William Whitehead, *Dieppe 1942: Echoes of Disaster* (Toronto: Personal Library, 1979), 16; John P. Campbell, *Dieppe Revisited: A Documentary Investigation* (London: Frank Crass, 1993).

280 "Dieppe: The Full Story," *Picture Post*, September 5, 1942, 7–17.

281 T. Jeffrey, 33–37; Hall, 93.

282 Whitehead and Campbell.

283 "Dieppe," 7.

284 Ibid. See also Whitehead, 186; Campbell, xiv.

285 "Dieppe," 8. Campbell finds this reasoning "negligible," xiv.

286 Spender's correspondence with the author, 1/2/97, and reiterated in a telephone conversation on 1/10/97, at which time Spender noted that the distant, aerial, and panoramic photographs were probably taken by agency photographers.

287 "Dieppe," 10–11.

288 "Dieppe," 13; Whitehead's investigation found insufficient air support, 186.

289 "Dieppe," 13.

290 Ibid., 17.

291 Larry Naughton, personal correspondence with the author, 5/15/95, 4; Larry Naughton is the son of Bill Naughton, who had been a Mass-Observer and a lorry driver in Bolton in the Thirties. Bill Naughton went on to become a well-known novelist and playwright; among his works was the story of a cockney, *Alfie*. Larry Naughton is currently working on a biography of his father. For the impact of *Picture Post* in the war years, see also Hall; T. Jeffrey, 33–37.

292 Mulford, 16.

293 Author's interviews with Spender, 1/20/95 and 1/23/95.

294 Mulford, 15.

295 Pauline Spender eventually gave up her acting career to raise their two sons but continued, until quite recently, to write plays for BBC Radio.

296 This and the following quotations are taken from Mulford, 16–24.

297 Stephen Spender, "The Left Wing Orthodoxy," 12.

# BIBLIOGRAPHY

## BOOKS AND EXHIBITION CATALOGUES

Abrahams, William, and Stansky, Peter. *London's Burning: Life, Death, and Art in the Second World War.* Stanford: Stanford University Press, 1994.

Agee, James, and Walker Evans. *Let Us Now Praise Famous Men.* Boston: Houghton Mifflin, 1941.

Barents, Els, and W. H. Roobol. *Dr. Erich Salomon, 1886–1944: aus dem Leben eines Fotografen.* Munich: Schirmer/Mosel, 1981.

Barthes, Roland. *Camera Lucida: Reflections on Photography.* Translated by Richard Howard. New York: Hill and Wang, 1994.

Benjamin, Walter. *Illuminations.* Edited by Hannah Arendt. New York: Harcourt Brace Jovanovich, 1968.

— *Reflections.* Edited by Peter Demetz. New York: Harcourt Brace Jovanovich, 1978.

Berger, Maurice. *How Art Becomes History: Essays on Art, Society, and Culture in Post-New Deal America.* New York: Icon Editions, 1992.

Biggs, Lewis. *The Thirties and After: Documentary Photographs by Humphrey Spender.* Exhibition catalogue. Bristol: Arnolfini Gallery, 1982.

Breton, André. *Nadja.* Translated by Richard Howard. New York: Grove Press 1960.

*Britain in the Thirties: Photographs by Humphrey Spender with an introduction and commentary by Tom Harrisson.* London: Lion and Unicorn Press, Royal College of Art, 1975.

*Britain's Contribution to Surrealism of the 30s.* Exhibition catalogue. London: Hamet Gallery, 1971.

Buck, Louisa. *The Surrealist Spirit in Britain.* London: Whitford and Hughes, 1988.

Burgin, Victor, ed. *Thinking Photography.* London: Macmillan, 1982.

Calder, Angus, and Dorothy Sheridan, eds. *Speak For Yourself: A Mass-Observation Anthology, 1937–1949.* Oxford: Oxford University Press, 1985.

Calvino, Italo. *Difficult Loves.* New York: Harcourt Brace Jovanovich, 1984.

Campbell, John P. *Dieppe Revisited: A Documentary Investigation.* London: Frank Cass, 1993.

Carey, Frances, and Antony Griffiths. *Avant-Garde British Printmaking, 1914–1960.* London: British Museum, 1990.

Coke, Van Deren. *Avant-Garde Photography in Germany, 1919–1939.* New York: Pantheon, 1982.

Corlett, A. *Mirror For the Masses: A Look at Working Class Life in the 30s.* Exhibition catalogue. Newcastle Upon Tyne Polytechnic, School of Art History, 1984.

Cross, Gary. *Worktowners at Blackpool: Mass-Observation and Popular Culture in the 1930s.* London: Routledge, 1990.

Cunningham, Valentine. *British Writers of the Thirties.* New York: Oxford University Press, 1988.

Evans, Harold. *Eyewitness: 25 Years Through World Press Photographs.* London: Quiller, 1981.

Feaver, William. *Pitmen Painters: The Ashington Group, 1934–1984.* London: Chatto and Windus, 1988.

*From Worktown to Our Town: Photographs of Bolton by John McDonald and Humphrey Spender.* Exhibition catalogue. Bolton Museum and Art Gallery, 1993.

Galassi, Peter. *Before Photography: Painting and the Invention of Photography.* New York: Museum of Modern Art, 1981.

Gidal, Tim. *Modern Photojournalism: Origin and Evolution, 1910–1933.* New York: Macmillan, 1973.

Goldberg, Vicki. *Photography in Print: Writings from 1816 to the Present.* Albuquerque: University of New Mexico Press, 1988.

— *The Power of Photography: How Photographs Changed Our Lives.* New York: Abbeville, 1991.

Goldenstein, Ann, and Mary Jane Jacob. *A Forest of Signs: Art in the Crisis of Representation.* Cambridge: MIT Press, 1989.

Gowing, Lawrence. *William Coldstream.* London: Arts Council of Great Britain, 1962.

Grigson, Geoffrey, ed. *The Arts Today.* London: Bodley Head, 1935.

Hambourg, Maria Morris, and Christopher Phillips. *The New Vision: Photography Between the World Wars.* New York: Abrams, 1989.

Harrisson, Tom. *Savage Civilization.* New York: Knopf, 1937.

Harrisson, Tom, ed. *Britain Revisited.* London: Victor Gollancz, 1961.

Harrisson, Tom, and Charles Madge. *Britain by Mass-Observation.* Harmondsworth: Penguin, 1939.

— *First Year's Work, 1937–38.* London: Lindsay Drummond, 1938.

— *Mass-Observation.* London: Frederick Muller, 1937.

Harrisson, Tom, and Godfrey Smith. *The Pub and the People.* 1st ed. London: Victor Gollancz, 1943.

— *The Pub and the People: A Worktown Study by Mass-Observation.* 2nd ed. Welwyn Garden City: Seven Dials Press, 1971.

— *The Pub and the People: A Worktown Study by Mass-Observation.* 3rd ed. London: Cresset Library, 1987.

Hopkinson, Tom. *Of This Our Time: A Journalist's Story*. London: Hutchinson, 1982.

— *Picture Post*. London: Allen Lane, 1970.

Hynes, Samuel. *The Auden Generation: Literature and Politics in England in the 1930s*. London: Bodley Head, 1976.

Isherwood, Christopher. *The Berlin Stories*. New York: New Directions, 1963.

Jeffrey, Ian, ed. *Bill Brandt: Photographs, 1928–1983*. London: Thames and Hudson, 1993.

Jeffrey, Tom. *Mass-Observation: A Short History*. Birmingham, University of Birmingham Centre for Contemporary Cultural Studies Occasional Papers, SP no. 55, 1978.

Jennings, Mary-Lou, ed. *Humphrey Jennings: Filmmaker, Painter, Poet*. London: British Film Institute, 1982.

Jussim, Estelle. *The Eternal Moment: Essays on the Photographic Image*. New York: Aperture, 1989.

Kee, Robert. *The Picture Post Album*. London: Barrie and Jenkins, 1989.

Krauss, Rosalind, and Dawn Ades. *L'Amour Fou: Surrealism and Photography*. New York: Abbeville, 1985.

Krüll, Germaine. *100 X Paris*. Berlin: Verlag der Reihe, 1929.

Laughton, Bruce. *The Euston Road School: A Study in Objective Painting*. Aldershot: Scolar Press, 1986.

Lewis, John. *The Left Book Club*. London: Victor Gollancz, 1970.

Lynd, Robert S., and Helen M. Lynd. *Middletown: A Study in Modern American Culture*. New York: Harcourt, Brace, 1929.

Madge, Charles, and Humphrey Jennings. *May the Twelfth: Mass-Observation Day Surveys, 1937, by Over Two Hundred Observers*. London: Faber and Faber, 1937.

Mass-Observation Archive. The University Library, Universityof Sussex, Brighton BN1 9QL, UK.

Mellor, David. *Humphrey Spender's Worktown Photographs of Bolton and Blackpool Taken for Mass-Observation, 1937–1938*. Exhibition catalogue. Gardner Art Centre, University of Sussex, Falmer, Brighton, 1977.

— *Mass-Observation in Bolton: Humphrey Spender's Worktown Photographs*. Exhibition catalogue. Bolton, Smithills Hall Museum, 1994.

Mellor, David, ed. *Germany: The New Photography, 1927–1933*. London: Arts Council of Great Britain, 1978.

Mellor, David, and Ian Jeffrey. *The Real Thing*. Exhibition catalogue. London, Hayward Gallery, 1975.

*Metamorphose: British Surrealists and Neo-Romantics, 1935–55*. New York: Guillaume Gallozzi, 1992.

*Modern Photography*. London: The Studio Ltd., 1931, 1932, 1933.

Morris, Lynda, and Robert Radford. *The Story of the Artists' International Association, 1933–1953*. Exhibition catalogue. Oxford, Museum of Modern Art, 1983.

Mulford, Jeremy, ed. *Worktown People: Photographs from Northern England, 1937–1938, by Humphrey Spender*. Bristol: Falling Wall Press, 1982.

Newhall, Beaumont. *The History of Photography*. 5th rev. ed. New York: Museum of Modern Art, 1982.

Orwell, George. *The Road to Wigan Pier*. London: Victor Gollancz, 1937.

Penrose, Roland, and Herbert Read. *International Surrealist Exhibition of 1936*. Exhibition catalogue. London, New Burlington Galleries, 1936.

Peukert, Detlev J. *The Weimar Republic: The Crisis of Classical Modernity*. Translated by Richard Deveson. New York: Wang and Hill, 1993.

Phillips, Christopher, ed. *Photography in the Modern Era*. New York: Metropolitan Museum of Art/Aperture, 1989.

Phillips, Sandra S. *Helen Levitt*. Exhibition catalogue. San Francisco: San Francisco Museum of Modern Art, 1991.

*Photographie*. Paris: Arts et Métiers Graphiques, 1930.

Price, Mary. *The Photograph: A Strange, Confined Space*. Berkeley: University of California Press, 1994.

Priestley, J. B. *English Journey*. London: Heineman, 1934.

— *English Journey* (includes photos by Humphrey Spender). Chicago: University of Chicago Press, 1984.

Raine, Kathleen. *The Land Unknown*. London: Hamish Hamilton, 1975.

Ray, Paul. *The Surrealist Movement in England*. Ithaca: Cornell University Press, 1971.

Roberts, Michael, ed. *The Faber Book of Modern Verse*. London: Faber and Faber, 1965.

Rosen, Charles, and Henri Zerner. *Romanticism and Realism: The Mythology of Nineteenth-Century Art*. New York: Viking, 1984.

Rotha, Paul. *Documentary Film*. London: Faber and Faber, 1935.

Schrader, Bärbel, and Jürgen Schebera. *The "Golden" Twenties: Art and Literature in the Weimar Republic*. New Haven: Yale University Press, 1988.

Sekula, Allan (essay), and Leslie Shedden (photographs). *Mining Photographs and Other Pictures, 1948–1968*. Halifax: Press of Nova Scotia College of Art and Design, 1983.

— *Photography Against the Grain: Essays and Photo Works, 1973–1983*. Halifax: Press of Nova Scotia College of Art and Design, 1984.

— *Walker Evans and Dan Graham*. New York: Whitney Museum of American Art, 1992.

Solomon-Godeau, Abigail. *Photography at the Dock: Essays on Photographic History, Institutions, and Practices*. Minneapolis: University of Minnesota Press, 1991.

Sontag, Susan. *On Photography*. New York: Anchor Doubleday, 1977.

Spender, Humphrey. *'Lensman': Photographs 1932–1952*. London: Chatto and Windus, 1987.

Spender, Stephen. *World Within World*. New York: St. Martin's Press, 1994.

Stanley, Nicholas Sheridan. "The Extra Dimension: A Study and Assessment of the Methods Employed by M-O in its First Period, 1937–1940." Ph.D. Thesis, Birmingham Polytechnic, 1981.

Stott, William. *Documentary Expression and Thirties America*. New York: Oxford University Press, 1973.

Sussex, Elizabeth. *The Rise and Fall of British Documentary*. Los Angeles: University of California Press, 1975.

Szarkowski, John. *The Photographer's Eye*. New York: Museum of Modern Art, 1966.

— *Photography Until Now*. New York: Museum of Modern Art, 1989.

Taft, Robert. *Photography and the American Scene*. New York: Dover, 1964.

Tagg, John. *The Burden of Representation: Essays on Photographies and Histories*. Minneapolis: University of Minnesota Press, 1988.

Taylor, John. *A Dream of England: Landscape, Photography, and the Tourist's Imagination*. Manchester: Manchester University Press, 1994.

Trachtenberg, Alan. *The American Image: Photographs from the National Archives, 1860–1960*. New York: Pantheon, 1979.

Trachtenberg, Alan, ed. *Classic Essays on Photography*. New Haven: Leete's Island Books, 1980.

Trevelyan, Julian. *Indigo Days*. London: McGibbon and Kee, 1957.

Varley, Ron. *Mass-Observation*. Brentford, Middlesex: Watermans Art Centre, 1987.

Whitehead, William. *Dieppe 1942: Echoes of Disaster*. Toronto: Personal Library, 1979.

Wyatt, Woodrow. *Into the Dangerous World*. London: Weidenfeld and Nicholson, 1952.

## ARTICLES

Baker, Howard S. "Aesthetics and Truth." *The Connecticut Scholar, The Creative Eye: Essays in Photographic Criticism*, Occasional Papers of the Connecticut Humanities Council, no. 4 (1981): 11–18.

Baqué, Dominique. "Reality by Design, The Picture Press in France, 1920–1939." *Afterimage*, December 1989, 10–12.

Bell, Graham. "Escape From Escapism, Paintings in the London Group." *Left Review* 3, no. 2 (December 1937): 663–66.

Benyon, Huw. "Our Cultural Heritage." *Ten 8*, no. 20 (1985): 4–13.

Blunt, Anthony. "How I Look at Modern Art." *Listener*, July 14, 1938, 74–75.

Bone, James. "Glasgow Revisited." *Listener*, October 1935, 750–52.

Boseley, Sarah. "Thatcher Clue in Writings of Little Islanders: Sarah Boseley Looks at the Mass-Observation Archive Revived a Decade Ago." *Guardian*, January 1, 1990, 9.

Clark, Kenneth. "The Future of Painting." *Listener*, October 2, 1935, 543–44, 578.

Clements, Richard. "Lightening the Black Country's Burden." *Listener*, December 5, 1934, 943–44.

Coombes, B. L. "What Life Means to Me." *Left Review* 2, no. 15 (December 1936): 828–29.

*Creative Camera*, special issue. "Fifty Years of Picture Magazines," no. 211/212, July/August 1982.

— "The British Worker in Photography, 1839–1939," no. 197/198, May/June 1981.

Duffus, R. L. "Getting at the Truth about an Average American Town." *New York Times Book Review*, January 20, 1929, 3.

Edwards, Stephen. "Disastrous Documents." *Ten 8*, no. 15 (1984): 12–23.

Elton, Arthur. "Realist Films To-day." *Left Review* 2, no. 9 (June 1936): 426–30.

Gascoyne, David. "Morning Dissertation." *New Verse*, no. 6 (December 1933): 11.

Goldberg, Vicki. "Ethics, the Camera, and Other Problems." *The Connecticut Scholar, The Creative Eye: Essays in Photographic Criticism*, Occasional Papers of the Connecticut Humanities Council, no. 4 (1981): 23–32.

Hagen, Charles. "Photographs and Time." *The Connecticut Scholar, The Creative Eye: Essays in Photographic Criticism*, Occasional Papers of the Connecticut Humanities Council, no. 4 (1981): 33–39.

Hall, Stuart. "The Social Eye of *Picture Post*." *Working Papers in Cultural Studies*, no. 2 (Spring 1972): 71–120.

Hallett, Michael. "Unobserved Observer." *British Journal of Photography* (June 11, 1992): 14–15.

Hardt, Hanno. "Pictures for the Masses: Photography and the Rise of Popular Magazines in Weimar Germany." *Journal of Communication Inquiry* 13, no. 1 (Winter 1989): 6–29.

Harrisson, Tom. "Anthropology at Home." *New Statesman and Nation*, January 30, 1937, 155.

— "The Fifty-Second Week: Impressions of Blackpool." *Geographical Magazine* (April 1938): 387–404.

— "What They Think in Worktown." *Listener*, August 25, 1938, 398–400.

— "Whistle While You Work." *New Writing* 1 (Autumn 1938): 47–67.

Hedges, Nick. "A Narrow Road." *Ten 8*, no. 5/6 (Spring 1981): 11–17.

Isherwood, Christopher. "The Isherwood Affair." Excerpt from *Christopher and His Kind*. *Sunday Times Weekly Review*, March 27, 1977, 33.

— "Wystan and Christopher." Excerpt from *Christopher and His Kind*. *Sunday Times Weekly Review*, April 3, 1977, 33.

Jeffrey, Ian. "Feeling for the Past: Photo-journalism." In *Thirties: British Art and Design Before the War*, edited by Jennifer Hawkins and Marianne Hollis, 109–20. London: Arts Council of Great Britain, 1979.

Joyce, Paul. "The Journey Home." *British Journal of Photography* (July 9, 1982): 720–23.

Kent, Sarah. "Slumming It." *Time Out*, August 6–13, 1982, 9–10.

Kerrick, Jean S. "The Influence of Captions on Picture Interpretation." *Journalism Quarterly* 32 (1955): 177–88.

Krauss, Rosalind. "Photography's Discursive Spaces." *Art Journal* 42, no. 4 (Winter 1982): 311–19.

Lindsay, A. D. "Helping the Unemployed to Help Themselves." *Listener*, July 13, 1932, 34–35, 71.

Loetscher, Hugo. "Wochenende." *Neue Zürcher Zeitung*, no. 90 (18/19 April, 1981): 61-65.

MacNeice, Louis. "Birmingham." *New Verse*, no. 7 (February 1934): 3–4.

Madge, Charles. "Drinking in Bolton." *New Writing* 1 (Autumn 1938): 46.

— "Instructions." *New Verse*, no. 2 (March 1933): 4–7.

— "Letter to Mr. Geoffrey Pyke." *New Statesman and Nation*, January 2, 1937, 12-13.

— "Oxford Collaborative Poem." *New Verse*, no. 25 (May 1937): 16–19.

— "Poetic Description and Mass-Observation." *New Verse*, no. 24 (February/March 1937): 1–6.

— "Surrealism for the English." *New Verse*, no. 6 (December 1933): 14–18.

McCausland, Elizabeth. "Documentary Photography." *Photo News*, January 1939, 7.

McClarence, Stephen. "The Quiet Observer: An Interview with Humphrey Spender." *Photographers' Magazine*, August-October 1979, 3–6.

Nash, Paul. "Abstract Art." *Listener*, August 17, 1932, 242.

— "Photography and Modern Art." In *Germany: The New Photography, 1927–1933*, edited by David Mellor, 22–24. London: Arts Council of Great Britain, 1978.

Naughton, Larry. Personal Correspondence, May 15, 1995, 1–4.

Newhall, Beaumont. "Photojournalism in the 1920s: A Conversation between Felix H. Man, Photographer, and Stefan Lorant, Picture Editor." In *Photography: Essays and Images*, 271–75. New York: Museum of Modern Art, 1980.

Osman, Colin. "Kurt Hutton." *Creative Camera Yearbook*, 1976, 194–228.

Peachey, John. "Another Time." *Amateur Photographer*, September 26, 1992, 14–17.

Phillips, Christopher. "The Judgment Seat of Photography." In *October: The First Decade, 1976–1986*, edited by Annette Michelson, 257–93. Cambridge: MIT Press, 1987.

Phillips, Sandra. "Magazine Photography in Europe Between the Wars." *Picturescope*, Fall/Winter 1982.

Picton, Tom. "Four Peen'orth of Hope." Interview with Tom Hopkinson and Bert Hardy. *Camerawork*, no. 5 (February 1977): 8–9.

Picton, Tom, and Derek Smith. "Humphrey Spender: Mass-Observation Photographs." *Camerawork*, special issue, no. 11 (September 1978): 6–9.

Price, Derrick. "Humphrey Spender." *Photography*, March 1989, 6–7.

Read, Herbert. "Ben Nicholson and the Future of Painting." *Listener*, October 9, 1935, 604–5.

— "Soviet Realism." *Listener*, October 2, 1935, 579.

Riis, Jacob A. "Introduction to 'The Battle with the Slum,' 1902." In *An American Primer*, edited by Daniel J. Boorstin, 665–72. Chicago: New American Library, 1966.

Robertson, Grace. "Humphrey Spender." *Creative Camera* 1 (January 1988): 9–11.

Rosler, Martha. "In, Around, and Afterthoughts (on documentary photography)." In *The Contest of Meaning: Critical Histories of Photography*, edited by Richard Bolton, 303–40. Cambridge: MIT Press, 1989.

Sander, August. "Lecture 5: Photography as a Universal Language." In *The Nature and Growth of Photography*. Typescript from a 1931 radio lecture. Translated by Anne Halley. *Massachusetts Review* 19, no. 4 (Winter 1978): 674–79.

Spender, J. A. "I Knew a Man, Mr. Gladstone." *Listener*, April 7, 1937, 631–33, 663.

Spender, Stephen. "Easter Monday." *New Verse*, no. 17 (October 1935): 16.

— "Fable and Reportage." *Left Review* 2, no. 14 (November 1936): 779–82.

— "The Left Wing Orthodoxy." *New Verse*, no. 31–32 (Autumn 1938): 12–16.

— "Letter to Tom Harrisson." March 23, 1938, Mass-Observation Archive, University of Sussex, W43/G.

— "Oxford To Communism." *New Verse*, no. 26–27 (November 1937): 9–10.

Stein, Sally. "Making Connections with the Camera: Photography and Social Mobility in the Career of Jacob Riis." *Afterimage* 10, no. 10 (May 1983): 9–16.

Taylor, John. "The Meaning of Style." *Ten 8*, no. 9 (1982): 28–33.

— "Picturing the Past." *Ten 8*, no.11 (1983): 8–31.

— "Public Views–Private Lives." *Ten 8*, no. 11 (1983): 36–38.

Taylor, John Russell. "The Thirties and After." *Times*, August 3, 1982, 12.

Tisdall, Caroline. "The Real Thing." *Guardian*, review, March 1975, 15.

Trevelyan, Julian. "Dreams." *transition*, March 1930, 120–24.

Webb, W. L. "The Wasting of Worktown." *Guardian*, February 18, 1982, 7.

## PICTURE POST ISSUES WITH SPENDER PHOTO-STORIES

October 15, 1938, William Cameron, "Whitechapel," 23–28, 72.

November 5, 1938, John Betjeman, "London's Bohemia," 29–34.

December 17, 1938, Michael Roberts, "Tyneside," 23–31.

December 31, 1938, Ada Barber, "Life in the Lambeth Walk," 47–53.

January 7, 1939, Tom Harrisson, "Birth of a Dance," 45–49.

January 21, 1939, Harold King, "Birmingham," 44–51.

March 4, 1939, John Langdon-Davis, "The Lord Mayor of Newcastle Shows Us Tyneside," 47–53.

April 1, 1939, Andrew Lothian, "Glasgow," 43–51.

July 15, 1939, "Deep Sea Trawler," 12–19.

July 29, 1939, "Bristol," 18–25.

August 19, 1939, "Portsmouth," 43–51.

September 9, 1939, Douglas MacDonald Hastings, "Harvest," 54–57.

February 17, 1940, J. T. Murphey, "Blackout By-Election," 15–17.

March 23, 1940, Douglas MacDonald Hastings, "A Day on a Minesweeper," 17–23.

April 20, 1940, "A Day with a Fighter Squadron," 33–37.

July 20, 1940, Douglas MacDonald Hastings, "Life on a Destroyer," 9–19.

November 23, 1940, "The Coming Winter," 14–15.

December 7, 1940, John Tunnard, "Life of a Coastguard," 9–13.

September 5, 1942, "Dieppe: The Full Story," 7–17.

August 8, 1942, "An Army Clerk Toughens Up," 10–26.

September 27, 1947, Robert Henriques, "The Windrush," 14–17.

July 15, 1950, Margaret Lane, "The Best of Britain," 24–27.

September 23, 1950, Garry Hogg, "A Country of Dales," 18–23.

April 7, 1951, "The Tropical Gardens of England," 11–15, 41.

August 23, 1952, Geoffrey Grigson, "High Summer in Ageless Wiltshire," 27–31.

# CATALOGUE OF THE EXHIBITION

Unless otherwise noted, works in the exhibition are gelatin silver prints of photographs by Humphrey Spender, lent by the photographer. The photographs of Bolton and Blackpool taken for Mass-Observation are reproduced with the permission of the Bolton Museum and Art Gallery. Photographs taken for *Picture Post* are reproduced with the permission of the Hulton Getty Picture Collection.

Dates indicate when the photographs were taken; with the exception of cat. nos. 12 and 60, the exhibition prints were made within the past three years by Danny Chau Photolabs, London. Measurements are given in inches followed by centimeters; height precedes width. The photographs marked "illustrated" are reproduced together at the back of the catalogue; works marked "illustrated" with a figure number are reproduced within the text.

## EARLY WORKS, 1933–1936

**1**
*Christopher Isherwood, Lützowplatz, Berlin,* 1933
13 ⅞ x 9 ⅝ (35.2 x 24.4)
ILLUSTRATED

**2**
*Lützowplatz, Berlin,* 1933
13 ⅞ x 9 ½ (35.2 x 24.1)
ILLUSTRATED

**3**
Mock-up of *Goodbye to Berlin* dust-jacket,
c. 1939
Cropped photograph with lettering in white ink
8 ⅛ x 7 ½ (20.6 x 19)
Board of Trustees of the
Victoria and Albert Museum, London

**4**
*Stephen Spender, Insel Rügen,* 1933
13 ¼ x 8 ⅞ (33.7 x 22.5)
ILLUSTRATED

**5**
*Country Fair, Rye, Sussex,* 1933
9 ⅝ x 14 (24.4 x 35.6)
ILLUSTRATED

**6**
*Chimneys, Stepney,* 1934
9 ½ x 13 ⅞ (24.1 x 35.2)
ILLUSTRATED

**7**
*Washerwomen, Stepney,* 1934
17 ½ x 11 ¾ (44.5 x 29.8)
ILLUSTRATED

**8**
*Mother and Daughter, Stepney,* 1934
14 ⅜ x 9 ¾ (36.5 x 24.8)
ILLUSTRATED

**9**
*Women and Prams, Stepney,* 1934
9 ⅞ x 14 ½ (25.1 x 36.8)
ILLUSTRATED

**10**
*Man Reading a Newspaper, Stepney,* 1934
9 ⅝ x 14 (24.4 x 35.6)
ILLUSTRATED

**11**
*Empty Bedroom, Stepney,* 1934
10 x 14 ¾ (25.4 x 37.5)
ILLUSTRATED

**12**
*Hitler Youth in a German Town,* c. 1934
8 ⅛ x 6 ⅛ (20.6 x 15.7)
Printed by Humphrey Spender, c. 1934
Board of Trustees of the
Victoria and Albert Museum, London

**13**
*Slate Quarries, Dinorwic, Wales,* c. 1935
9 ⅜ x 13 ⅞ (23.8 x 35.2)
ILLUSTRATED

14

*Tyneside*, 1936

9 7/8 x 14 1/4 (25.1 x 36.2)

ILLUSTRATED

15

*Jarrow Hunger Marchers Approaching Trafalgar Square*, 1936

13 7/8 x 9 5/8 (35.2 x 24.4)

ILLUSTRATED

16

*Jarrow Hunger Marchers, Trafalgar Square, 1936*

9 3/4 x 14 3/8 (24.8 x 36.5)

ILLUSTRATED

17

*Jarrow Hunger Marchers, Trafalgar Square, 1936*

9 5/8 x 14 (24.4 x 35.2)

ILLUSTRATED

18

*Market Day, Sudbury*, 1937

9 1/2 x 13 7/8 (24.1 x 35.2)

ILLUSTRATED

MASS-OBSERVATION, 1937–1938

19

*Tom Harrisson in Davenport Street, Bolton, 1937*

9 3/4 x 14 1/2 (24.8 x 36.8)

20

*Tom Harrisson with Mass-Observers, Bolton, 1937*

9 7/8 x 14 1/2 (25.1 x 36.8)

ILLUSTRATED

21

*Grape's Hotel, Bolton*, 1937

9 1/4 x 13 5/8 (23.5 x 34.6)

ILLUSTRATED

22

*Pub, Bolton*, 1937

9 1/2 x 14 1/8 (24.1 x 35.9)

ILLUSTRATED

23

*Dominoes in the Pub, Bolton*, 1937

9 3/4 x 14 1/2 (24.8 x 36.8)

ILLUSTRATED

24

*Woman Scrubbing Doorstep, Bolton*, 1937

9 1/4 x 13 1/2 (23.5 x 34.3)

ILLUSTRATED

25

*Wash on the Lines, Bolton*, 1937

9 1/4 x 13 1/2 (23.5 x 34.3)

ILLUSTRATED

26

*Wasteland, Bolton*, 1937

9 3/4 x 13 7/8 (24.8 x 35.2)

ILLUSTRATED

27

*Catapult Kids, Bolton*, 1937

9 1/2 x 13 7/8 (24.1 x 35.2)

ILLUSTRATED

28

*Children in Paper Hats, Bolton*, 1937

9 1/2 x 13 7/8 (24.1 x 35.2)

ILLUSTRATED

29

*Children during By-Election, Bolton*, 1937

9 1/4 x 13 1/2 (23.5 x 34.3)

ILLUSTRATED

30

*Children in Paper Hats, Bolton*, 1937

9 5/8 x 13 7/8 (24.4 x 35.2)

ILLUSTRATED

31

*Children, Beer Barrels, and Church, Bolton, 1937*

14 x 9 5/8 (35.6 x 24.4)

ILLUSTRATED

32

*"Christ Is Risen," Bolton*, 1937

9 1/4 x 14 (23.5 x 35.6)

ILLUSTRATED

**33**

*Sunday Congregation, Bolton*, 1937

9 5/8 x 14 1/4 (24.4 x 36.2)

**34**

*Public Library, Bolton*, 1937

10 1/2 x 15 3/8 (26.7 x 39.1)

**35**

*Women Leaving Factory, Bolton*, 1937

9 3/8 x 13 1/2 (23.8 x 34.3)

ILLUSTRATED, FRONTISPIECE

**36**

*Open Market, Bolton*, 1937

14 1/2 x 9 7/8 (36.8 x 25.1)

ILLUSTRATED

**37**

*Open Market, "Truth Is Stranger than Fiction," Bolton*, 1937

15 x 10 (38.1 x 25.4)

ILLUSTRATED

**38**

*Working Man's Hair Specialist, Bolton*, 1937

9 5/8 x 13 7/8 (24.4 x 35.2)

ILLUSTRATED

**39**

*Baby Getting a Bath, Bolton*, 1937

9 1/4 x 13 1/2 (23.5 x 34.3)

ILLUSTRATED

**40**

*Funeral, Bolton*, 1937

9 3/8 x 13 1/2 (23.8 x 34.3)

ILLUSTRATED

**41**

*William Coldstream Painting on the Roof of the Art Gallery, Bolton*, 1938

9 3/8 x 13 1/2 (23.8 x 34.3)

ILLUSTRATED

Spender recorded William Coldstream painting his view of the town (cat. 43) in April 1938. At the same time Graham Bell was at work on his view of Bolton (cat. 44). Another photograph (reproduced in Lawrence Gowing and David Sylvester, *The Paintings of William Coldstream 1908–1987*, exhibition catalogue, London, Tate Gallery, 1990, p. 110) shows Coldstream and Bell together on the roof with Bell at work on his painting.

**42**

*View from the Art Gallery, Bolton*, 1938

10 1/2 x 15 5/8 (26.7 x 39.7)

ILLUSTRATED

**43**

William Coldstream (1908–1987)

*Bolton*, 1938

Oil and graphite on canvas

28 1/4 x 36 (71.3 x 91.3)

National Gallery of Canada, Ottawa
Gift of the Massey Collection of English Painting, 1946

ILLUSTRATED, FIG. 6

Coldstream, invited by Tom Harrisson to paint Bolton as part of Mass-Observation, worked on his painting from the roof of the Art Gallery from April 19 to May 10. When Harrisson took a photograph of the painting around the pubs of Bolton to solicit comments, there were complaints, according to Julian Trevelyan,

"generally on the lines that humanity was absent. 'We're dead, we are,' they said." (Julian Trevelyan, *Indigo Days*, Aldershot, Hants: Scolar Press, 1996, originally published 1957, p. 87)

**44**

Graham Bell (1910–1943)

*Thomasen Park, Bolton*, 1938

Oil on canvas

20 x 24 (50.9 x 61)

Yale Center for British Art, Paul Mellon Fund

ILLUSTRATED, FIG. 7

In a letter of April 22, 1938, Bell referred to the pictures he and Coldstream were painting: Coldstream's as "a sandy children's playground with rows and rows of little red dirty houses swathed in smoke behind it" and his own "of the grimy little park with cotton mills and smoke and the inevitable slums." (Quoted in Bruce Laughton, *The Euston Road School: A Study in Objective Painting*, Aldershot: Scolar Press, 1986, p. 190).

**45**

Graham Bell

*The Café*, 1937–38

Oil on canvas

47 1/2 x 35 1/2 (120.7 x 90.2)

Manchester City Art Gallery

ILLUSTRATED. FIG. 5

Bell depicts the Café Conte in Goodge Street in London, a popular haunt of the Euston Road School artists, a number of whom appear in the painting (see Laughton, p. 137).

FIG. 26   JULIAN TREVELYAN, *BOLTON MILLS*, 1938, COLLAGE, PEN, AND INK
BOLTON MUSEUM AND ART GALLERY

FIG. 27   HUMPHREY SPENDER
*INDUSTRIAL LANDSCAPE
WITH PYLONS*, 1938
OIL ON CANVAS
LEICESTER GALLERIES, LONDON

FIG. 28   HUMPHREY JENNINGS, *ALLOTMENTS, BOLTON*, c. 1944–45, OIL ON CANVAS
BOLTON MUSEUM AND ART GALLERY

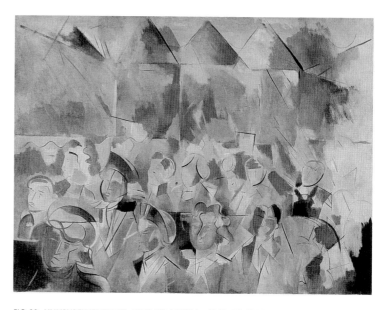

FIG. 29   HUMPHREY JENNINGS, *LISTEN TO BRITAIN*, c. 1949, OIL ON CANVAS
BOLTON MUSEUM AND ART GALLERY

**46**

Graham Bell
*Mass-Observation Sketchbook*, 1938
Pencil, pen and ink, and watercolor
85 pages, 9 x 7 (22.9 x 17.8)
Bolton Museum and Art Gallery

Bell and Coldstream intended to paint a series
of Bolton subjects; however, apart from their
paintings from the roof of the Art Gallery
(cat. 43 and 44) none progressed beyond
sketches.

**47**

Julian Trevelyan (1910–1988)
*Bolton Mills*, 1938
Collage, pen and ink
15 ¼ x 22 ¼ (38.7 x 56.5)
Bolton Museum and Art Gallery

ILLUSTRATED, FIG. 26

Trevelyan, who had worked in Paris in the early
1930s and had contributed three paintings to the
International Surrealist Exhibition in London in
1936, was recruited by Tom Harrisson to paint
Bolton for Mass-Observation in 1937. As
Trevelyan later recalled, "At this time I was
making *collages;* I carried a large suit-case full
of newspapers, copies of *Picture Post,* seed
catalogues, old bills, coloured papers and other
scraps, together with a pair of scissors, a pot of
gum, and a bottle of indian ink. I was applying
the *collage* techniques I had learnt from the
Surrealists to the thing seen, and I now tore up
pictures of the Coronation crowds to make
cobblestones of Bolton." (*Indigo Days,* p. 84)

**48**

Humphrey Spender
*Industrial Landscape with Pylons*, 1938
Oil on canvas
24 x 16 (61 x 40.6)
The Leicester Galleries, London

ILLUSTRATED, FIG. 27

Julian Trevelyan noted that at the time Spender
was taking his photographs of Bolton, "he was
also beginning to paint strange, almost Surrealist
views of the tram lines and the complex wire-
scape of Bolton against a background of sinister
decay." (*Indigo Days,* pp. 96–97).

**49**

Humphrey Jennings (1907–1950)
*Allotments, Bolton,* c. 1944–45
Oil on canvas
17 ¼ x 21 (43.8 x 53.3)
Bolton Museum and Art Gallery

ILLUSTRATED, FIG. 28

Jennings was an organizer of the International
Surrealist Exhibition in 1936 and a documentary
filmmaker for John Grierson's General Post
Office film unit. Mass-Observation called on his
skills as a writer, editor, and compiler but not as
an artist or filmmaker. However, he later turned
his stay in Bolton for Mass-Observation to
artistic account in paintings such as this one.

**50**

Humphrey Jennings
*Listen to Britain,* c. 1949
Oil on canvas
30 ¼ x 40 ¼ (76.8 x 102.2)
Bolton Museum and Art Gallery

ILLUSTRATED, FIG. 29

In his 1942 film Listen to Britain for the
Crown Film Unit, Jennings drew on his Mass-
Observation experience in creating a portrait
of English life in wartime. This painting is based
on a still from the film.

**51**

*Pier, Blackpool,* 1937
9 ⅝ x 13 ⅞ (24.4 x 35.2)

ILLUSTRATED

**52**

*Boat Cars and Oyster Carts, Blackpool,* 1937
13 ⅝ x 9 ¼ (34.6 x 23.5)

ILLUSTRATED

**53**

*Arcade Game, Blackpool,* 1937
9 ⅝ x 13 ⅞ (24.4 x 35.2)

ILLUSTRATED

**54**

*Midway Clowns, Blackpool,* 1937
9 ¼ x 13 ½ (23.5 x 34.3)

ILLUSTRATED

**55**

*Evening, Blackpool*, 1937
10 x 14 ¾ (25.4 x 37.5)
ILLUSTRATED

**56**

Tom Harrisson
"The Fifty-Second Week:
Impressions of Blackpool"
*The Geographical Magazine*, vol. VI, no. 6
(April 1938), pp. 387–404
Sterling Memorial Library, Yale University

Twenty-six of Spender's Mass-Observation
photographs of Blackpool, including cat. 54
and 55, were reproduced as illustrations to
Harrisson's article.

PICTURE POST YEARS, 1938–1942

**57**

*Eights Week, Cambridge*, 1938
9 ½ x 14 (24.1 x 35.6)
ILLUSTRATED

This photograph was part of a proposed article
on Cambridge for *Picture Post*, which was
never run.

**58**

*Aggressive Fascism, Italy*, 1938
9 ½ x 14 ¼ (24.1 x 36.2)
ILLUSTRATED

**59**

*John Banting in Lenk, Austria*, 1938
9 ⅝ x 14 (24.4 x 35.6)
ILLUSTRATED

Spender took cat. nos. 59 and 60 during a skiing
holiday in Austria with his friend the surrealist
painter John Banting. Standing outside a hotel in
which Heinrich Himmler and his retinue were
staying, Banting registers his disgust with the
hotel's Nazi occupants.

**60**

*The Arrival of German Troops into Innsbruck
Is Greeted with Mixed Emotions*, 1938
Two photographs: 4 ¾ x 7 ⅝ (12.1 x 19.3)
and 6 ⅝ x 9 ⅝ (16.9 x 24.6)
Printed by Humphrey Spender, c. 1938
Board of Trustees of the
Victoria and Albert Museum, London

**61**

*"Vienna Today! London?" Whitechapel*, 1938
9 ⅞ x 14 ½ (25.1 x 36.8)
ILLUSTRATED

**62**

*All-In Wrestling, Whitechapel*, 1938
9 ⅞ x 14 ⅜ (25.1 x 36.5)
ILLUSTRATED

**63**

*Card Players, Whitechapel*, 1938
9 ⅞ x 14 ½ (25.1 x 36.8)
ILLUSTRATED

**64**

*Woman Busker with Street Organ, Whitechapel*,
1938
14 x 9 ½ (35.6 x 24.1)
ILLUSTRATED

**65**

*New Writing*, new series, 1 (Autumn 1938)
Edited by John Lehman, with the assistance of
Christopher Isherwood and Stephen Spender;
illustrations chosen and arranged with the
assistance of Humphrey Spender
London: The Hogarth Press, 1938
Collection of Humphrey Spender

Four photographs by Humphrey Spender
appeared in the volume, including two of street
scenes in Whitechapel. In addition to works
by W. H. Auden, Stephen Spender, and Louis
MacNeice, the volume also contained a poem
by Charles Madge, "Drinking in Bolton," and
an essay by Tom Harrisson, "Whistle While You
Work," based on Mass-Observation material.

**66**
John Betjeman
"London's Bohemia"
*Picture Post*, November 5, 1938, pp. 29–34
Collection of the author

As with all of his work for *Picture Post* in this period, Humphrey Spender's photographs for this story appeared uncredited in the text.

**67**
*Royal Turk's Head, Tyneside*, 1938
9 7/8 x 14 1/2 (25.1 x 36.8)
ILLUSTRATED

**68**
*Newcastle United Football Club Changing Rooms, Tyneside*, 1938
14 x 9 3/8 (35.6 x 23.8)
ILLUSTRATED

**69**
*Unemployed Men Picking for Coal on a Slag-Heap, Tyneside*, 1938
9 7/8 x 14 1/2 (25.1 x 36.8)
ILLUSTRATED

**70**
*Children in the Rubble, Tyneside*, 1938
9 3/4 x 14 3/8 (24.8 x 36.5)
ILLUSTRATED

**71**
Michael Roberts
"Tyneside,"
*Picture Post*, December 17, 1938, pp. 23–31
Collection of the author

**72**
*The Feathers Pub*, Lambeth, 1938
9 3/8 x 13 3/4 (23.8 x 34.9)
ILLUSTRATED

**73**
*The Feathers Pub*, Lambeth, 1938
9 7/8 x 14 1/2 (25.1 x 36.8)

**74**
*Eel and Pie Saloon, Lambeth*, 1938
9 7/8 x 14 3/8 (25.1 x 36.5)
ILLUSTRATED

**75**
*Woman Cleaning Pavement, Lambeth*, 1938
9 7/8 x 14 1/2 (25.1 x 36.8)
ILLUSTRATED

**76**
*Lambeth Street Market*, 1938
9 7/8 x 14 1/2 (25.1 x 36.8)
ILLUSTRATED

**77**
Ada Barber
"Life in the Lambeth Walk"
*Picture Post*, December 31, 1938, p. 53
Collection of the author

**78**
*Market Hall, Birmingham*, 1938
9 3/4 x 14 1/2 (24.8 x 36.8)
ILLUSTRATED

**79**
*Navigation Street, Birmingham*, 1939
9 7/8 x 14 1/2 (25.1 x 36.8)
ILLUSTRATED

**80**
*Commercial Travellers' Dance, Birmingham*, 1939
9 3/8 x 14 (23.8 x 35.6)
ILLUSTRATED

**81**
*City Architect, Anxious Tenants, Tyneside*, 1939
9 1/8 x 13 1/2 (23.2 x 34.3)
ILLUSTRATED

**82**
*National Provincial Bank, Tyneside*, 1939
9 7/8 x 14 1/2 (25.1 x 36.8)
ILLUSTRATED

**83**
*Saint James's Park, London*, 1939
9 3/4 x 14 (24.8 x 35.6)
ILLUSTRATED

Spender took this photograph in connection with a proposed article on London parks for *Picture Post*, which was never run.

**84**
*Street Bookstall, Glasgow*, 1939
14 1/2 x 9 7/8 (36.8 x 25.1)
ILLUSTRATED

**85**

*Balmano Brae, Glasgow*, 1939

9 7/8 x 14 1/2 (25.1 x 36.8)

ILLUSTRATED

**86**

*Bristol Soup Kitchen*, 1939

9 7/8 x 14 1/2 (25.1 x 36.8)

ILLUSTRATED

**87**

*Bristol Soup Kitchen*, 1939

9 3/4 x 14 1/2 (24.8 x 36.8)

**88**

*Merchant Seamen's Almshouse, Bristol*, 1939

14 3/8 x 9 7/8 (36.5 x 25.1)

ILLUSTRATED

**89**

*Pub Scene with Sailors, Portsmouth*, 1939

9 7/8 x 14 3/8 (25.1 x 36.5)

ILLUSTRATED

**90**

*Mme. Walker's Academie of Dance and Elocution, Portsmouth*, 1939

9 7/8 x 14 3/8 (25.1 x 36.5)

ILLUSTRATED

**91**

*English Summer, Portsmouth*, 1939

9 3/4 x 13 7/8 (24.8 x 35.2)

ILLUSTRATED

**92**

*Black-Out By-Election, Southwark*, 1940

13 7/8 x 9 1/2 (35.2 x 24.1)

ILLUSTRATED

**93**

*Officers on a Minesweeper*, 1940

14 1/2 x 9 7/8 (36.8 x 25.1)

ILLUSTRATED

**94**

*Signalman on a Minesweeper*, 1940

14 1/2 x 9 7/8 (36.8 x 25.1)

ILLUSTRATED

**95**

Douglas MacDonald Hastings
"A Day on a Minesweeper"
*Picture Post*, March 23, 1940, pp. 17–23
Collection of Humphrey Spender

**96**

*Free-French Fishermen in Penzance*, 1940

9 1/2 x 14 (24.1 x 35.6)

ILLUSTRATED

**97**

*Fighter Pilots Resting on Alert*, 1940

9 7/8 x 14 1/2 (25.1 x 36.8)

ILLUSTRATED

**98**

John Tunnard
"Life of a Coastguard"
*Picture Post*, December 7, 1940, pp. 9–13
Collection of Humphrey Spender

**99**

*Dieppe Raid Return*, 1942

7 3/4 x 7 1/2 (19.7 x 19.1)

ILLUSTRATED

**100**

"Dieppe: The Full Story"
*Picture Post*, September 5, 1942, pp. 7–17
Collection of Humphrey Spender

## EPILOGUE

In June 1981, Humphrey Spender revisited
Bolton and Blackpool with a film crew from
Granada Television for a program called
"Return Journey" about his experiences
photographing for Mass-Observation in the
1930s. The following photographs of Bolton
were taken at the time of the filming.

101
*Children, Bolton*, 1981
9 ¾ x 14 (24.8 x 35.6)

102
*Street Scene, Bolton*, 1981
9 ⅜ x 14 (23.8 x 35.6)

The photograph shows the demolition of
Davenport Street, the location of Mass-
Observation's headquarters in 1937.

103
*Self-Portrait*, c. 1984
9 ⅝ x 14 ¼ (24.4 x 36.2)
ILLUSTRATED

Spender took the photograph in his studio in
Ulting, Essex. The easel belonged to the
Victorian painter Augustus Leopold Egg.

# THE PHOTOGRAPHS

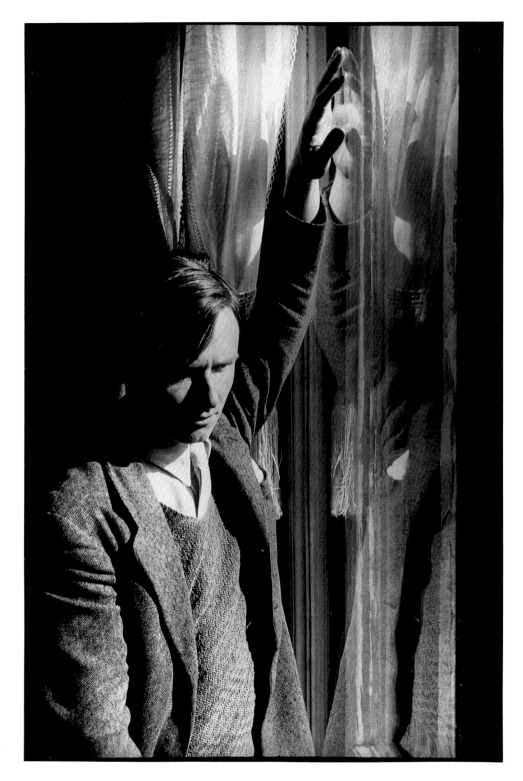

I   CHRISTOPHER ISHERWOOD, LÜTZOWPLATZ, BERLIN, 1933

2   LÜTZOWPLATZ, BERLIN, 1933

4   STEPHEN SPENDER, INSEL RÜGEN, 1933

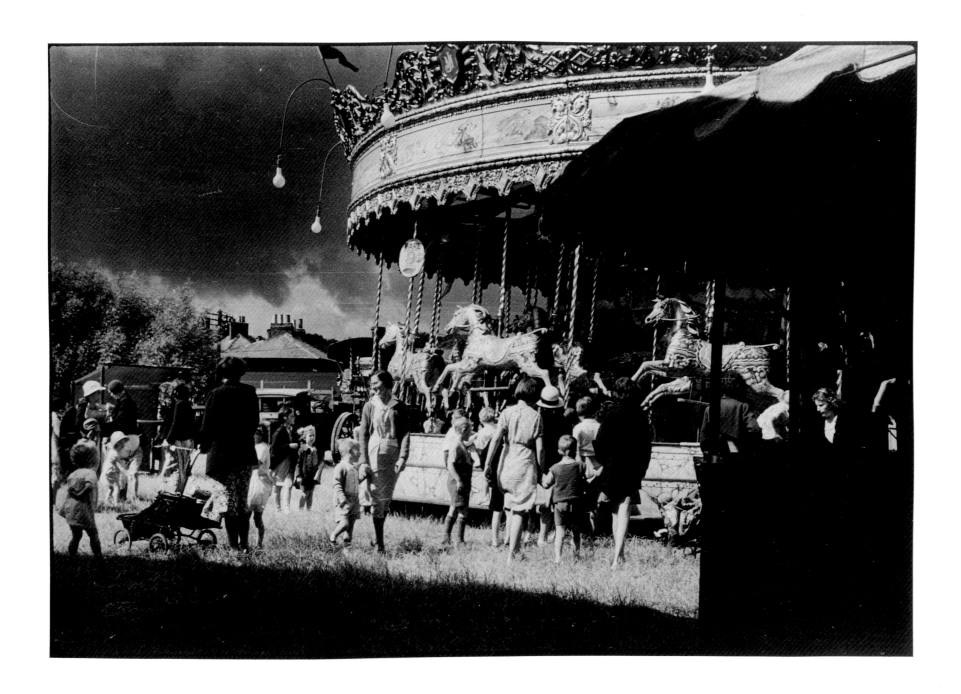

5   COUNTRY FAIR, RYE, SUSSEX, 1933

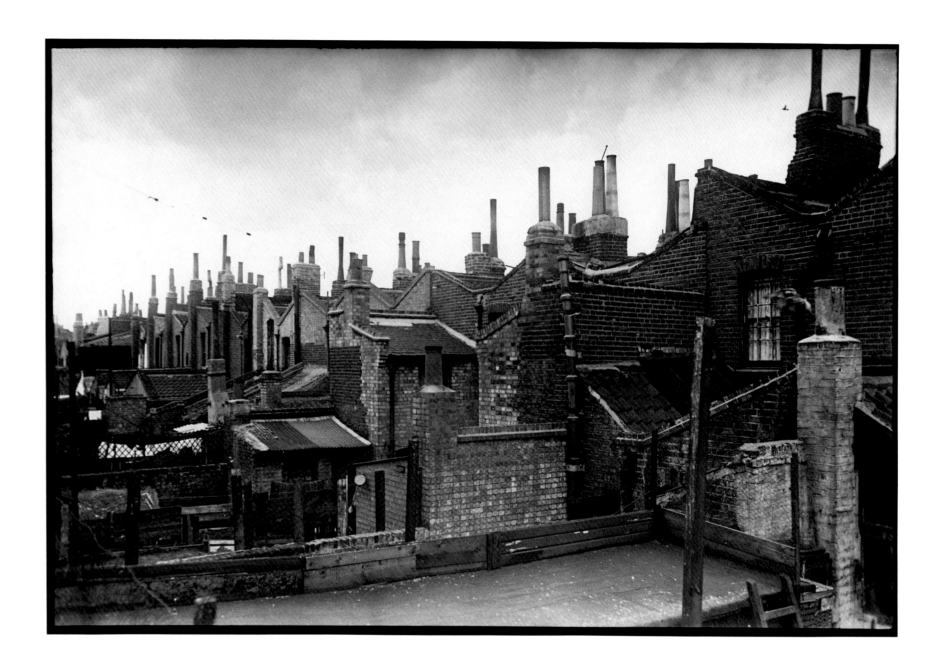

6   CHIMNEYS, STEPNEY, 1934

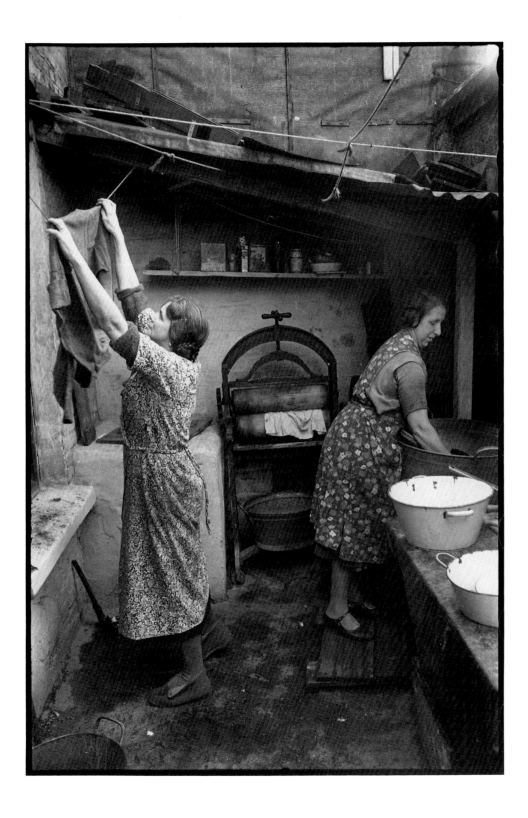

7 WASHERWOMEN, STEPNEY, 1934

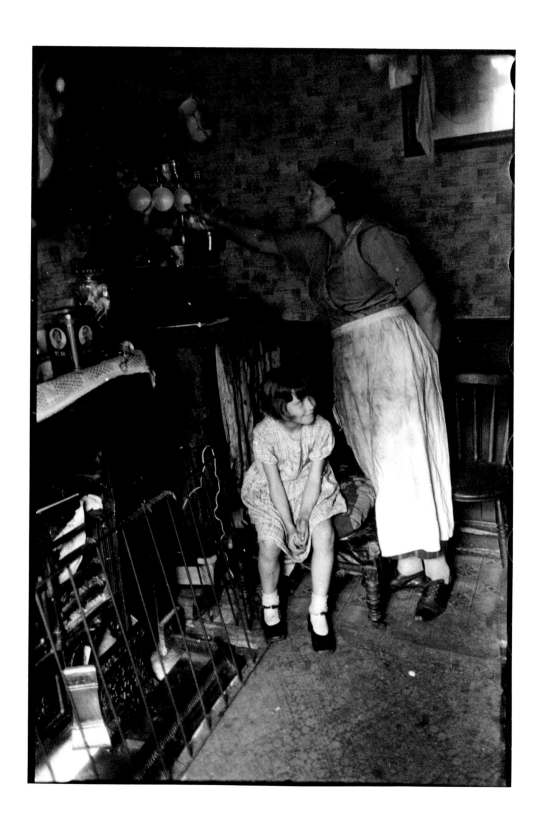

8 MOTHER AND DAUGHTER, STEPNEY, 1934

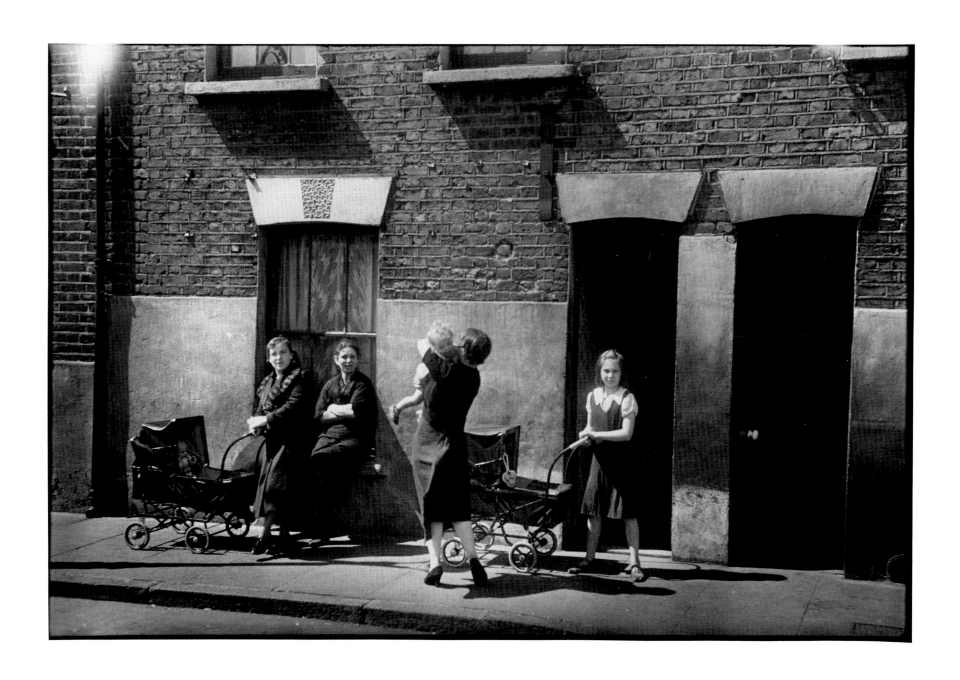

9   WOMEN AND PRAMS, STEPNEY, 1934

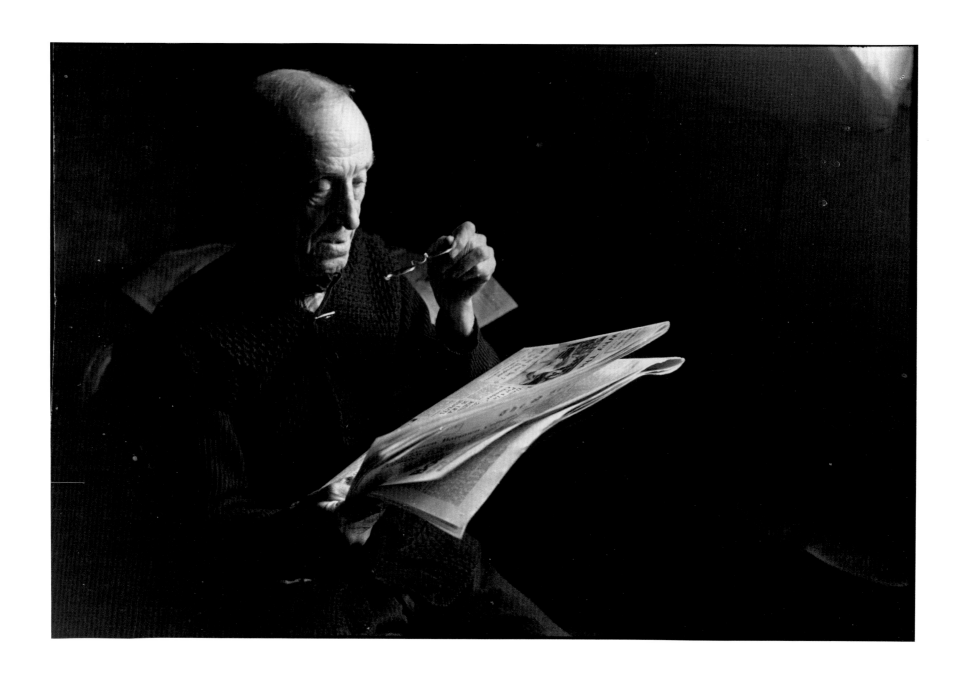

10   MAN READING A NEWSPAPER, STEPNEY, 1934

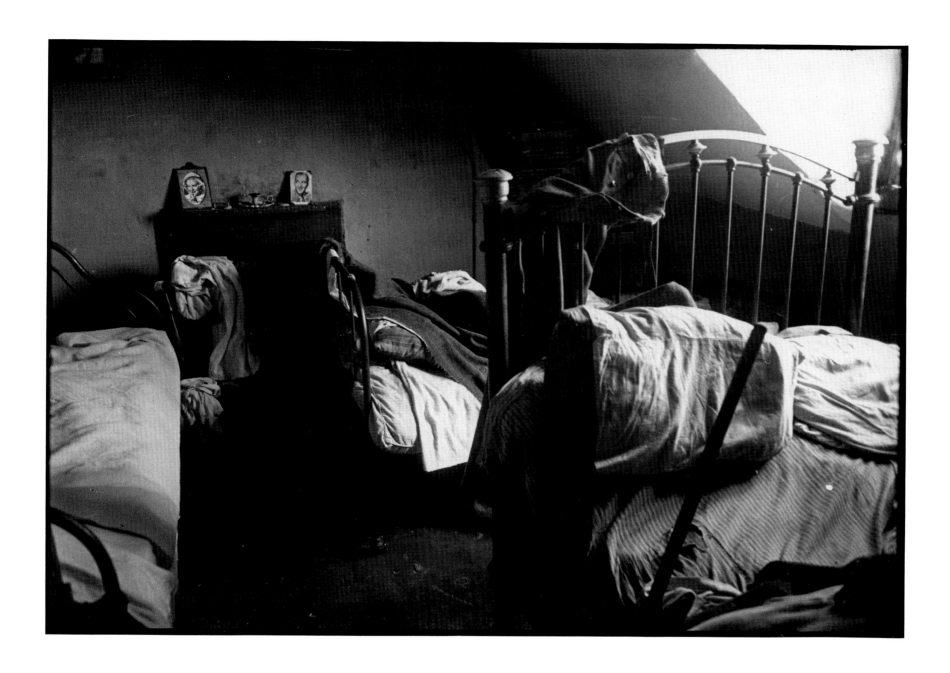

11   EMPTY BEDROOM, STEPNEY, 1934

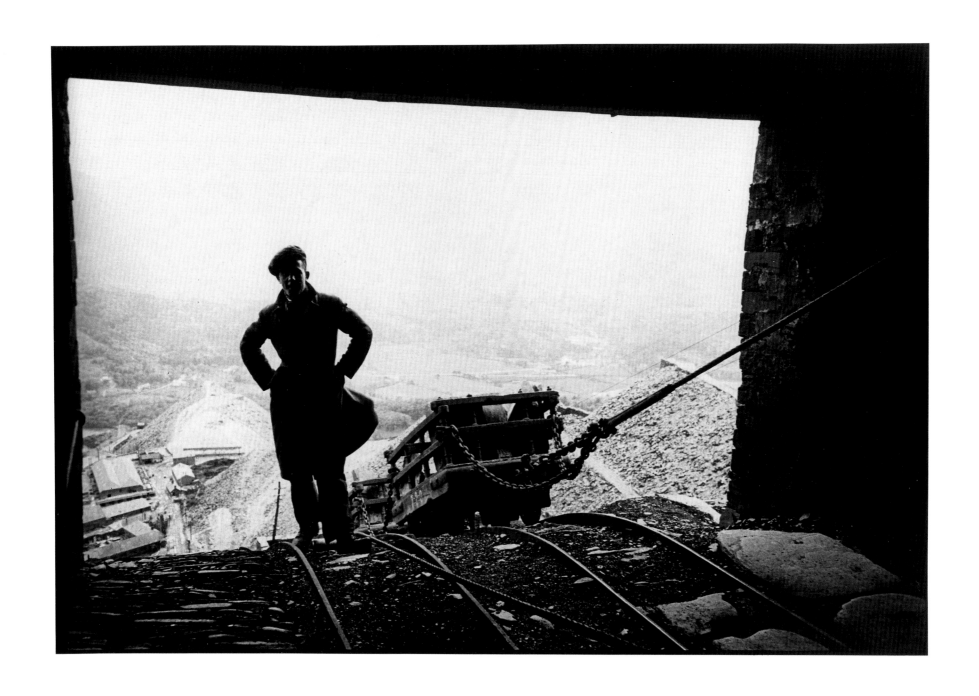

13   SLATE QUARRIES, DINORWIC, WALES, c.1935

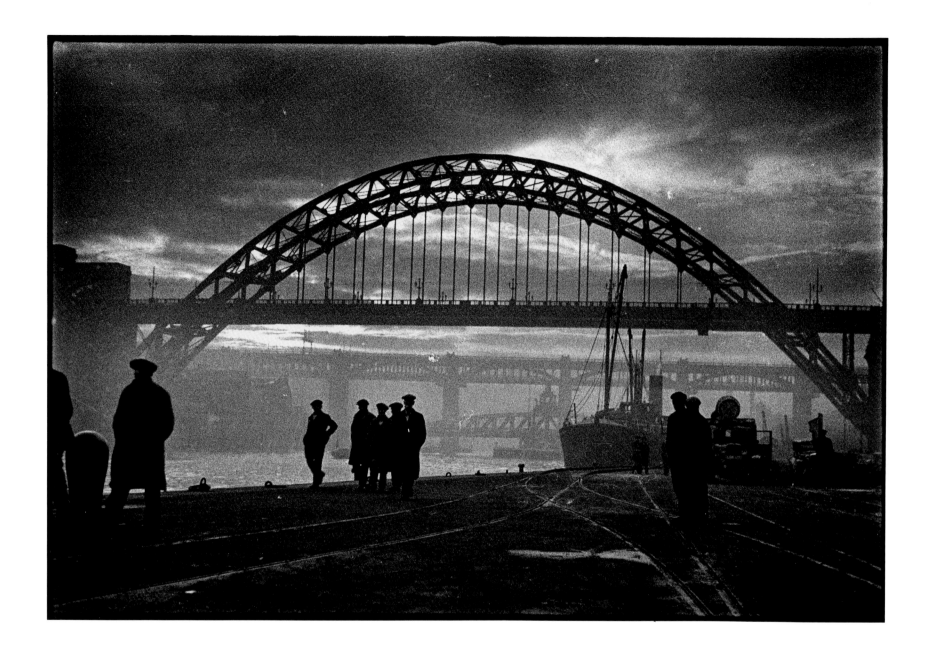

14    TYNESIDE, 1936

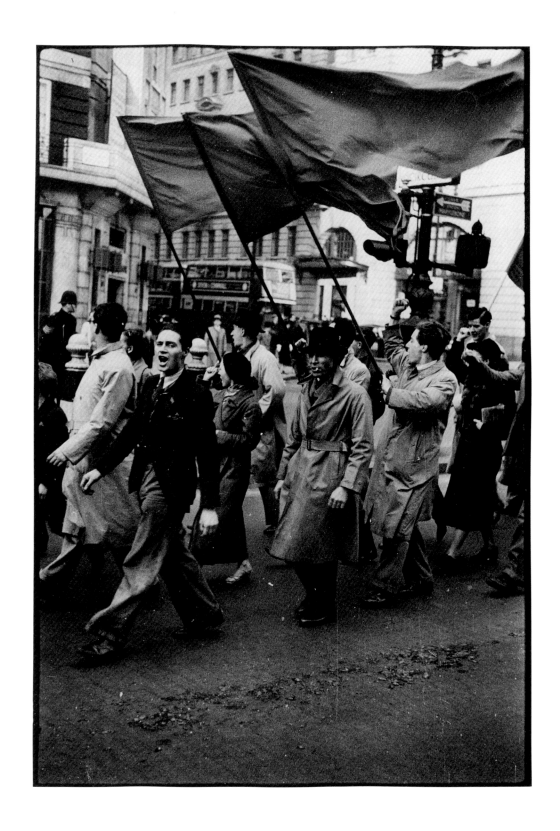

15  JARROW HUNGER MARCHERS APPROACHING
    TRAFALGAR SQUARE, 1936

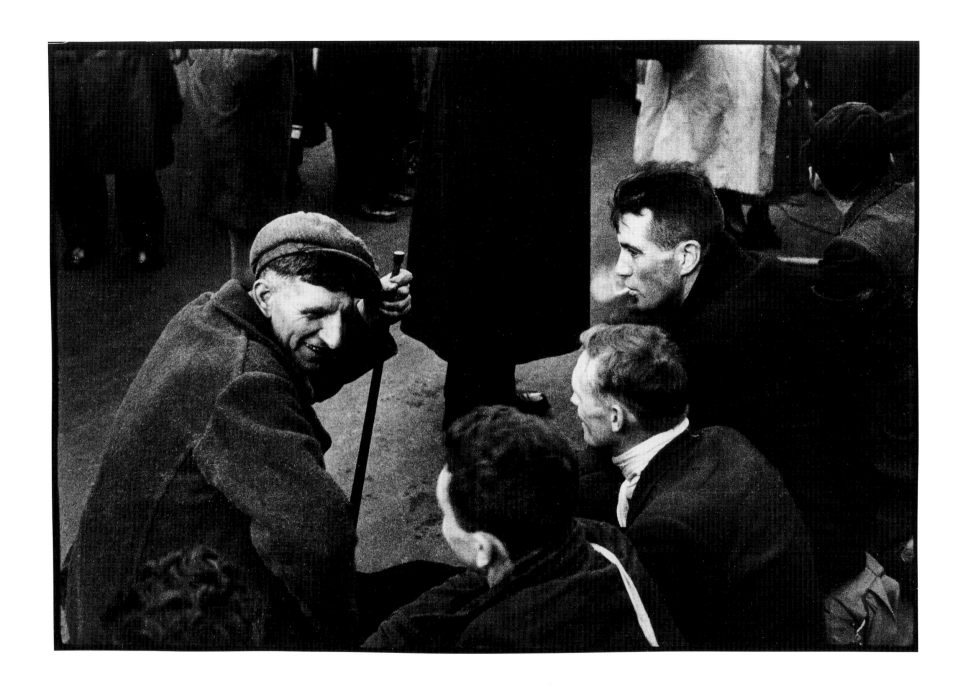

16   JARROW HUNGER MARCHERS, TRAFALGAR SQUARE, 1936

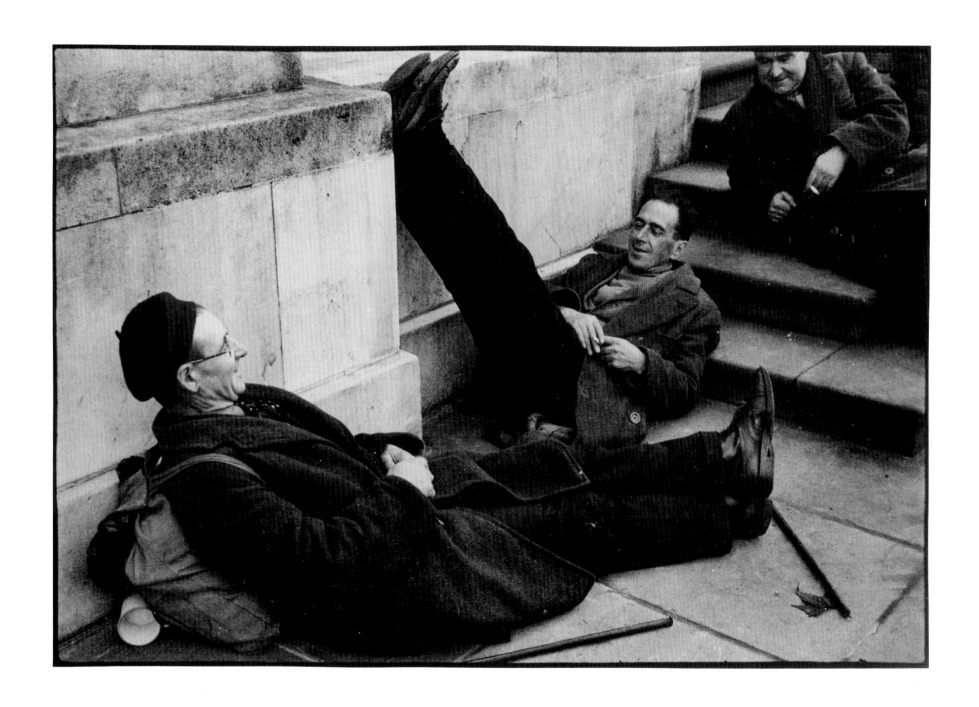

17   JARROW HUNGER MARCHERS, TRAFALGAR SQUARE, 1936

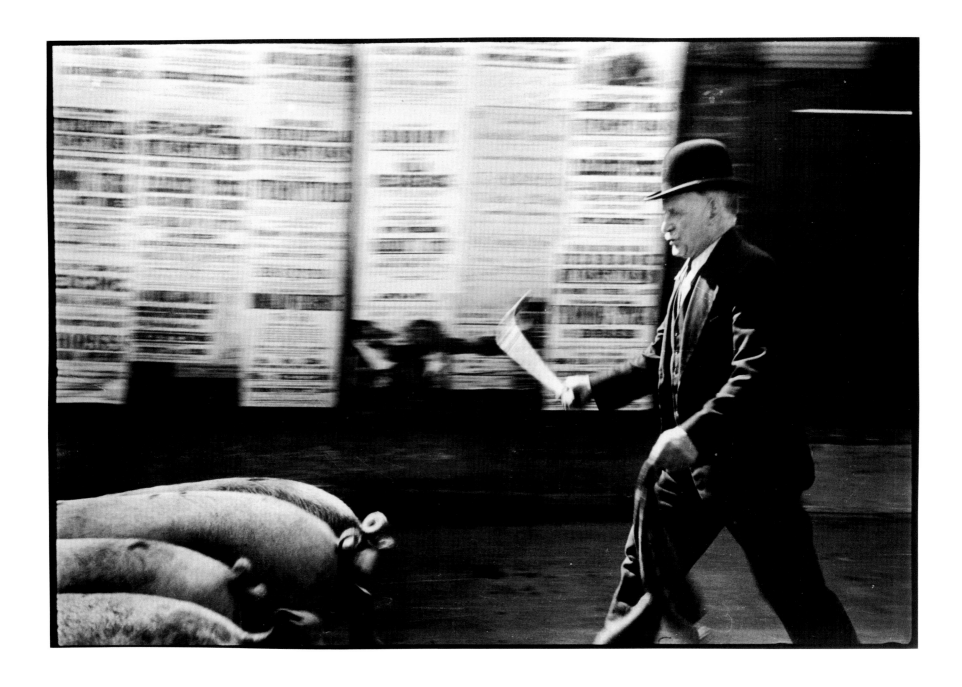

18   MARKET DAY, SUDBURY, 1937

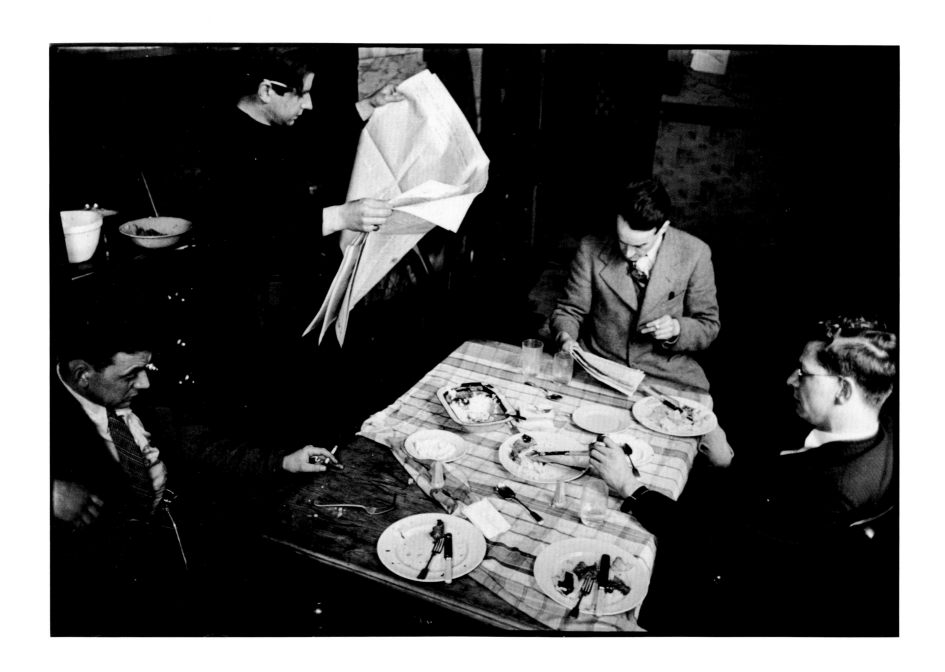

20   TOM HARRISSON WITH MASS-OBSERVERS, BOLTON, 1937

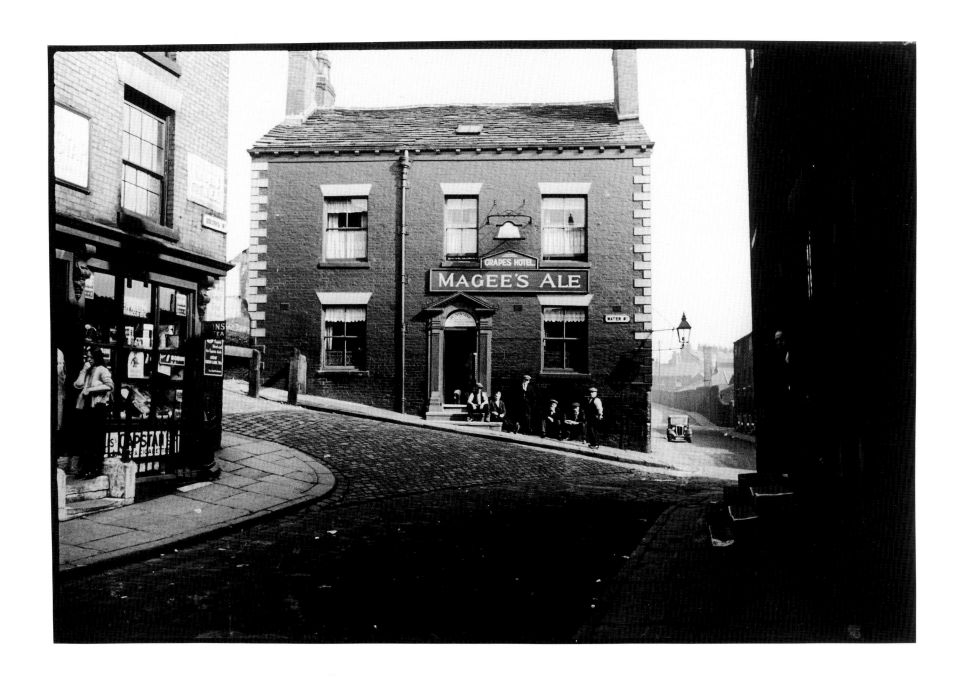

21 GRAPE'S HOTEL, BOLTON, 1937

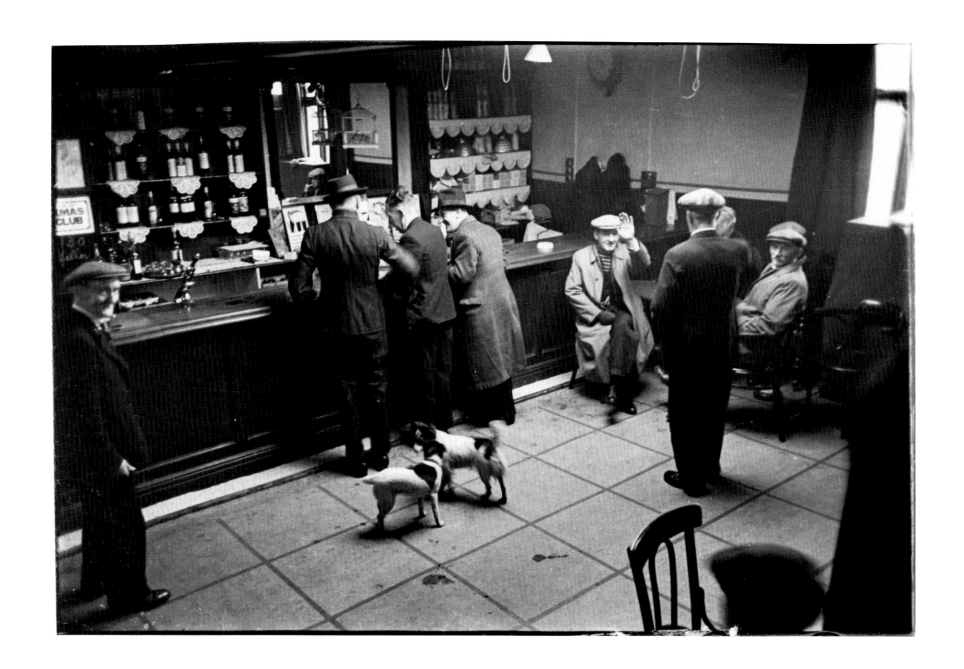

22   PUB, BOLTON, 1937

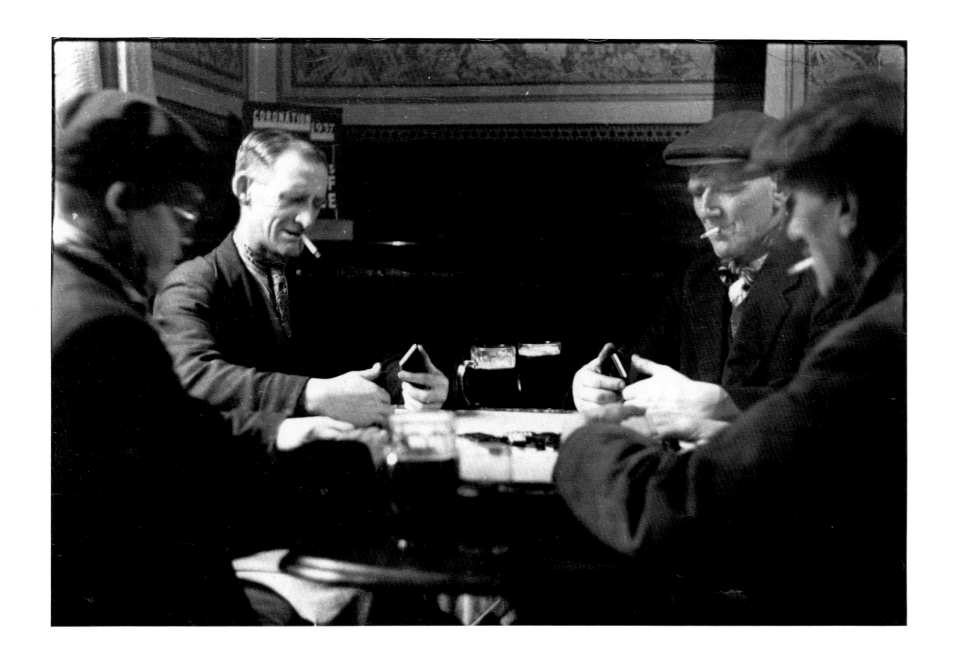

23   DOMINOES IN THE PUB, BOLTON, 1937

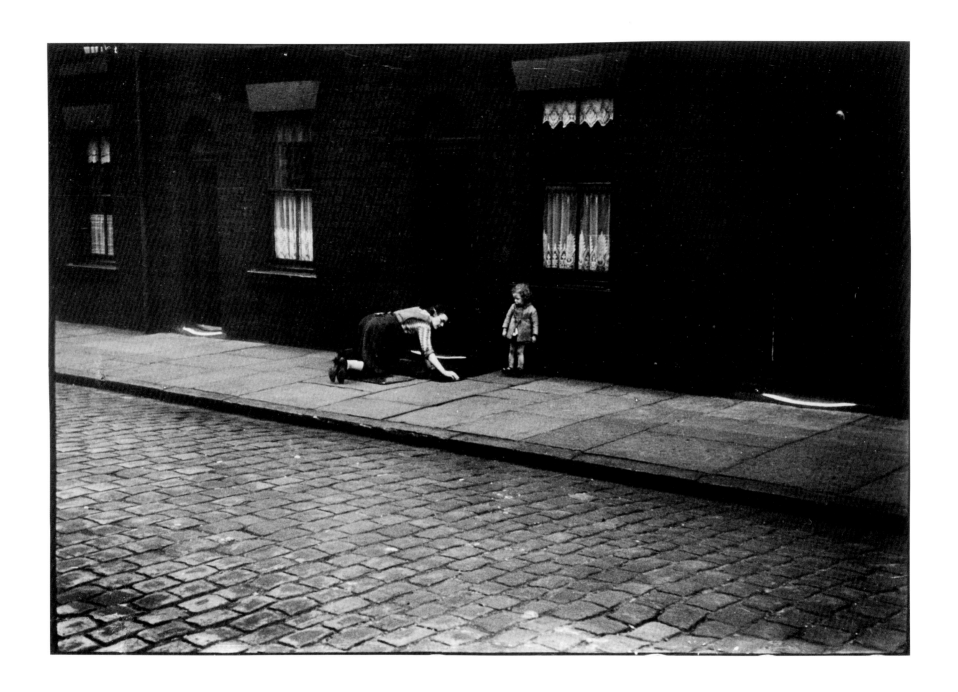

24  WOMAN SCRUBBING DOORSTEP, BOLTON, 1937

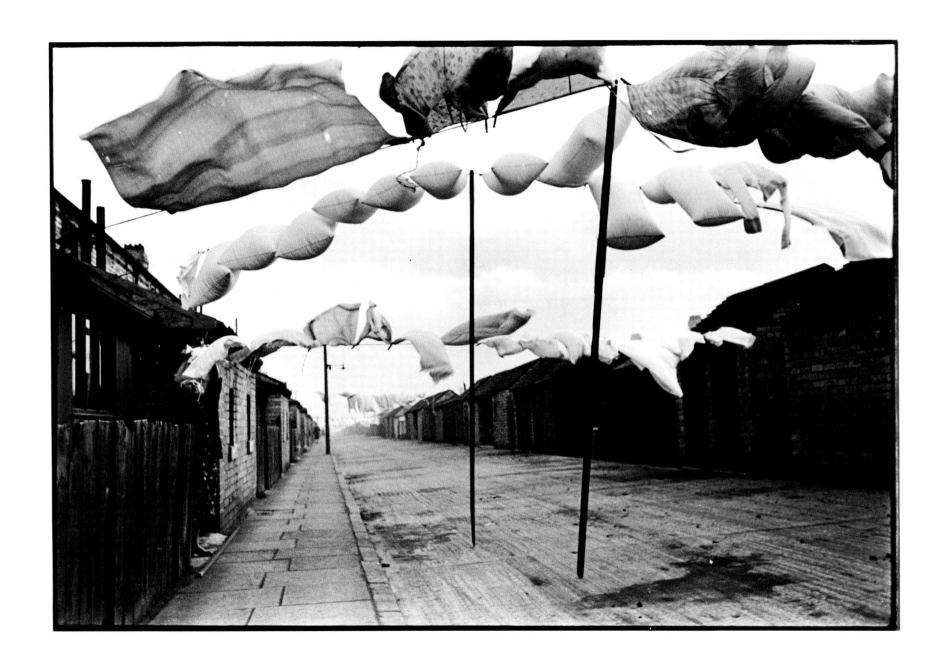

25   WASH ON THE LINES, BOLTON, 1937

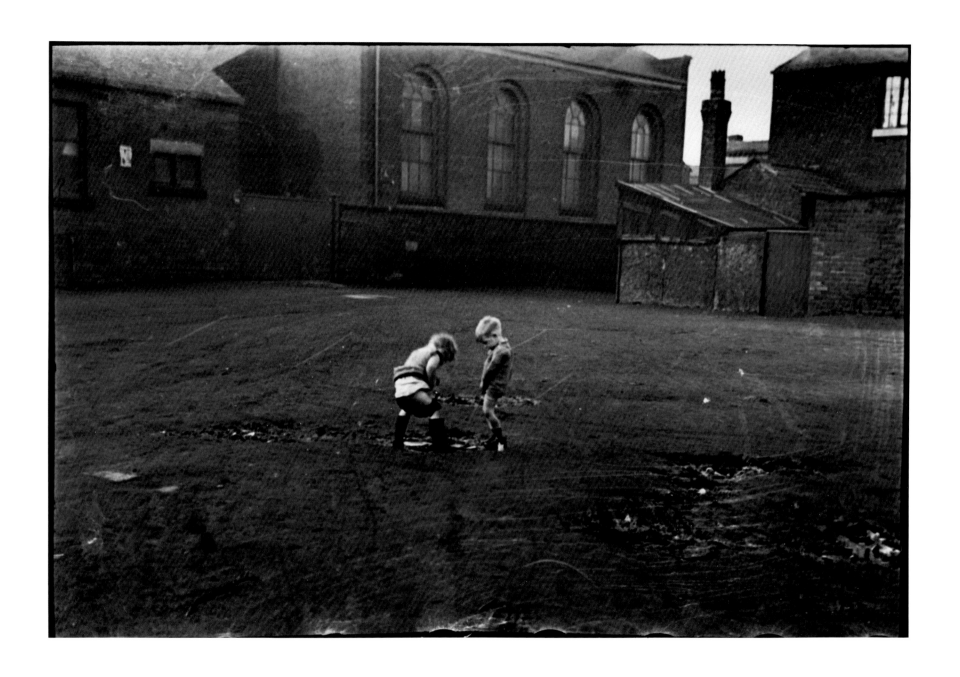

26   WASTELAND, BOLTON, 1937

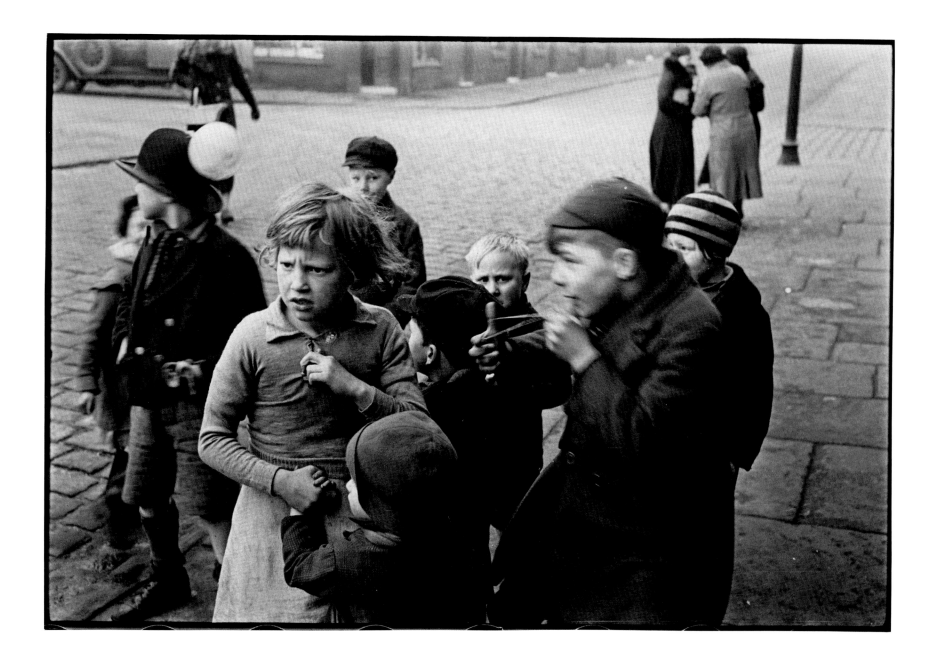

27　CATAPULT KIDS, BOLTON, 1937

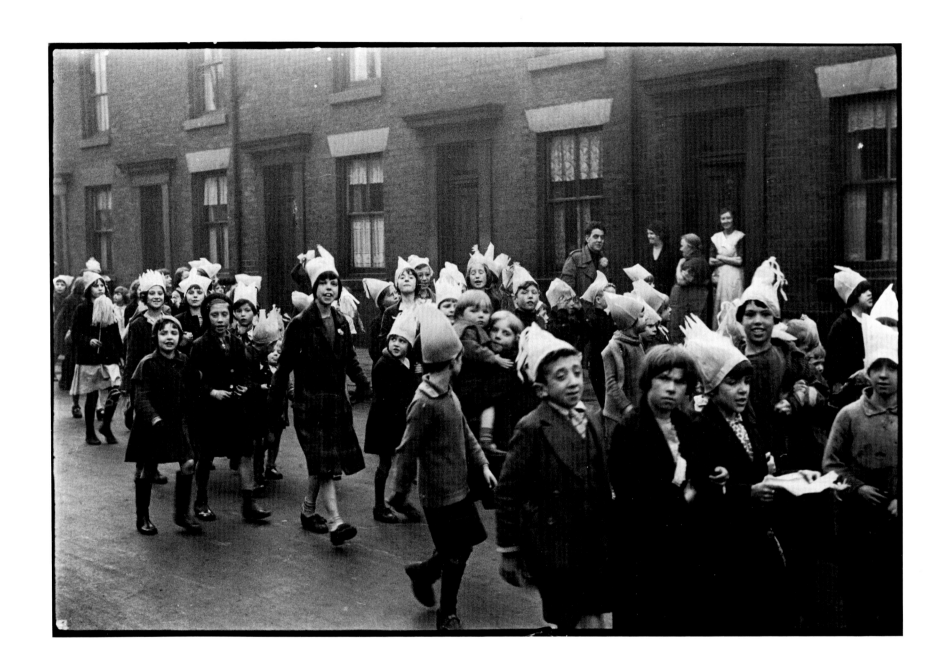

28   CHILDREN IN PAPER HATS, BOLTON, 1937

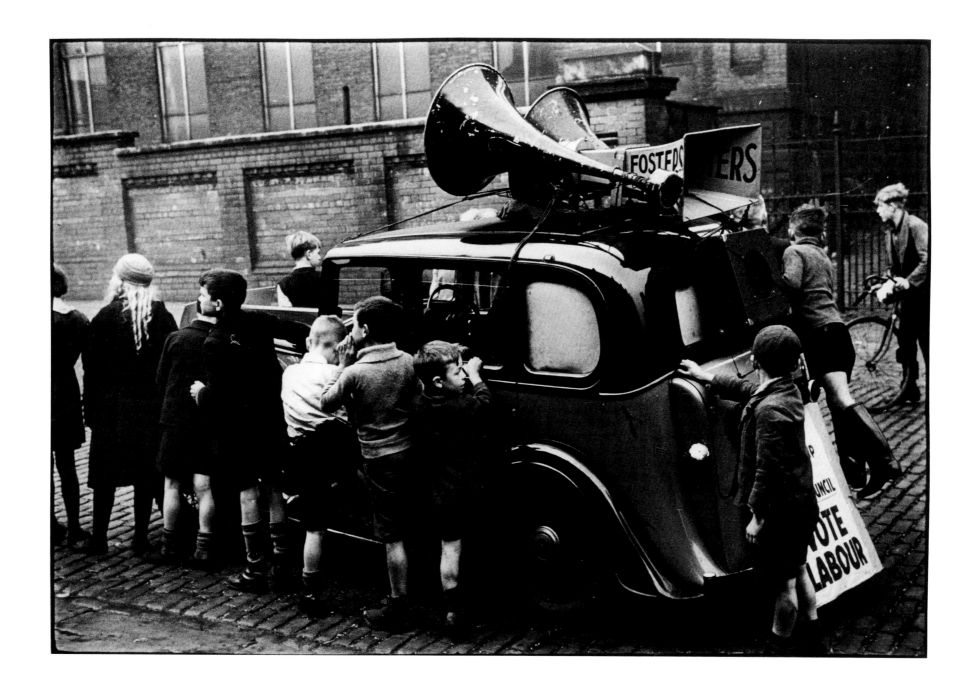

29  CHILDREN DURING BY-ELECTION, BOLTON, 1937

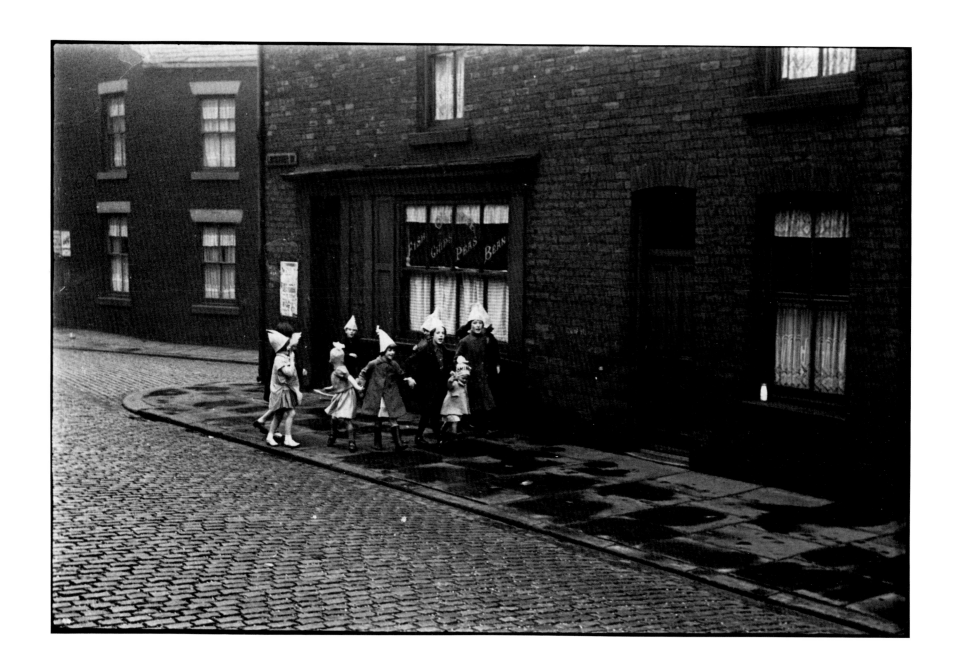

30    CHILDREN IN PAPER HATS, BOLTON, 1937

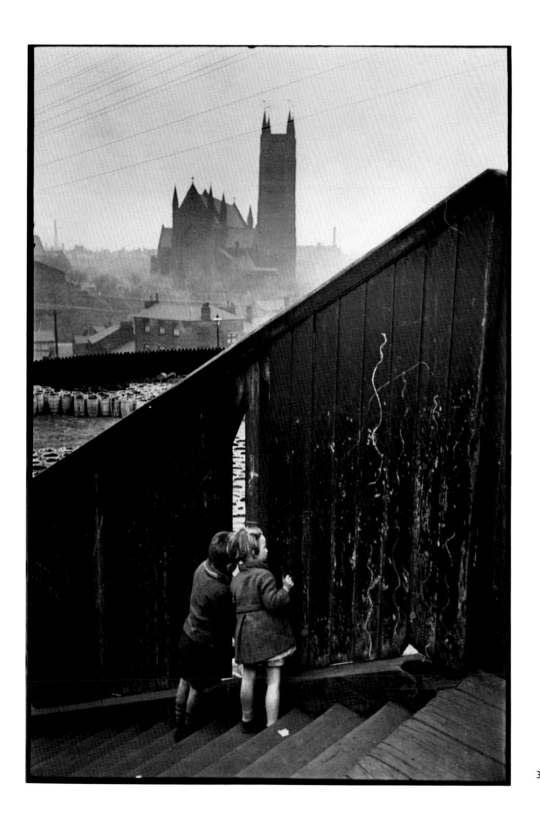

31   CHILDREN, BEER BARRELS, AND CHURCH, BOLTON, 1937

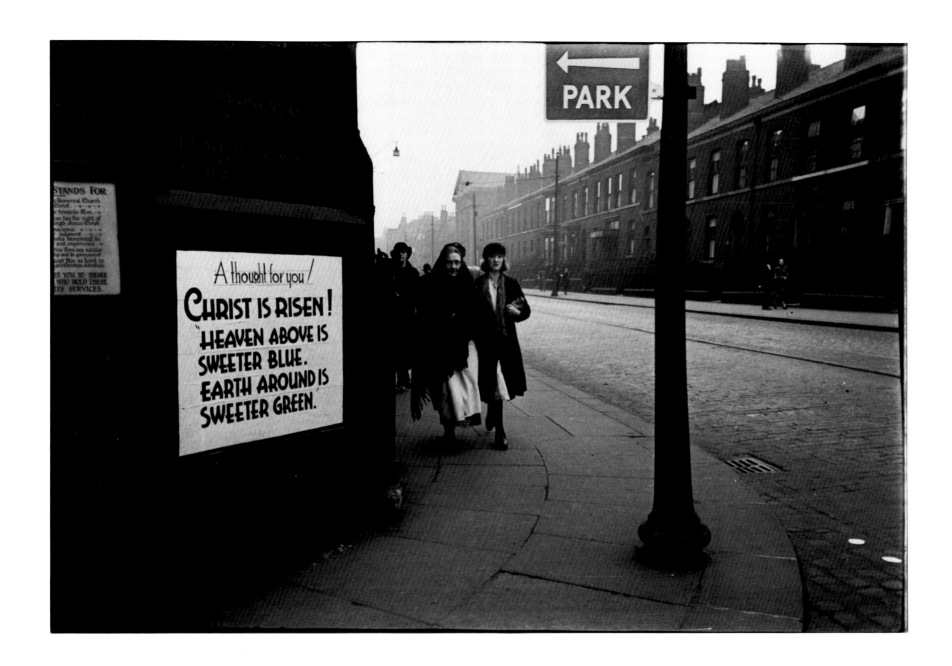

32 "CHRIST IS RISEN," BOLTON, 1937

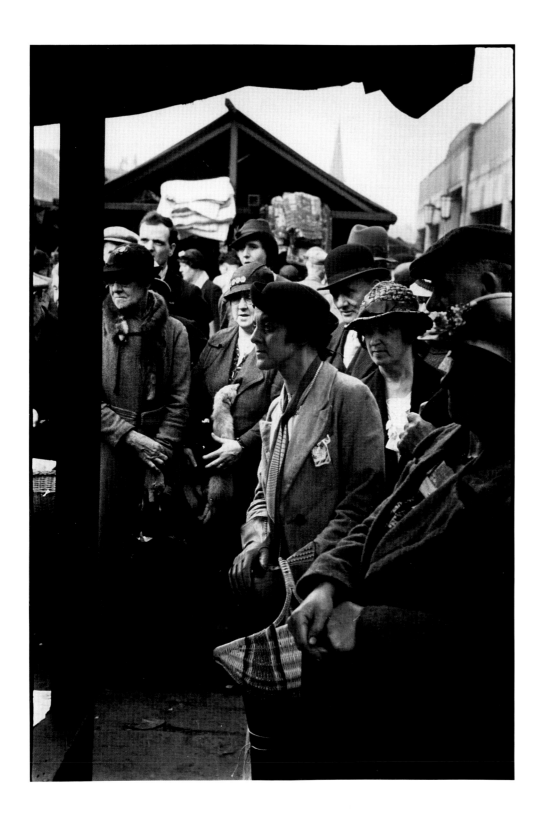

36   OPEN MARKET, BOLTON, 1937

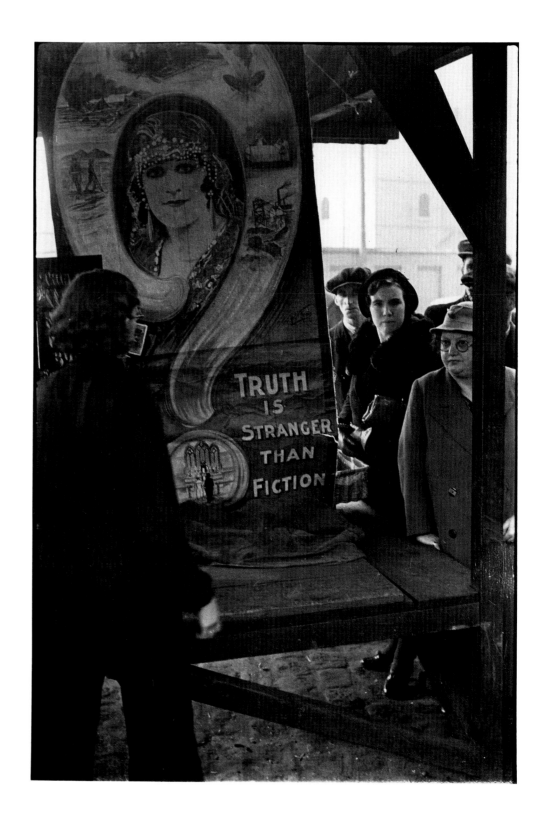

37   OPEN MARKET, "TRUTH IS STRANGER THAN FICTION"
     BOLTON, 1937

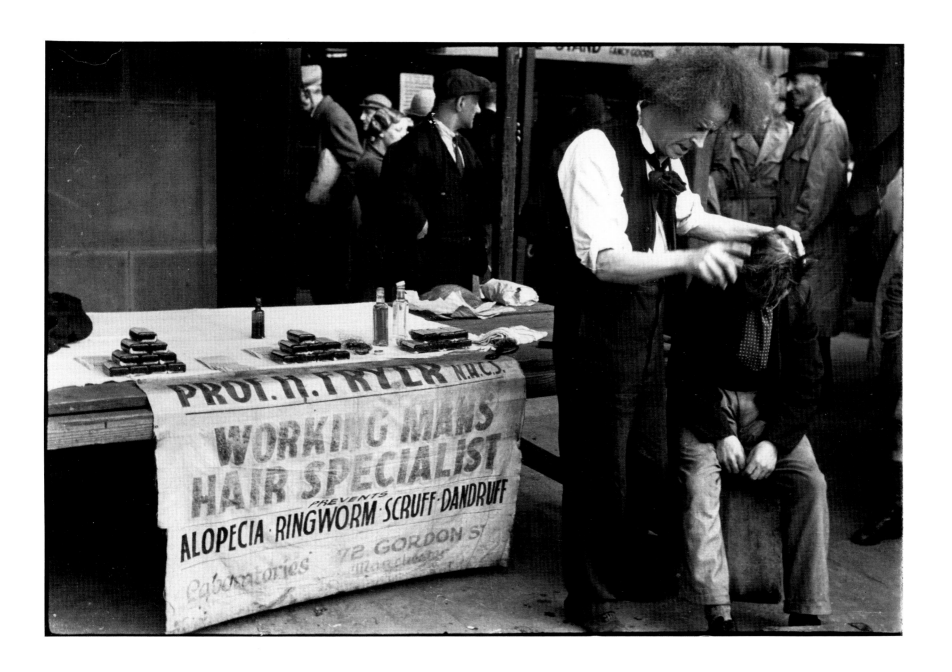

38   WORKING MAN'S HAIR SPECIALIST, BOLTON, 1937

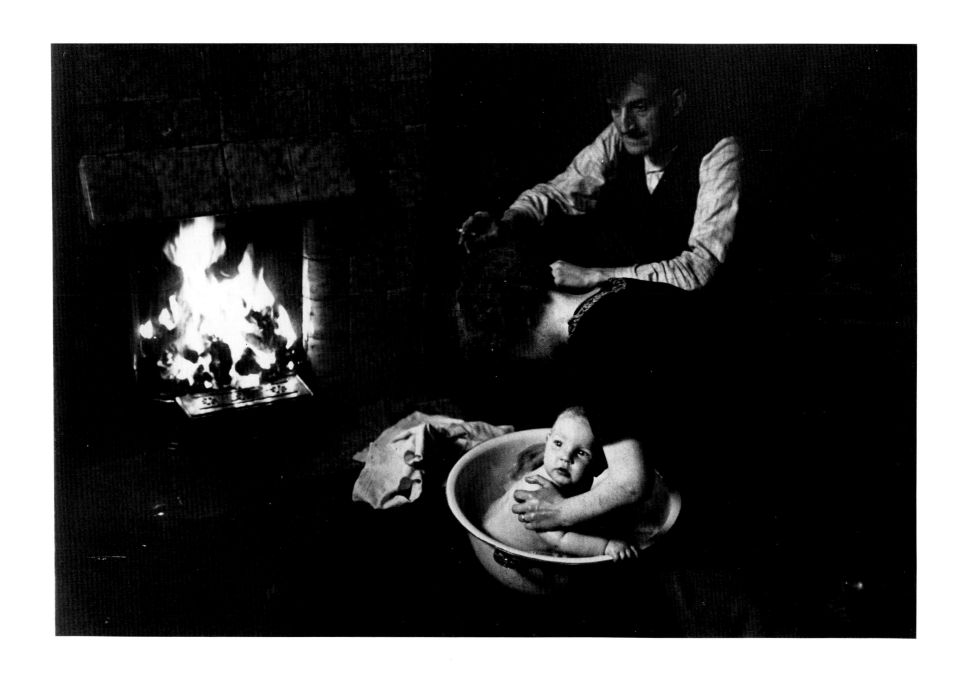

39   BABY GETTING A BATH, BOLTON, 1937

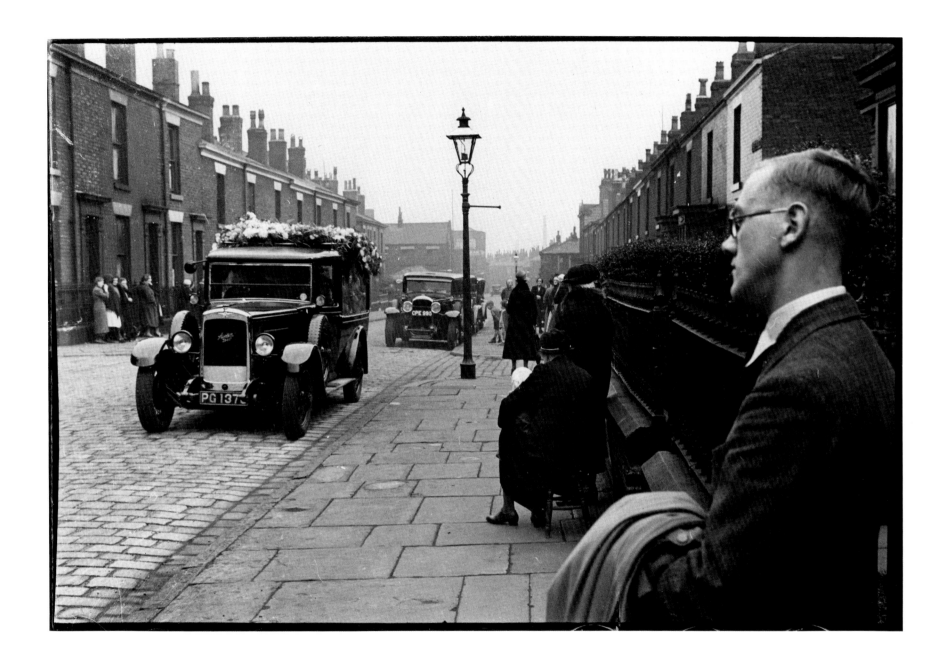

40   FUNERAL, BOLTON, 1937

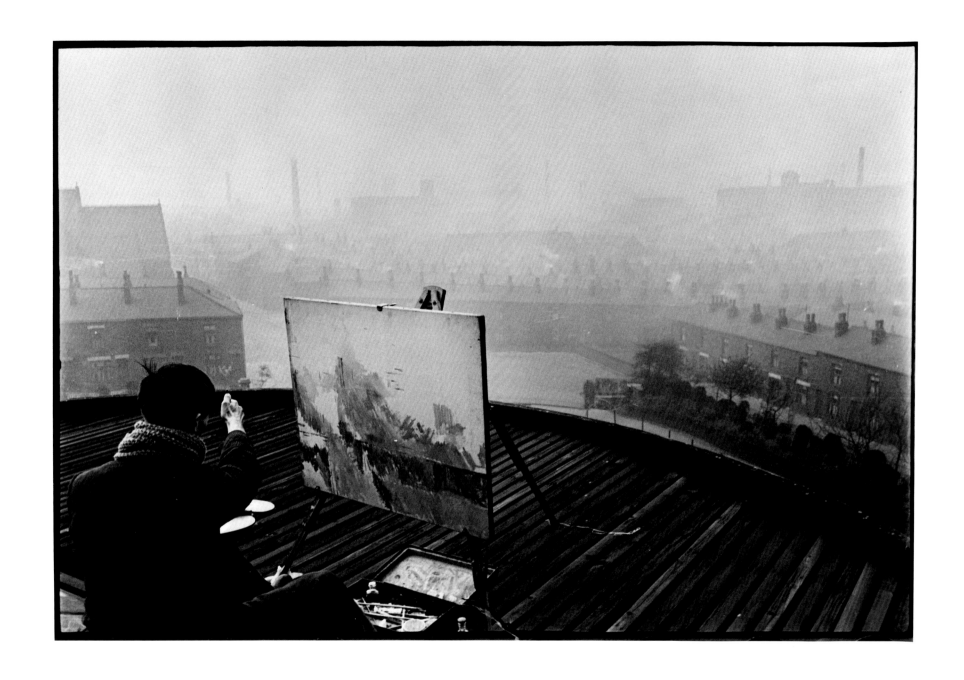

41   WILLIAM COLDSTREAM PAINTING ON THE ROOF OF THE ART GALLERY, BOLTON, 1938

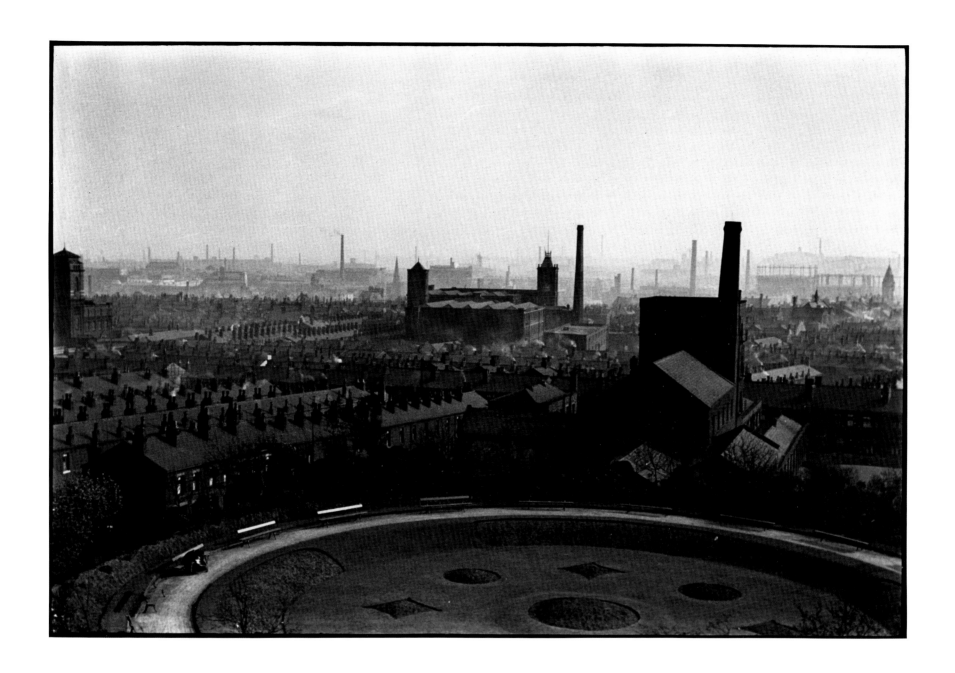

42    VIEW FROM THE ART GALLERY, BOLTON, 1938

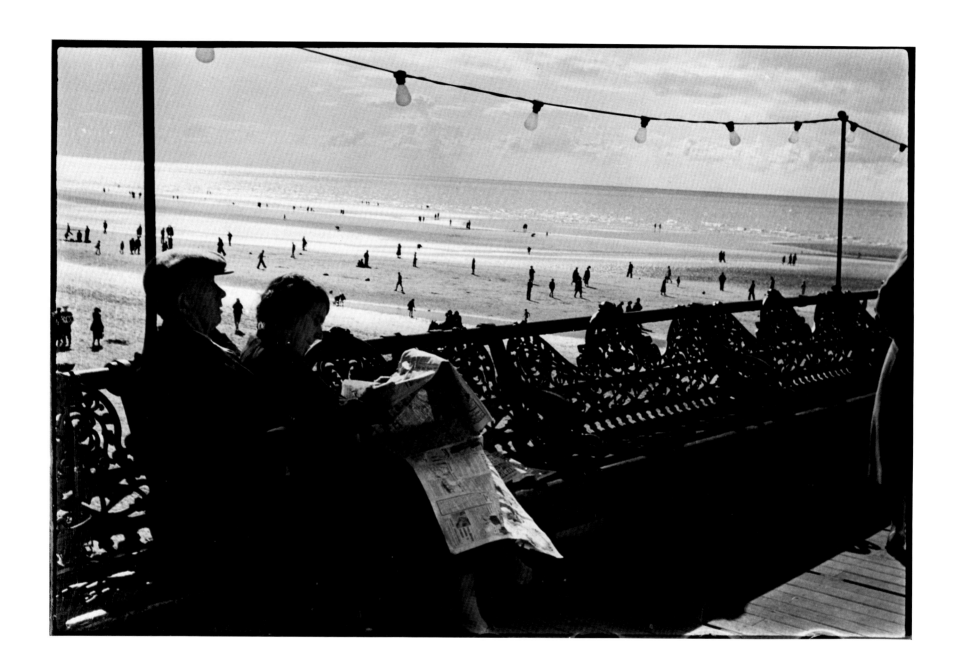

51   PIER, BLACKPOOL, 1937

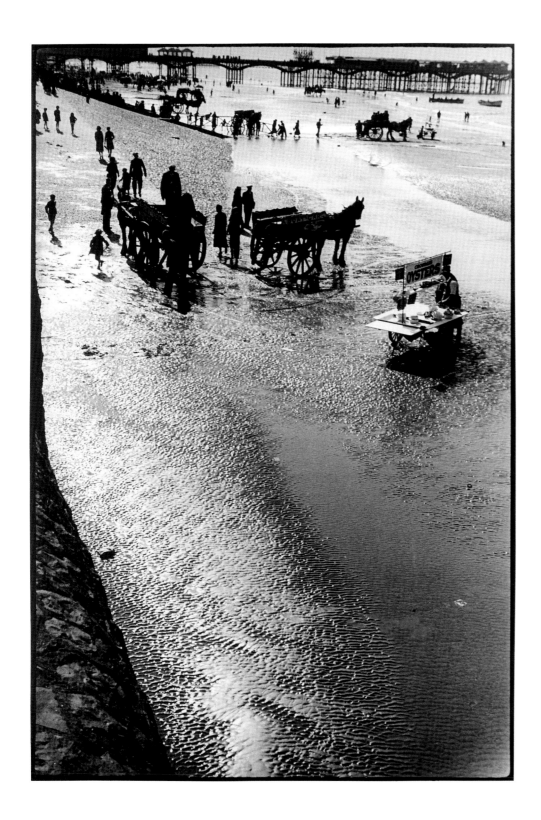

52   BOAT CARS AND OYSTER CARTS, BLACKPOOL, 1937

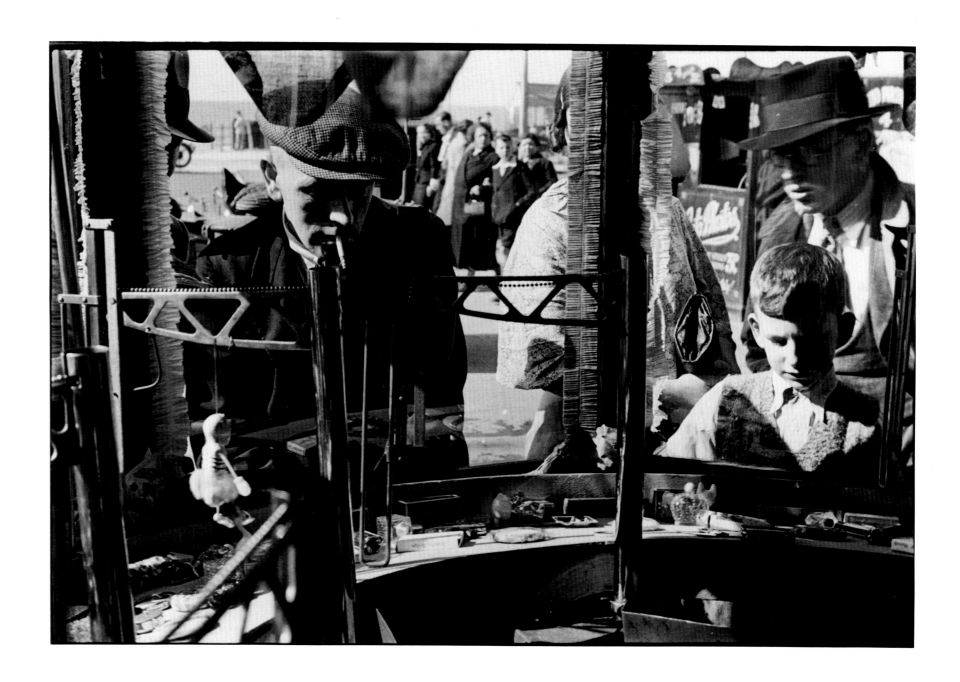

53   ARCADE GAME, BLACKPOOL, 1937

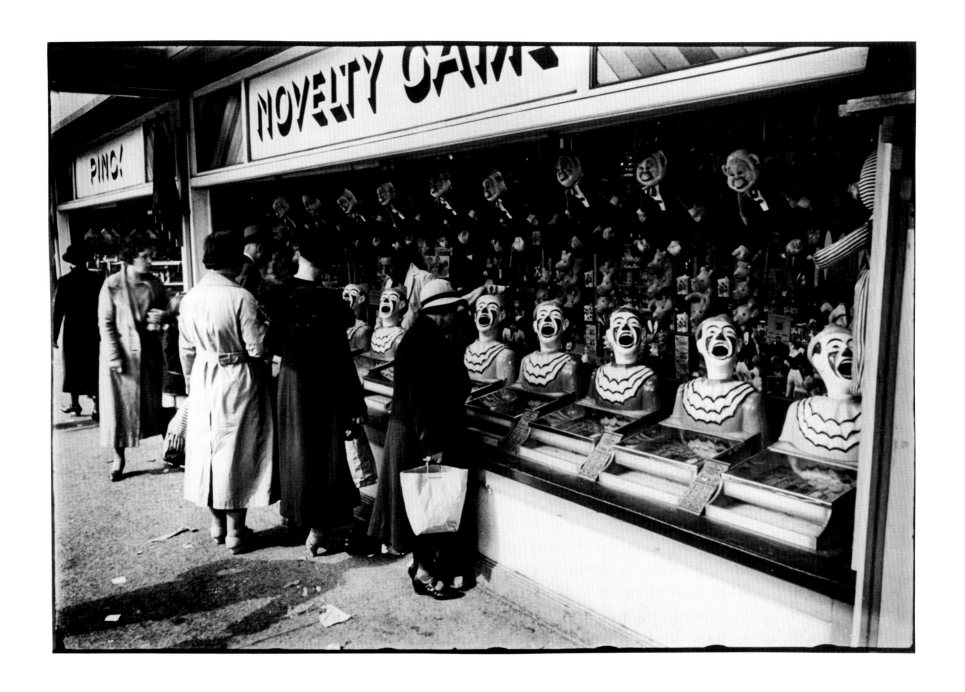

54   MIDWAY CLOWNS, BLACKPOOL, 1937

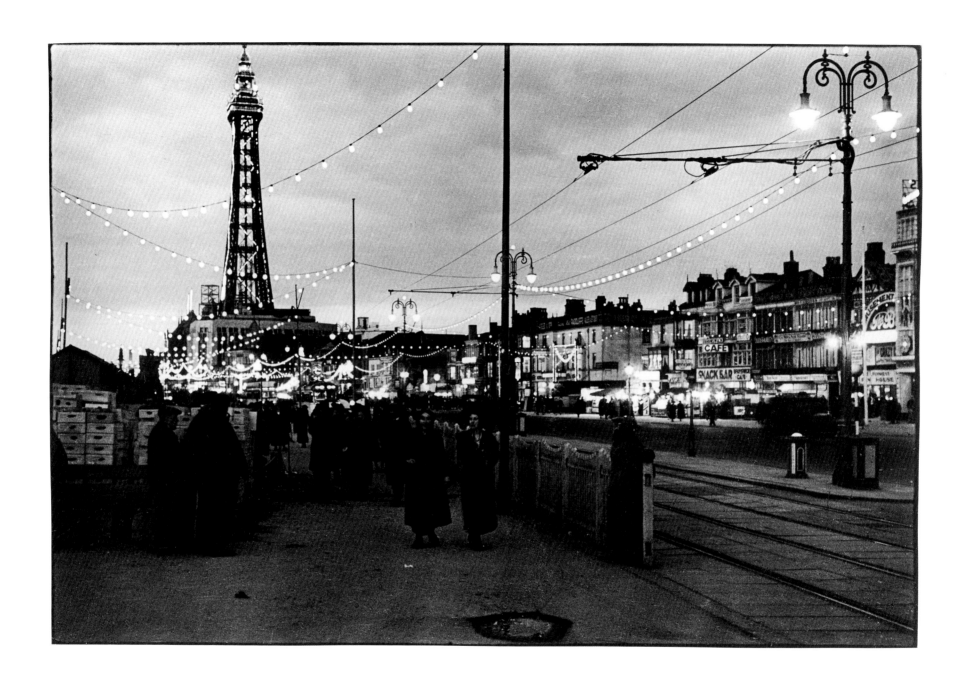

55   EVENING, BLACKPOOL, 1937

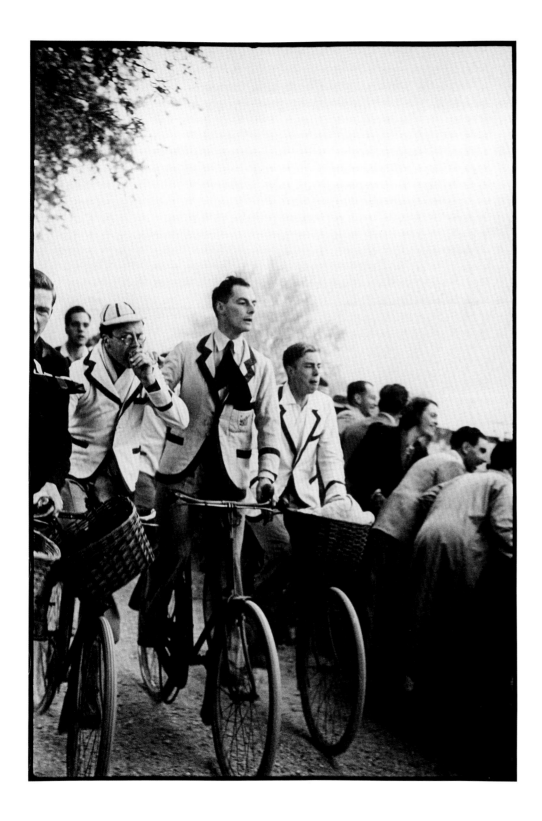

57   EIGHTS WEEK, CAMBRIDGE, 1938

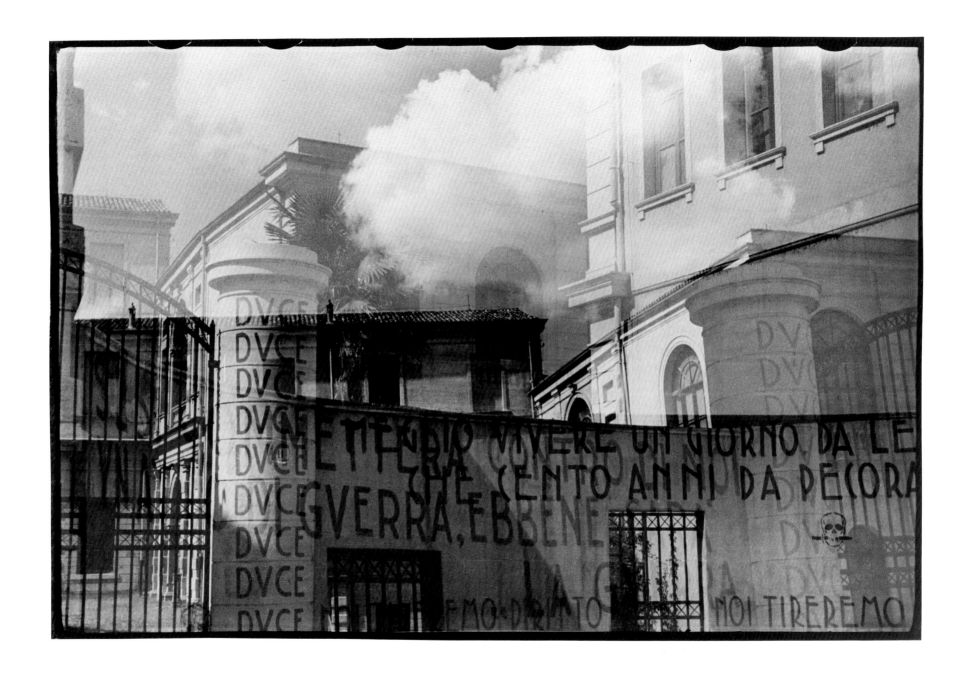

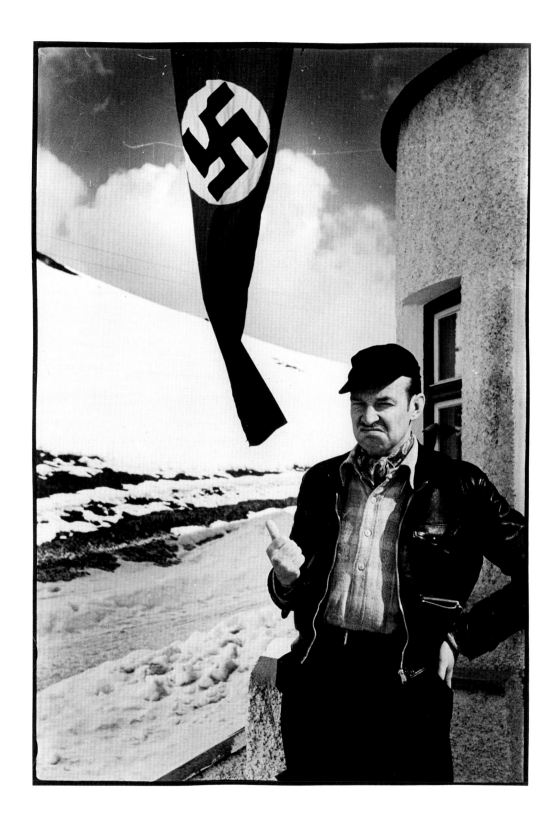

59   JOHN BANTING IN LENK, AUSTRIA, 1938

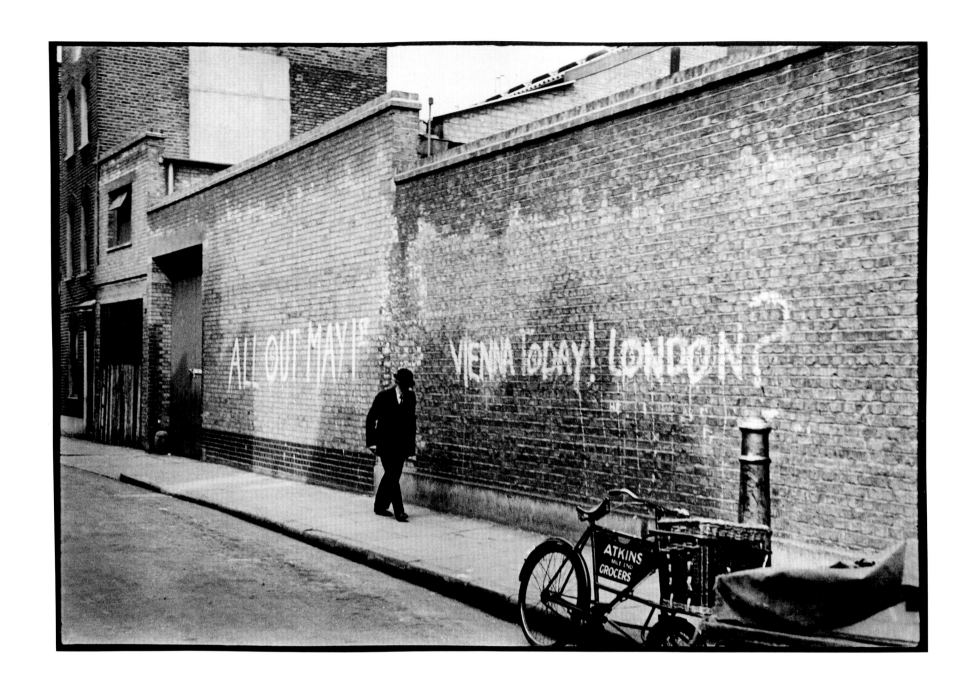

61   "VIENNA TODAY! LONDON?" WHITECHAPEL, 1938

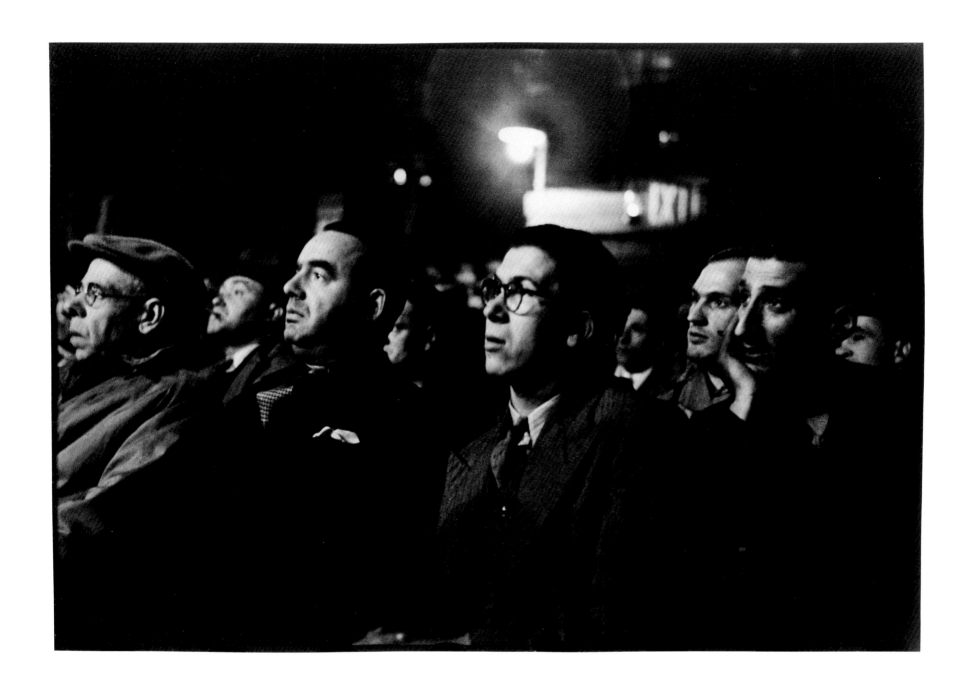

62   ALL-IN WRESTLING, WHITECHAPEL, 1938

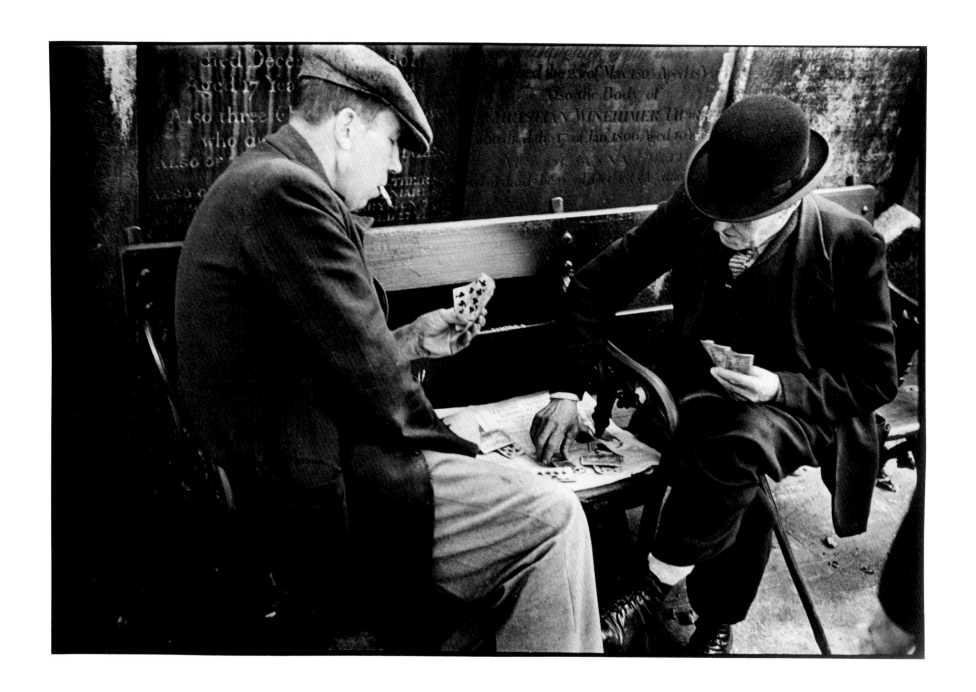

63   CARD PLAYERS, WHITECHAPEL, 1938

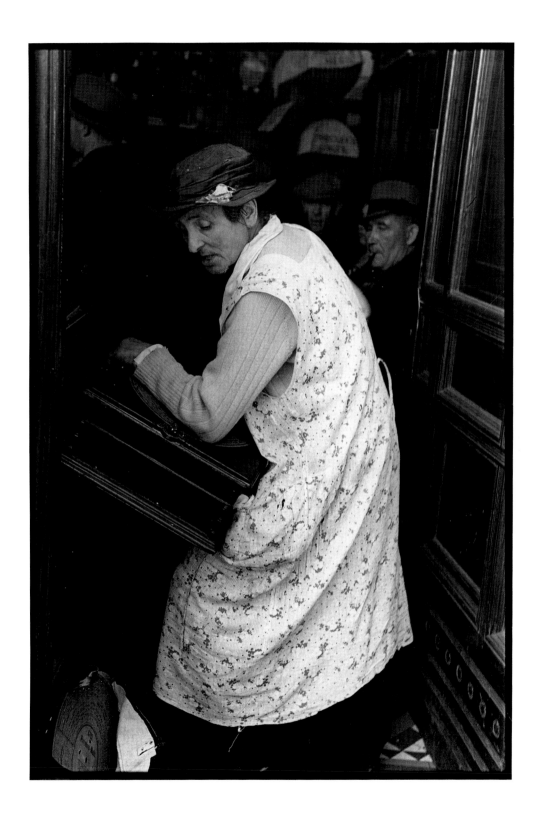

64   WOMAN BUSKER WITH STREET ORGAN
     WHITECHAPEL, 1938

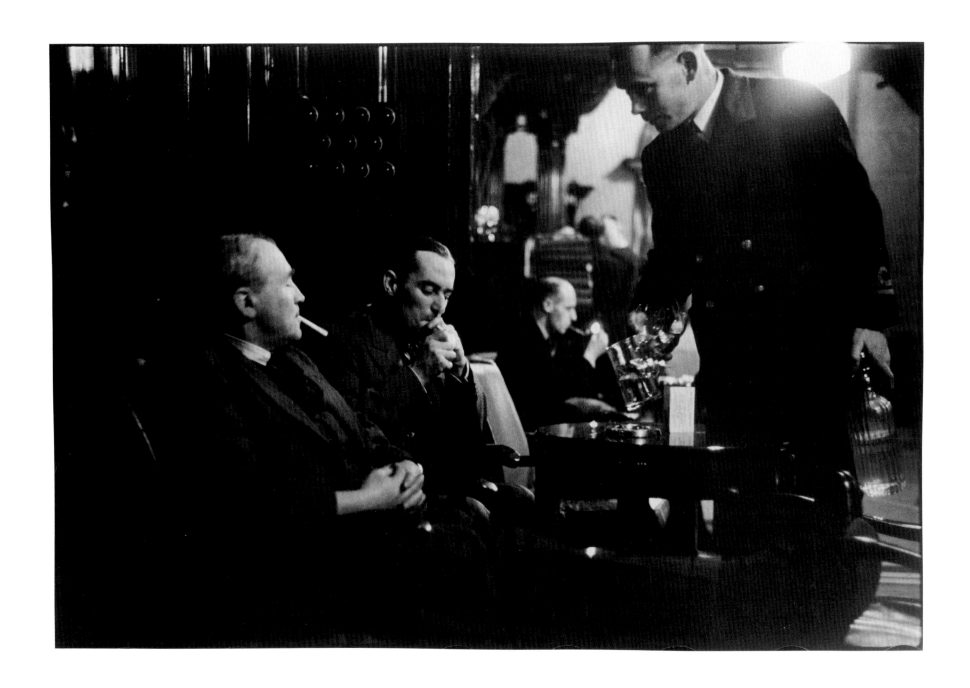

67   ROYAL TURK'S HEAD, TYNESIDE, 1938

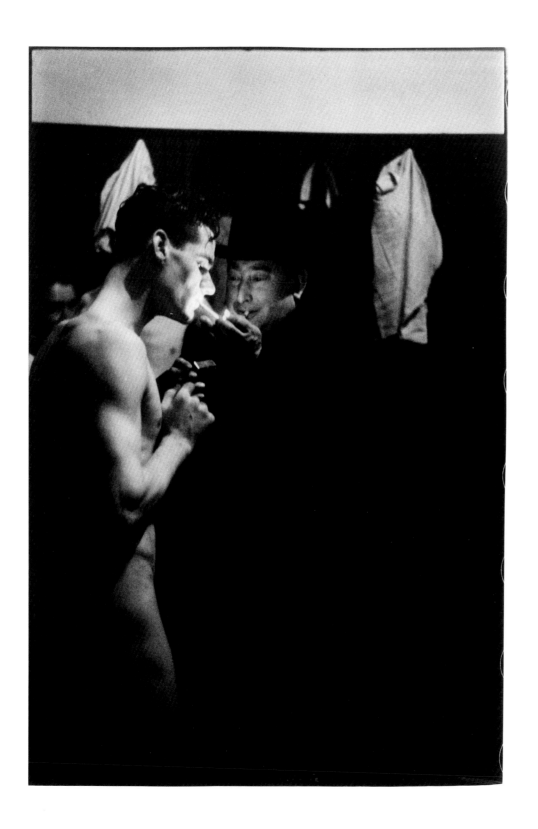

68   NEWCASTLE UNITED FOOTBALL CLUB
     CHANGING ROOMS, TYNESIDE, 1938

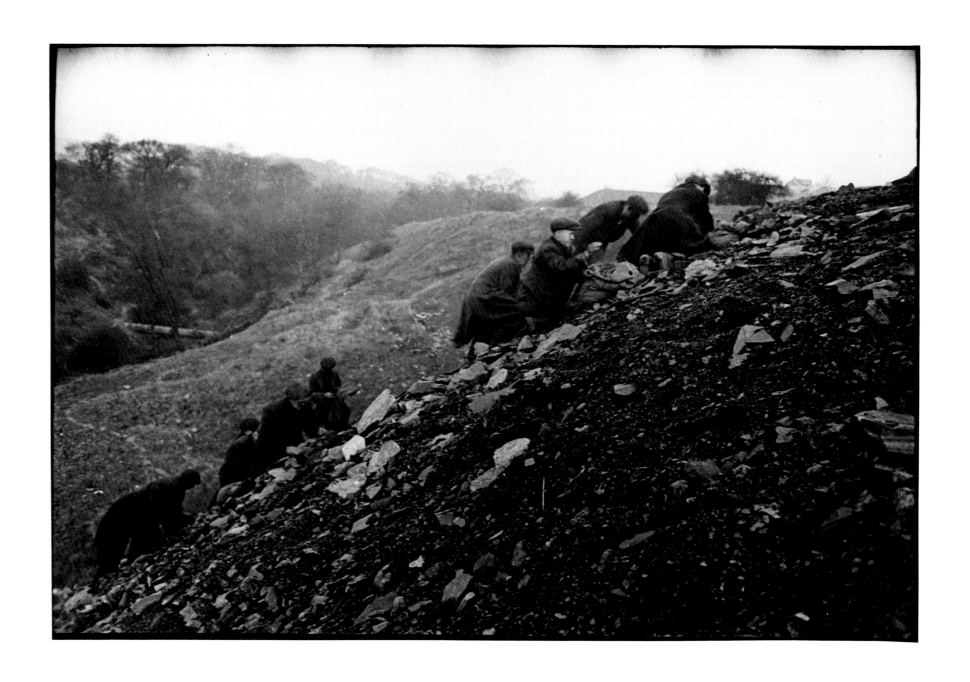

69   UNEMPLOYED MEN PICKING FOR COAL ON A SLAG-HEAP, TYNESIDE, 1938

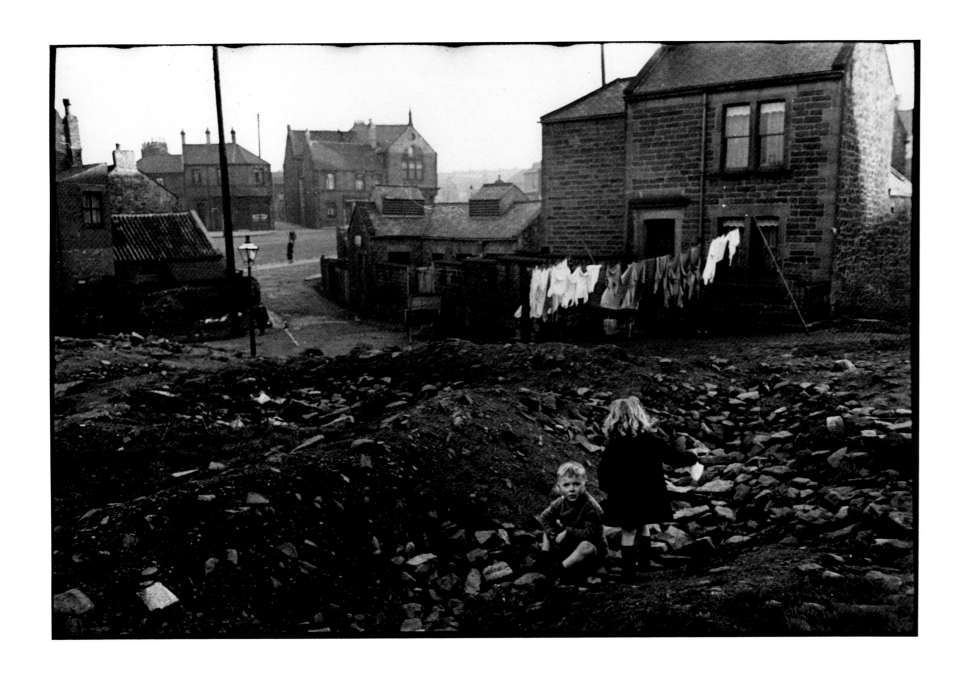

70   CHILDREN IN THE RUBBLE, TYNESIDE, 1938

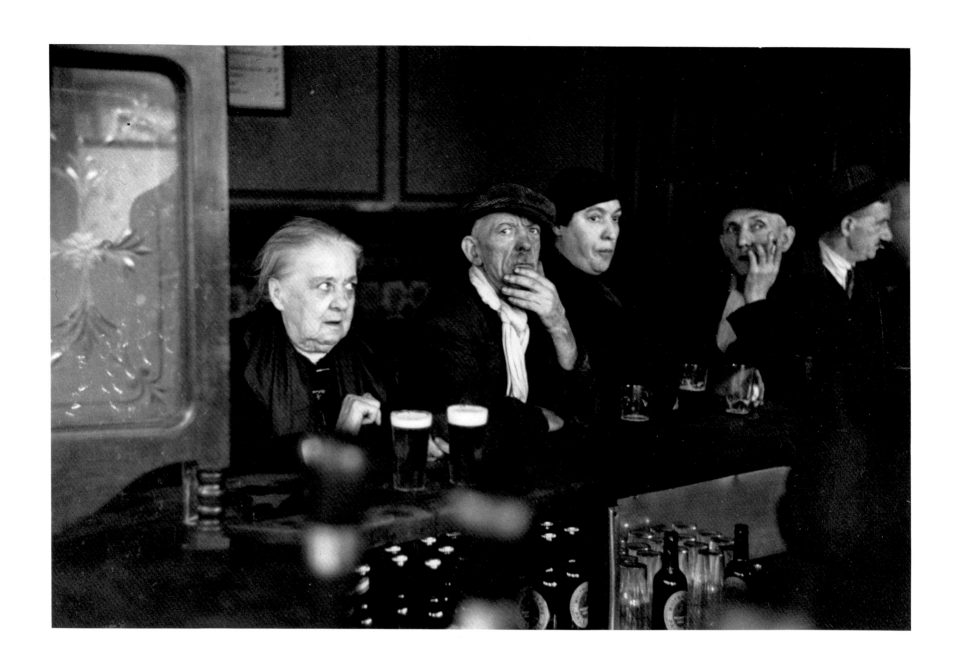

72 THE FEATHERS PUB, LAMBETH, 1938

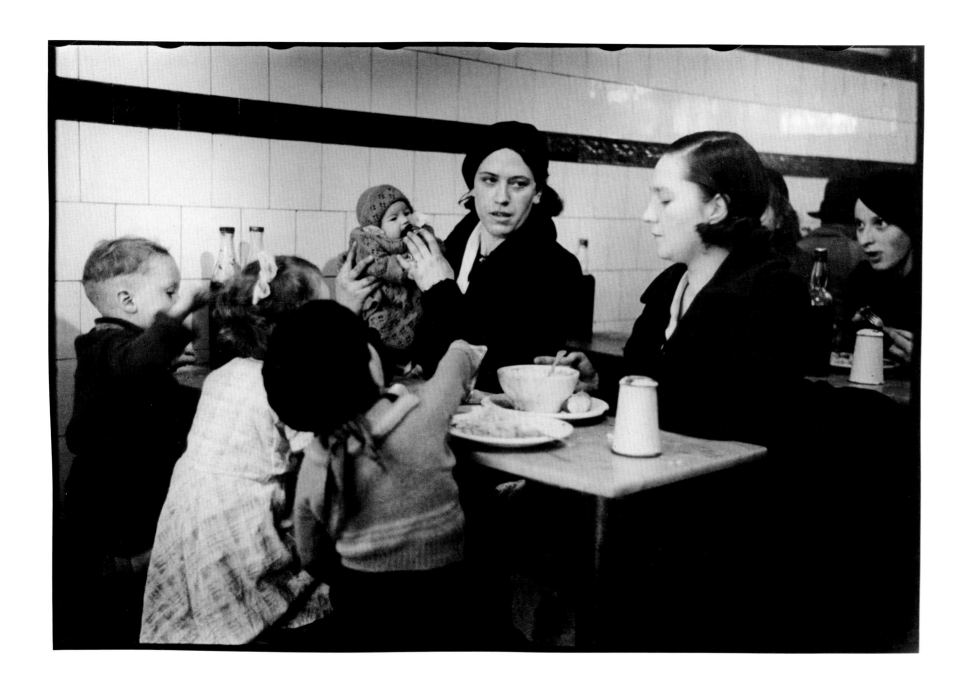

74   EEL AND PIE SALOON, LAMBETH, 1938

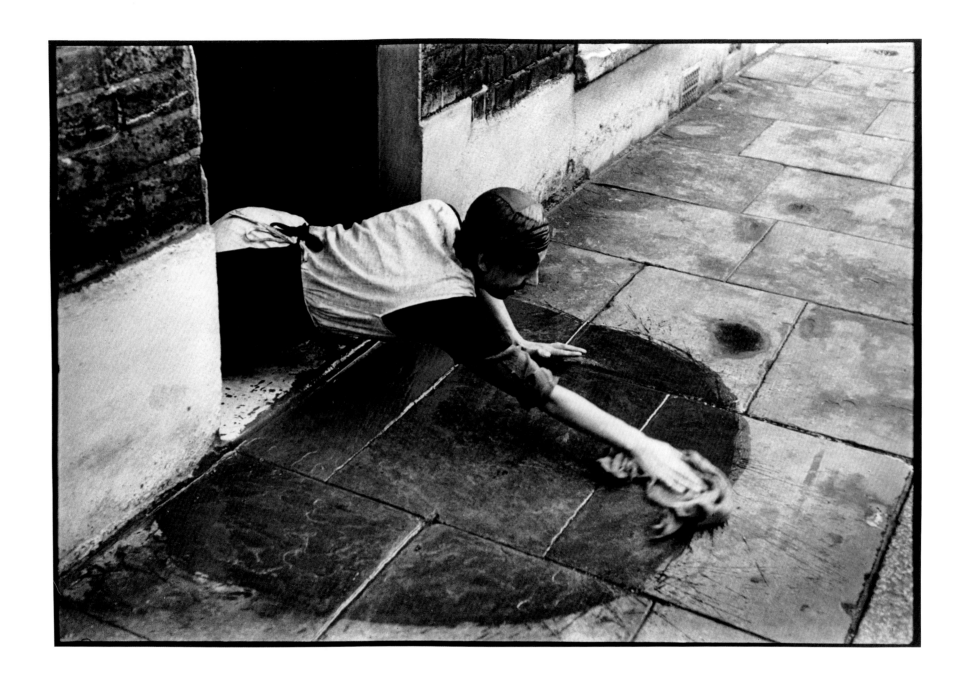

75   WOMAN CLEANING PAVEMENT, LAMBETH, 1938

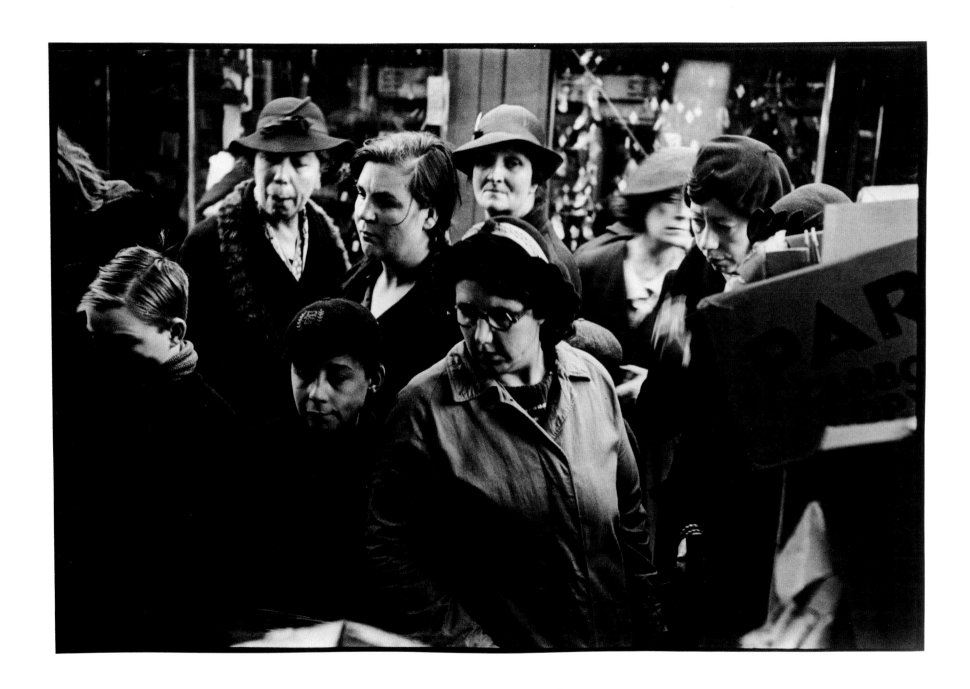

76 LAMBETH STREET MARKET, 1938

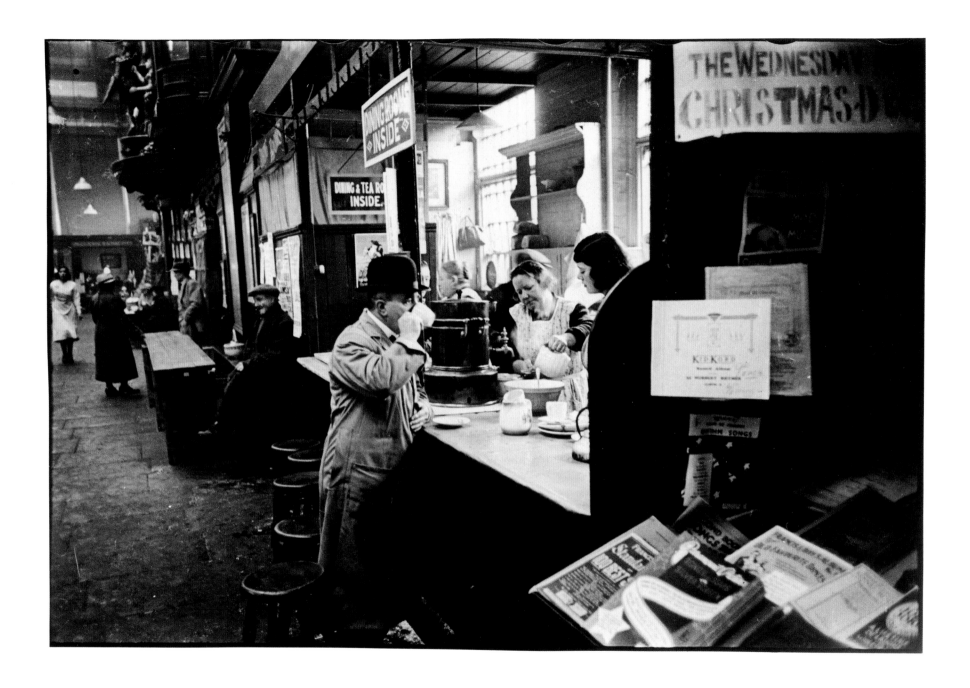

78   MARKET HALL, BIRMINGHAM, 1938

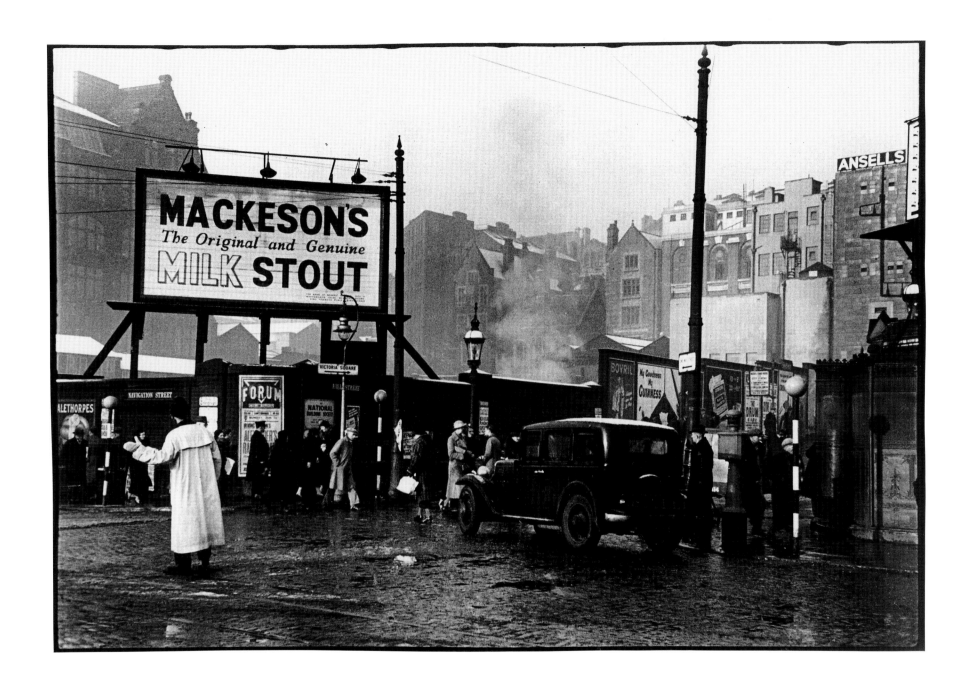

79   NAVIGATION STREET, BIRMINGHAM, 1939

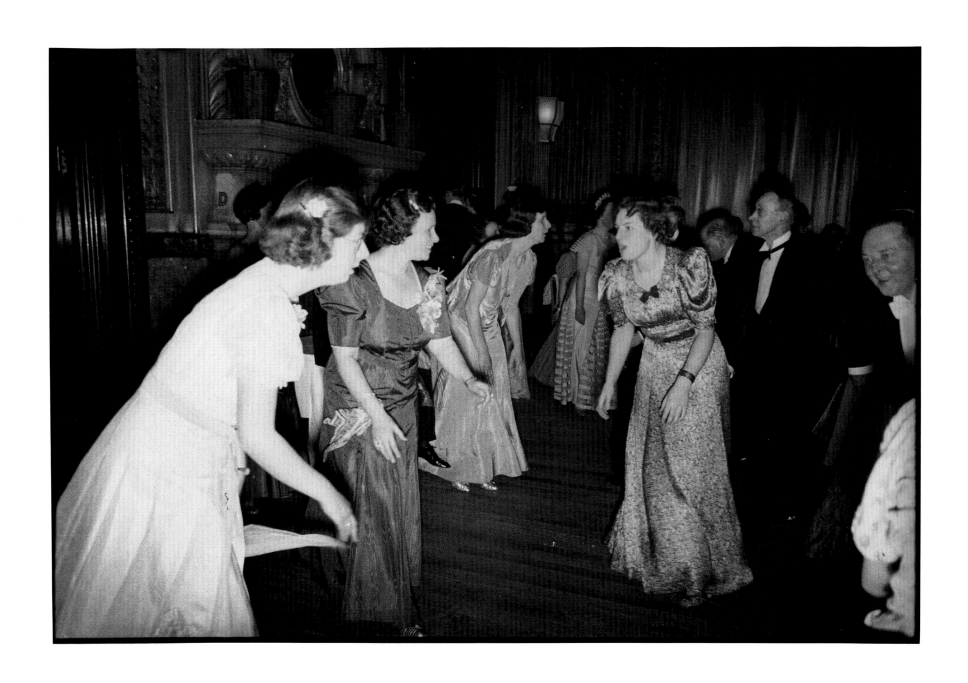

80   COMMERCIAL TRAVELLERS' DANCE, BIRMINGHAM, 1939

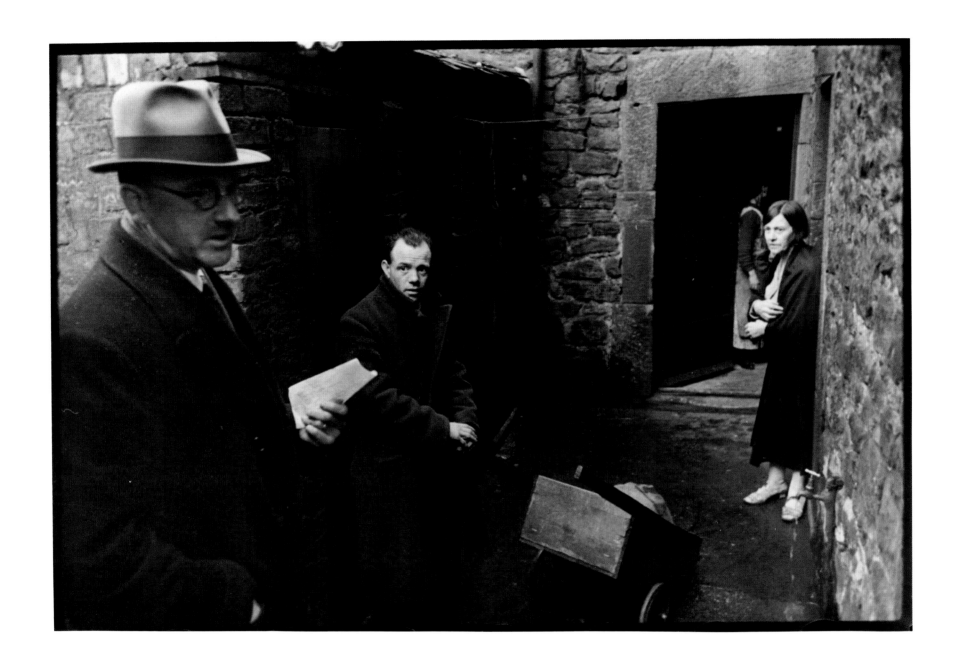

81   CITY ARCHITECT, ANXIOUS TENANTS, TYNESIDE 1939

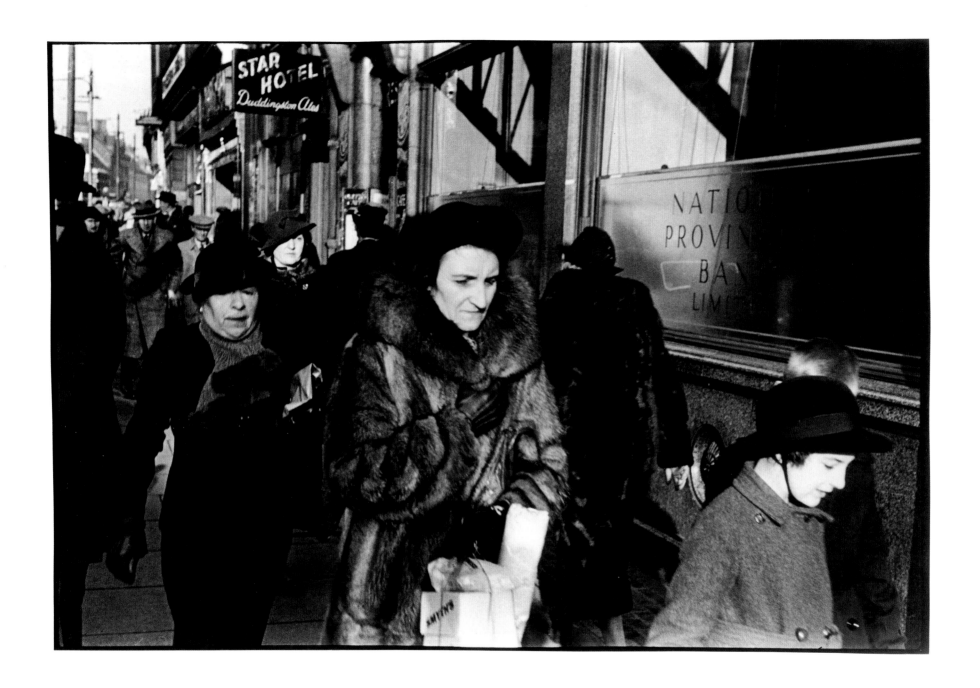

82   NATIONAL PROVINCIAL BANK, TYNESIDE, 1939

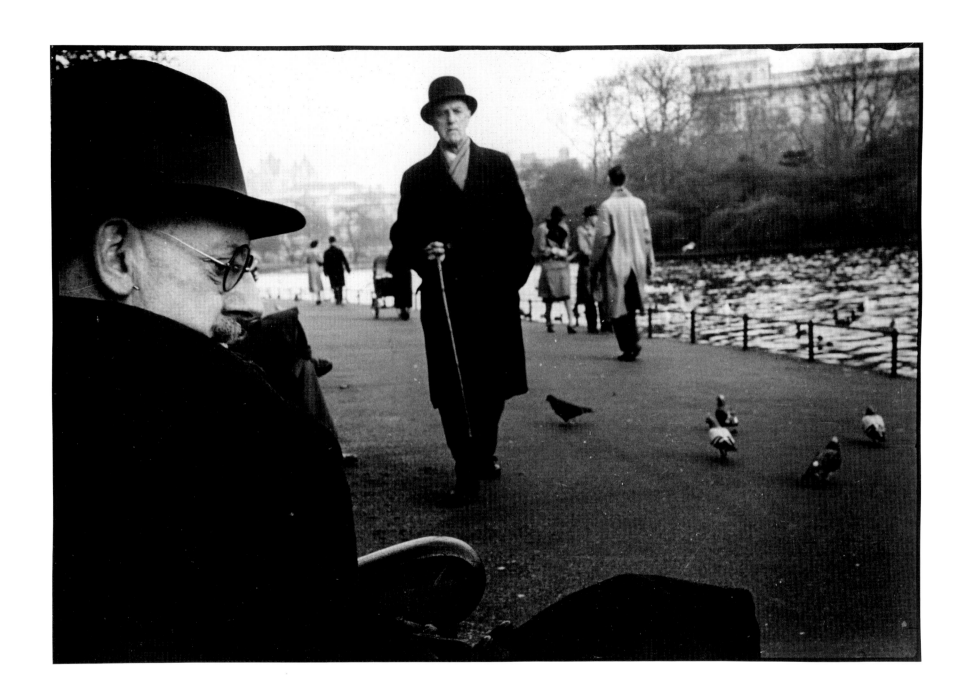

83 SAINT JAMES'S PARK, LONDON, 1939

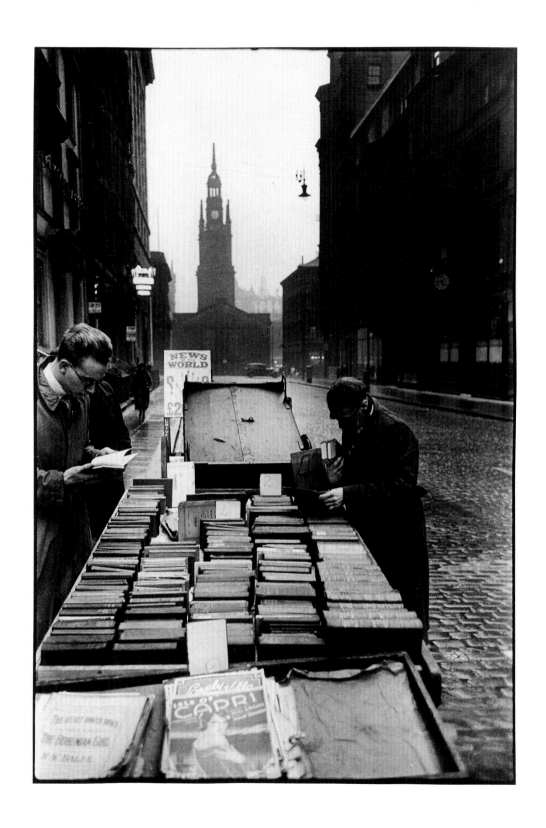

84    STREET BOOKSTALL, GLASGOW, 1939

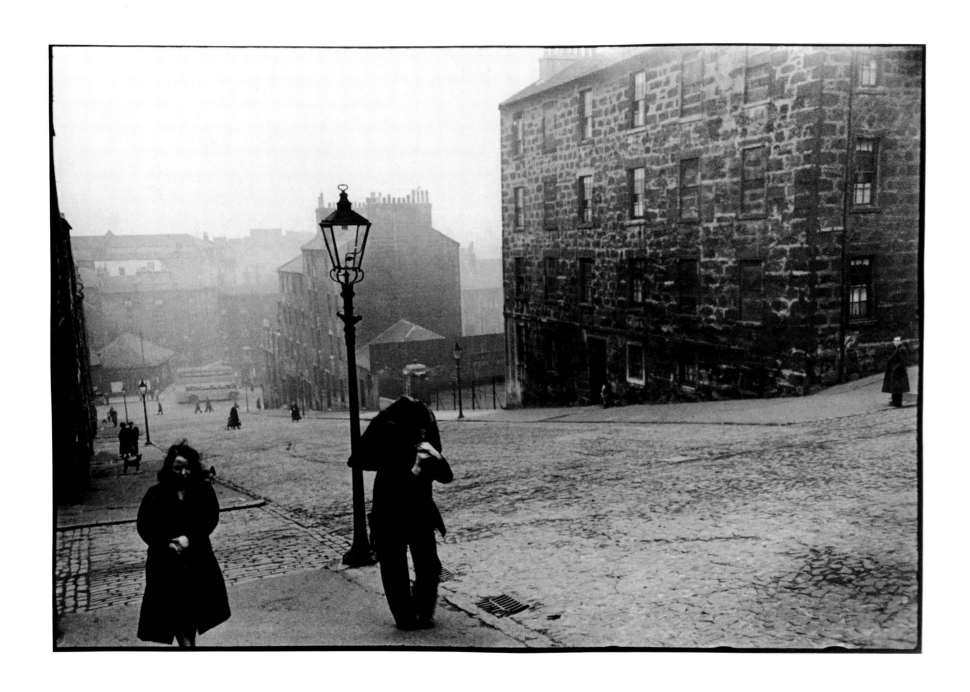

85   BALMANO BRAE, GLASGOW, 1939

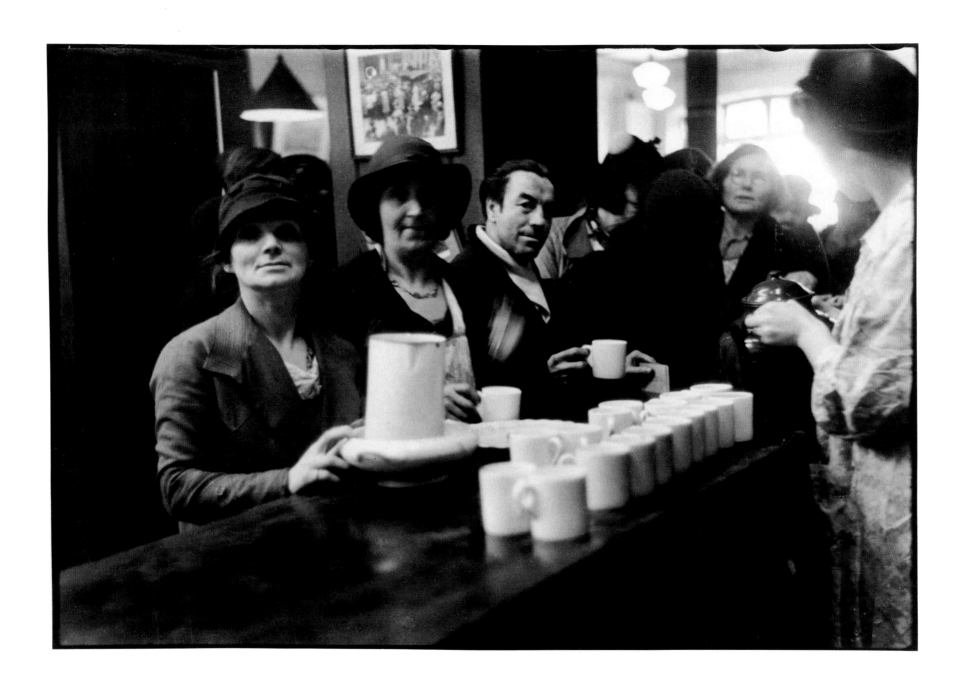

86   SOUP KITCHEN, BRISTOL, 1939

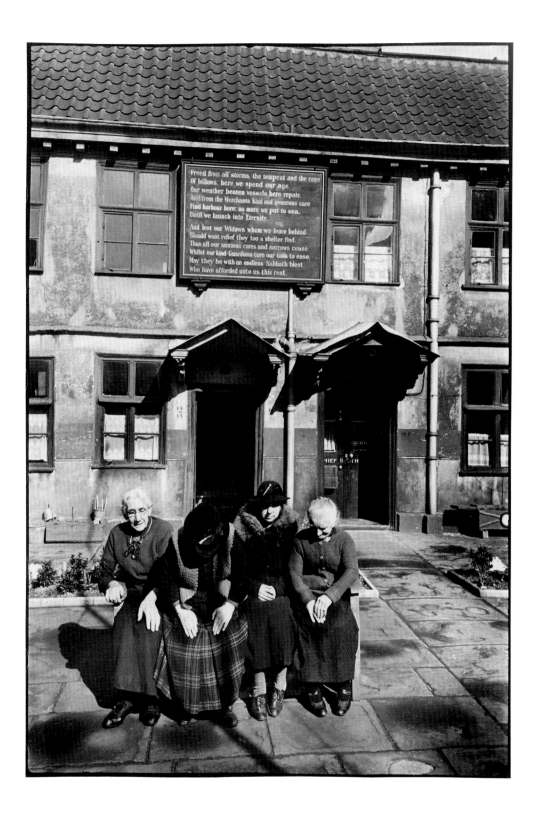

The text within the image reads:

Freed from all storms, the tempest and the rage
Of billows, here we spend our age.
Our weather beaten vessels here repair,
And from the Merchants kind and generous care
Find harbour here: no more we put to sea,
Until we launch into Eternity.

And lest our Widows whom we leave behind
Should want relief they too a shelter find.
Thus all our anxious cares and sorrows cease
Whilst our kind Guardians turn our toils to ease.
May they be with an endless Sabbath blest
Who have afforded unto us this rest.

88   MERCHANT SEAMEN'S ALMSHOUSE, BRISTOL, 1939

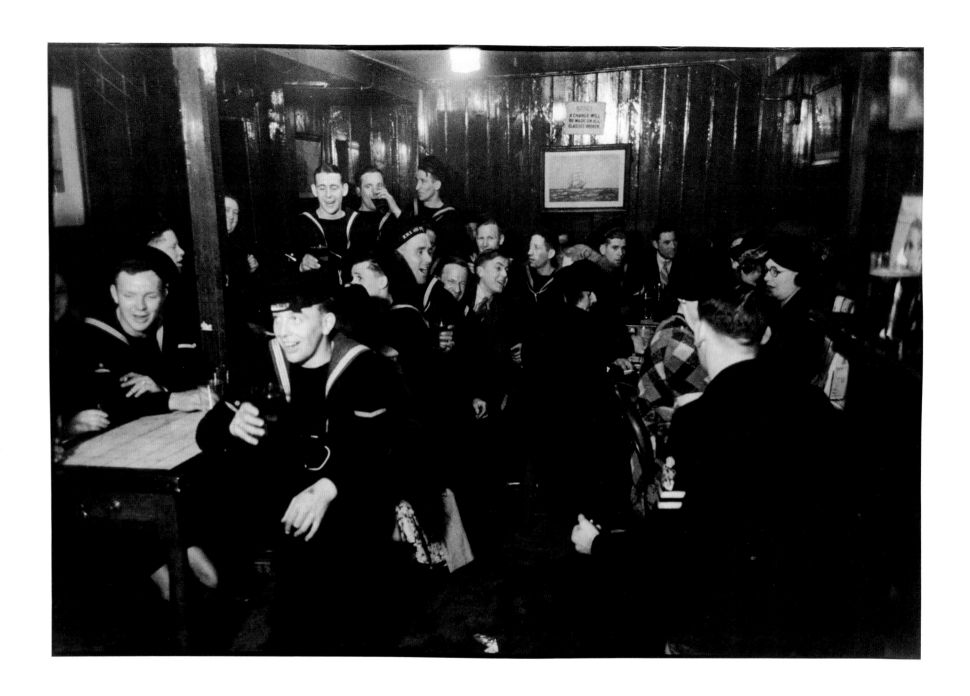

89　PUB SCENE WITH SAILORS, PORTSMOUTH, 1939

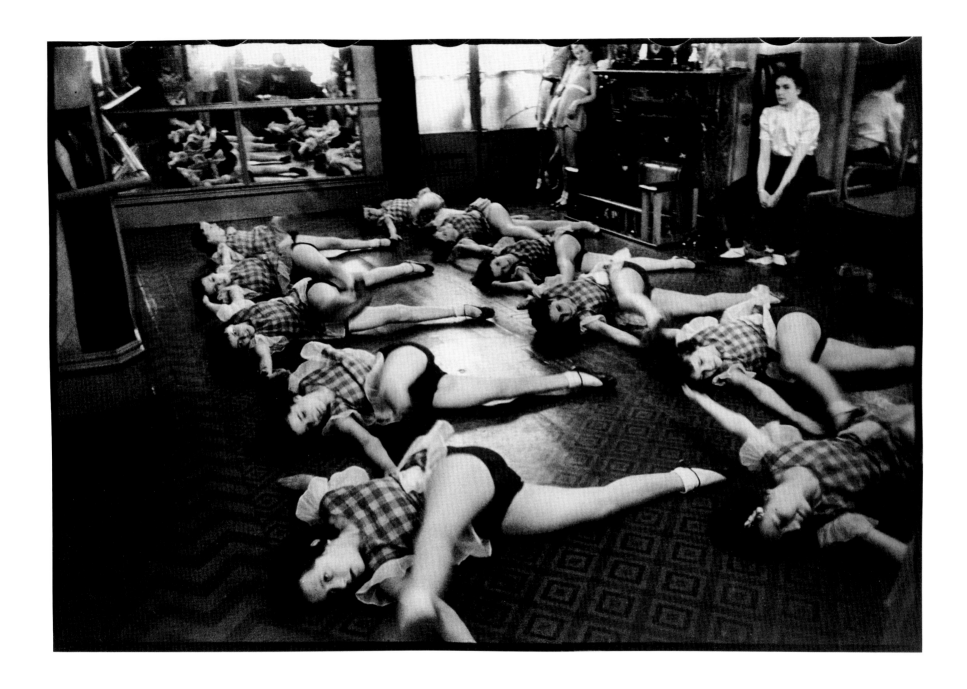

90   MME. WALKER'S ACADEMIE OF DANCE AND ELOCUTION, PORTSMOUTH, 1939

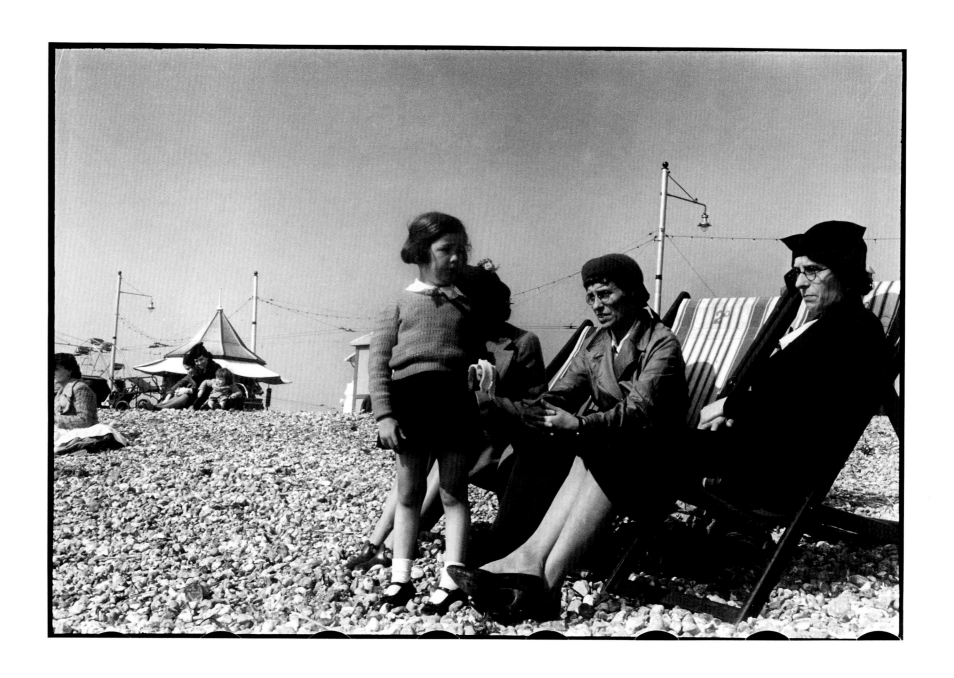

91   ENGLISH SUMMER, PORTSMOUTH, 1939

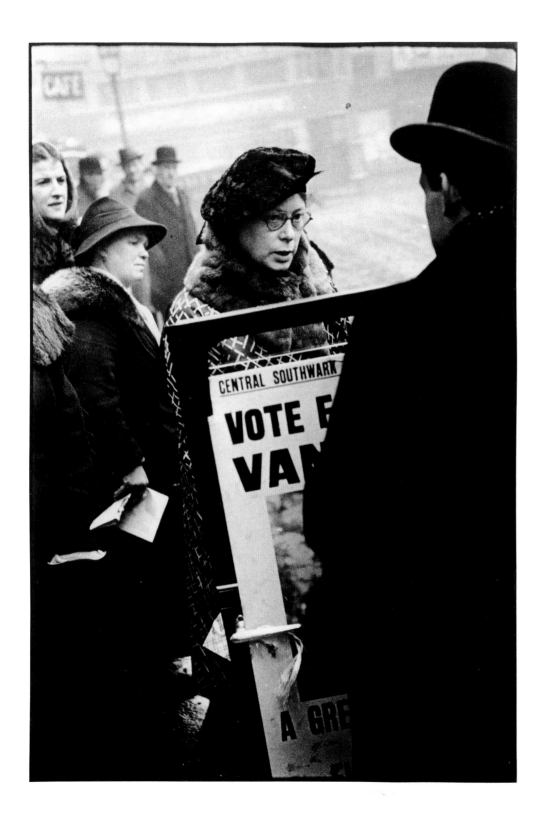

92　BLACK-OUT BY-ELECTION, SOUTHWARK, 1940

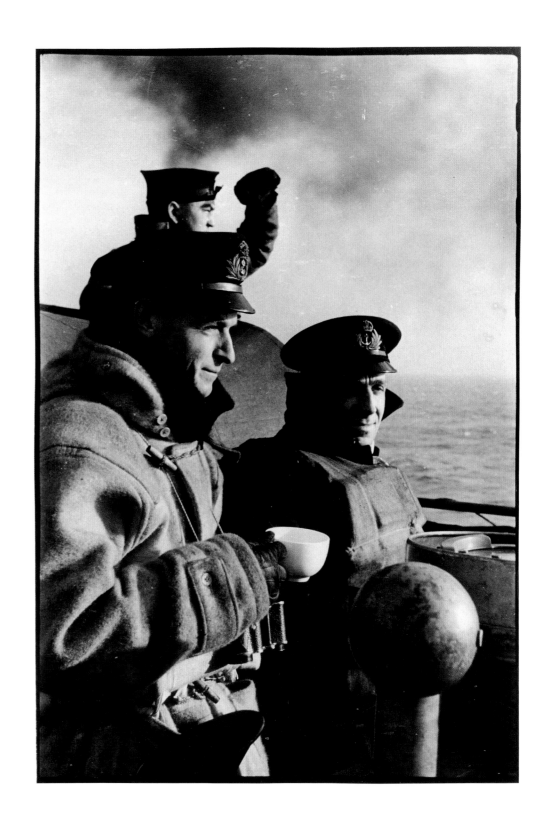

93　OFFICERS ON A MINESWEEPER, 1940

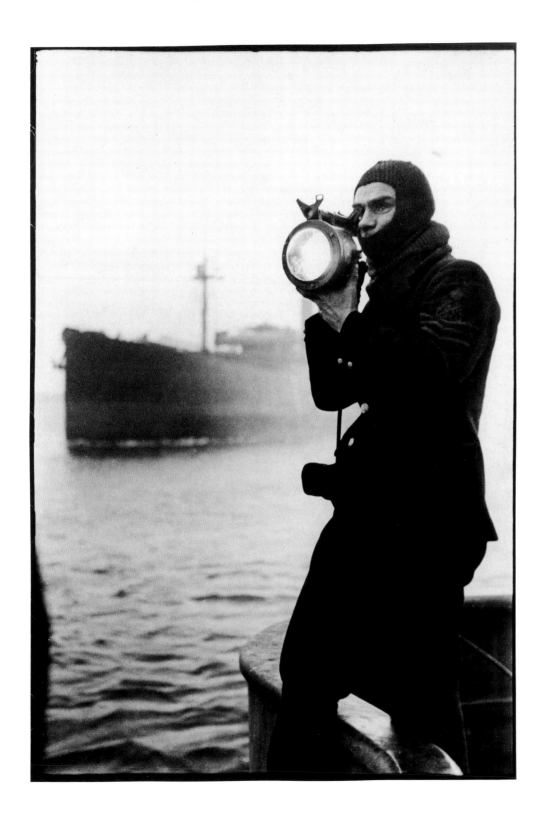

94  SIGNALMAN ON A MINESWEEPER, 1940

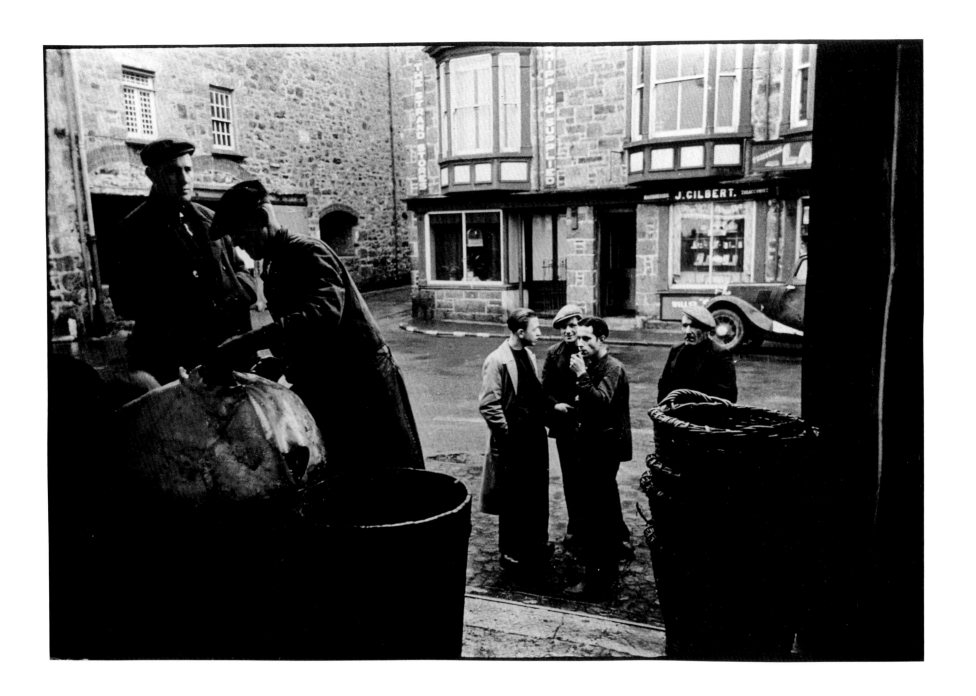

96    FREE-FRENCH FISHERMEN IN PENZANCE, 1940

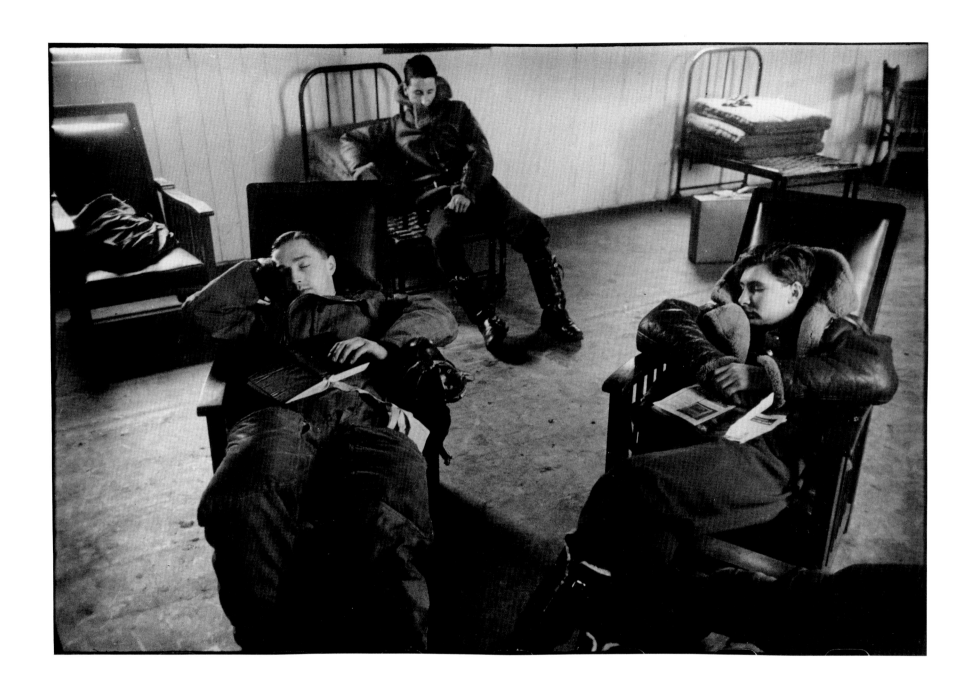

97    FIGHTER PILOTS RESTING ON ALERT, 1940

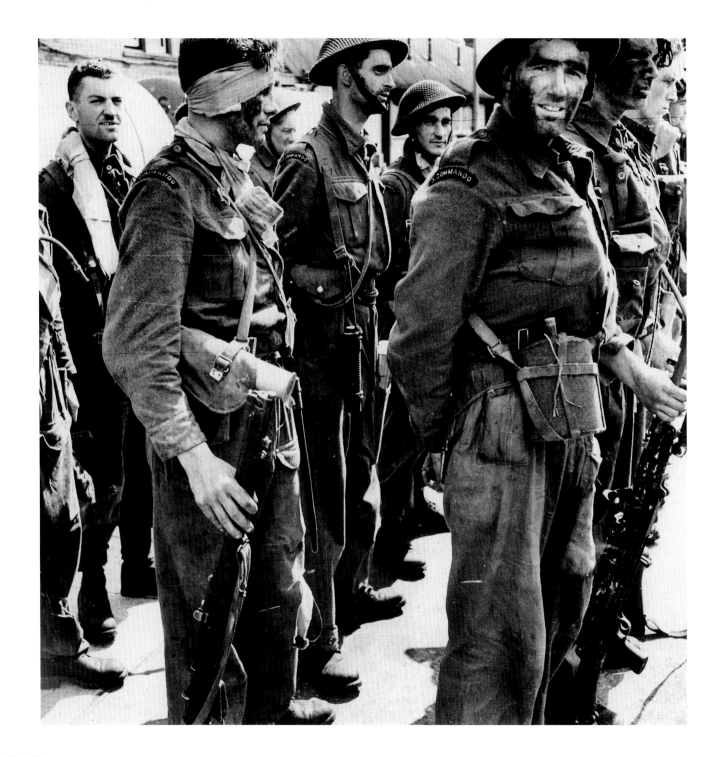

99 DIEPPE RAID RETURN, 1942

103   SELF-PORTRAIT, c.1984

Figs. 1–4, 11, 12, 14, 15, 20, 22–25; cat. nos. 4, 5, 13, 15–18, 20, 21, 24, 29, 44, 55, 57–59, 61–63, 67, 68, 74–76, 79, 82–86, 88–90, 92–94, 96, 97, 99 copy photography by Richard Caspole.

Figs. 11, 12, 14, 15, 22–25; cat. nos. 61–64, 67–70, 72, 74–76, 78–82, 84–86, 88–94, 96, 97 reproduced by permission of the Hulton Getty Picture Collection

Cat. nos. 20–32, 35–42, 51–55 reproduced by permission of the Bolton Museum and Art Gallery

Cat. no. 99 reproduced by permission of the Imperial War Museum, London

Fig. 5    Graham Bell, *The Café*, 1937–38, Manchester City Art Galleries

Fig. 6    William Coldstream, *Bolton*, 1938, National Gallery of Canada, Ottawa, Gift of the Massey Collection of English Painting, 1946

Fig. 8    Bill Brandt, *Halifax*, 1948 © Bill Brandt Archive Ltd.

Fig. 9    Still photograph from *Coalface*, 1935. Copyright of the GPO and reproduced by their kind permission

Fig. 10   Walker Evans, *Interior of West Virginia Coal Miner's House*, 1935. Copy print © 1997 The Museum of Modern Art, New York

Fig. 13   Bill Brandt, *East End Morning, September 1937* © Bill Brandt Archive Ltd.

Fig. 16   Laszlo-Moholy-Nagy, *From the Radio Tower, Berlin*, c. 1928. Julien Levy Collection, Special Photography Acquisition Fund, 1979.84. Photograph © The Art Institute of Chicago. All rights reserved

Fig. 17   Lewis W. Hine, *Steelworkers, Empire State Building, New York*, 1931. Courtesy George Eastman House, Rochester, New York

Fig. 18   Lewis W. Hine, *Carolina Cotton Mill*, 1908. Copy print © 1997 The Museum of Modern Art, New York

Fig. 19   Henri Cartier-Bresson, *Children Playing in Ruins, Seville, Spain*, 1933 © Henri Cartier-Bresson/Magnum Photos, Inc.

Fig. 21   Edward Weston, *Hot Coffee, Mojave Desert*, 1937 © 1981 Center for Creative Photography, Arizona Board of Regents. Copy print © 1997 The Museum of Modern Art, New York

Fig. 26   Julian Trevelyan, *Bolton Mills*, 1938, Bolton Museum and Art Gallery

Fig. 27   Humphrey Spender, *Industrial Landscape with Pylons*, 1938, Leicester Galleries, London

Fig. 28   Humphrey Jennings, *Allotments, Bolton*, c. 1944–45, Bolton Museum and Art Gallery

Fig. 29   Humphrey Jennings, *Listen to Britain*, c. 1949, Bolton Museum and Art Gallery